Advance praise for

Media Literacy, Social Networking, and the Web 2.0 Environment for the K–12 Educator

"This book offers a timely and much-needed framework for educators to infuse media literacy education across the curriculum. Belinha S. De Abreu's multidimensional view of media literacy encompasses the ever-expanding digital world and reinforces the importance of fostering critical thinking and analytical skills. An engaging and relevant read for anyone educating twenty-first century students."
—*Kat Stewart, Director of Strategic Initiatives, Cable in the Classroom*

"In an age where citizenship, democracy, and community are increasingly negotiated in mediated spaces, approaches to teaching and learning about these constructs must be focused around media. This book provides a new and fresh look at how media literacy education can enhance our understanding of new media technologies in the classroom. The book insightfully combines foundations in media literacy education with participatory culture, social media, and mobile technologies. The result is…a definitive guideline for teaching and learning about media, social networks, and digital media. Teachers, parents, and the general public will find Belinha S. De Abreu's text vital for understanding how to effectively navigate online spaces for more engaged, active and participatory lifestyles."
—*Paul Mihailidis, Assistant Professor, Journalism, Media, PR, Hofstra University, New York; Director, Salzburg Academy on Media & Global Change, Salzburg Global Seminar*

"Belinha S. De Abreu is a passionate, energetic media educator with a practical awareness of the needs of students and an understanding of the importance of a global perspective to break through the limitations of classroom walls."
—*Marieli Rowe, Executive Director of the National Telemedia Council and Karen Ambrosh, President of the National Telemedia Council*

"*Media Literacy, Social Networking, and the Web 2.0 Environment for the K–12 Educator*'s vision of media education is a powerful synthesis *and* evolution of media literacy research, theory, and practice. Belinha S. De Abreu's text is loaded with practical resources informed by her middle school teaching experience. The text should be required reading for all professors, teachers, students, and parents committed to the mindful use of new media across the K–college curriculum."
—*Ryan R. Goble, Founder of the Making Curriculum Pop Ning (http://mcpopmb.ning.com) and co-chair of NCTE's Media and Digital Literacy Collaborative*

Media Literacy, Social Networking, and the Web 2.0 Environment for the K–12 Educator

minding the media

CRITICAL ISSUES FOR LEARNING AND TEACHING

Shirley R. Steinberg and Pepi Leistyna
General Editors

Vol. 4

The Minding the Media series is part of the Peter Lang Education list.
Every volume is peer reviewed and meets
the highest quality standards for content and production.

PETER LANG
New York • Washington, D.C./Baltimore • Bern
Frankfurt • Berlin • Brussels • Vienna • Oxford

Belinha S. De Abreu

Media Literacy, Social Networking, and the Web 2.0 Environment for the K–12 Educator

PETER LANG
New York • Washington, D.C./Baltimore • Bern
Frankfurt • Berlin • Brussels • Vienna • Oxford

Library of Congress Cataloging-in-Publication Data
De Abreu, Belinha S.
Media literacy, social networking, and the web 2.0 environment
for the K–12 educator / Belinha S. De Abreu.
p. cm. — (Minding the media; v. 4)
Includes bibliographical references and index.
1. Media literacy—Study and teaching. 2. Internet in education.
3. Educational technology. I. Title.
LB1043.D385 302.23071—dc22 2010026812
ISBN 978-1-4331-1009-2 (hardcover)
ISBN 978-1-4331-1008-5 (paperback)
ISSN 2151-2949

Bibliographic information published by **Die Deutsche Nationalbibliothek**.
Die Deutsche Nationalbibliothek lists this publication in the "Deutsche
Nationalbibliografie"; detailed bibliographic data is available
on the Internet at http://dnb.d-nb.de/.

FSC
Mixed Sources
Product group from well-managed
forests, controlled sources and
recycled wood or fiber

Cert no. SCS-COC-002464
www.fsc.org
©1996 Forest Stewardship Council

The paper in this book meets the guidelines for permanence and durability
of the Committee on Production Guidelines for Book Longevity
of the Council of Library Resources.

© 2011 Peter Lang Publishing, Inc., New York
29 Broadway, 18th floor, New York, NY 10006
www.peterlang.com

Printed in the United States of America

Contents

Foreword

Frank Gallagher, Executive Director, *Cable in the Classroom*

In this important book, educator and media literacy advocate Belinha De Abreu quotes a provocative question once asked by filmmaker George Lucas: "If students aren't taught the language of sound and images, shouldn't they be considered as illiterate as if they left college without being able to read and write?" This question should be, but too often isn't, included in the conversations about education reform that are taking place in classrooms, living rooms, conference rooms, and hearing rooms across the country.

We teach children how to read, write, analyze and evaluate text, but do we teach them how to read, write, and think critically about videos, web pages, or Facebook profiles? The point George Lucas raised is that an increasing amount of the information we take in and produce is more than just words on paper. The images, sounds, colors, layouts, fonts, camera angles, lighting, movements, and editing can themselves convey a great deal of information. Sometimes the images and sounds effectively reinforce and elaborate the words. Sometimes they can contradict or overwhelm the words. It behooves us to understand how and why professional media makers use these techniques so that we appreciate when they're used artistically, are aware when they're being used to shape our emotions or opinions, and can use them effectively in our own productions. In a nutshell, that's what media literacy is all about and it becomes all the more important in the world of Web 2.0.

It's hard to overstate just how dramatically the media landscape has changed in the last decade. Prior to 2002, there was no MySpace or Facebook or YouTube, no Twitter or Second Life. With the advent of the creative tools, interactive platforms and broadband connections that together make up what is called Web 2.0, a fundamental shift of power occurred. We left behind a world of one-way mass media where large companies effectively controlled television, radio, newspapers, books, movies, and websites and also decided what information and entertainment would be delivered to us. We are now in a two-way world in which anyone with a computer or smart phone can search for and find content from all over the world and, more importantly, can be a media creator and not only reach, but also interact with, a worldwide audience. This great shift has profound implications for everything from how business is done, to how we communicate with each other, to how we educate children, to how we define ourselves.

Businesses no longer just market to consumers; they also engage us in conversations and interactions through games and social media. A company may involve thousands of consumers in designing, developing and providing feedback on new products. Bloggers matter as much as advertising agencies. Corporate officials monitor the traffic on YouTube, blogs, and Twitter and respond immediately whenever something appears that affects their company. Corporations use social media to create buzz around a product, to enhance their brand, and to seek out and evaluate potential employees.

TV shows and movies also have a vibrant web presence, with exclusive content and information to engage fans and provide extra levels of experience. Even newspapers encourage reader involvement through online videos and multimedia, comments, voting, and the like. Content from songs, movies and videogames is being sampled, remixed, and reshaped by millions of web users. A YouTube video turns into a network TV show; fan fiction into novels; bloggers into print columnists and TV correspondents. Even the business models of media companies are changing, with innovations like iTunes and Hulu competing with CDs, DVDs and Prime Time TV.

In the news what appears on YouTube or in a blog can drive coverage and affect what happens in government, business and society. Unusual stories can find the light of day, but sensational and misleading claims that appear online can be picked up and replayed over and over on websites and TV news programs. Both rumors and unsubstantiated assertions can spread far and wide.

A generation ago, most of what we knew about the world came from personal experience or through the newspapers, magazines, books, television, and movies that were our dominant sources of news and information. If we wanted information, we'd look in a library or ask an expert. In either case, we had a pretty good idea where the data came from and whether it was trustworthy.

Today, we may be consulting blogs or YouTube videos or a friend's delicious bookmarks, or we may be creating them ourselves. We may spend more time Googling health information than talking to our doctors, or we might start an online support group for others with the same medical condition we have. There's an "app" for almost anything you want to do. Amidst this ocean of information—some good and some less so—how we gather, sort, analyze, and evaluate the information and entertainment we consume and how we make our own digital contributions to knowledge and culture is no simple matter.

Some of the greatest changes have occurred in our own interactions with each other. Facebook, Flickr, YouTube, and twitter; multi-

player online games and virtual worlds; and the various other ways we can engage with each other through smart phones, game consoles, and mobile devices have dramatically changed how, where, when, and what we communicate. A child's social networking profile lets him explore his identity and connect with others who share his interests. The near instantaneous ability to send photos and messages lets us share our experiences with friends and family in real time. The easy-to-use tools and applications and instant, ubiquitous connections let us express our creativity in myriad ways.

And, yet, for all of these examples, there is a dark side. At a time when anyone can be a media creator, how can we tell what is a trusted source of reliable information? When companies seek to engage their customers, how can we tell where the line dividing communication from manipulation rests? When media are easy to find, copy, and distribute, where do we learn about copyright, piracy and plagiarism? When it's easy to share information, how do we know when we've shared too much, with the wrong people? How do you create, protect, and burnish your digital reputation? Where do we learn about privacy in a digital universe that was set up to make information (to borrow from researcher danah boyd) permanent, searchable, replicable and scalable? And where do we learn appropriate behaviors when our audience is invisible and the social context may be unclear?

These questions cry out for comprehensive media literacy education that explores the products, problems, and potential of Web 2.0. Yet few schools have incorporated media literacy into their curriculum and many still block, restrict, or avoid social media and other Web 2.0 applications.

Some schools avoid using Web 2.0 for fear of something bad happening. While understandable, it is also at least partly the result of the excessive attention the news media devote to sensational stories (which is a media literacy lesson in itself). Other schools haven't yet seen the potential of educational value. Where social media is addressed, it is often by telling students what not to do, and, while safety is important, it's not followed often enough by what one should do.

Asking George Lucas' question in a slightly different way, then, what then does it mean to be an educated citizen in the 21st century? What skills and knowledge are required to fully participate in economic, social, and civic life when so much of each now takes place in digital spaces? Certainly the ability to read and write is an absolute necessity, but that is no longer sufficient. If you are not able to effectively communicate using a variety of media, are you really prepared for life and work?

To hear college professors and executives at leading businesses talk about it, the answer is a resounding no! Today's jobs (and many college classes) often require working in project teams that may be dispersed geographically, communicating and collaborating over the Internet through project wikis, meetings in Second Life or interactive webcasts. Careers from nursing to auto mechanics can involve online continuing education courses that incorporate Web 2.0 tools for discussions and presentations. Professionals use LinkedIn to network, a Ning to share best practices and advice, and Twitter to stay current and enhance their reputations as thought leaders. These interactive tools have become central to the lives of more and more people, yet, without media literacy, do we really know how to use them well?

Simply adding blogs or Second Life to a course is, obviously, no panacea. A blog, wiki or YouTube video is a tool, like a pencil, that can be used well or poorly, with purpose or ineffectively. A pencil can be used to write the next great American novel or scribble insults on a bathroom wall. It can be used to poke someone's eye out or to sketch a new design for an artificial heart valve. In school and at home, we teach kids how to hold and operate the pencil, how to use it in safe, effective, and efficient ways to communicate, and we teach the social norms and etiquette of different writing situations. We have to bring that same mindset to the interactive tools of Web 2.0, and school may be the one place where kids can learn how to properly use these tools, under adult guidance, in a safe and supportive environment.

This is a time of transition in education. The Common Core State Standards Initiative has many states rewriting their curricula. Years of investment in technology in schools has provided opportunities for educators to use Web 2.0 tools in creative ways. Mobile devices make digital learning possible anywhere, anytime. However, to use these technologies thoughtfully, effectively, and safely both students and educators need to learn new skills. While kids may be facile with the devices, that doesn't mean they are good at using them to learn, and the activities teachers have for decades successfully used in classrooms won't necessarily work in collaborative digital spaces.

That's why books like this are so important. Media literacy provides a useful framework with which one can approach the safe and effective use of these technologies for what the Partnership for 21st Century Skills calls the four C's—critical thinking and problem solving, communication, collaboration, and creativity and innovation—which are vital skills that can be applied to any academic subject and which will be needed by people at all levels of business and professional work.

There are teachers doing this now. Even a cursory search of teacher blogs turns up a wealth of examples of effective and seamless integration of social media tools into English, social studies, math, science, and other lessons across all grade levels. Many also take the additional step to include the critical thinking and analysis of media literacy.

A large proportion of youth (and quite a few adults) is already deeply engaged in what Henry Jenkins calls a participatory culture: creating, sharing and transforming all sorts of information using digital media. There are rich learning opportunities here, as we collaborate, create, solve problems, and build knowledge. And there are vast opportunities for schools to take advantage of youth's affinity for and interest in Web 2.0 applications to stimulate critical thinking and deepen understanding of content in all subject areas. But only if we include media literacy in the mix will our students of today be the safe, ethical, thoughtful, successful citizens of tomorrow, prepared for college and career, and for all of the opportunities available through these tools and technologies.

I have been involved in media literacy education for the past fifteen years. During that time, both the education landscape and the media industry have undergone waves of dramatic changes. Never have I been more optimistic at the potential for media literacy to have a major impact in education and never have I been as concerned that the opportunity may be squandered. Talented, dedicated, innovative educators like Belinha de Abreu and books like this give me hope.

Preface

We live in a media-filled world that keeps growing and advancing with each technological gadget. Today's media are not simply about the television or the movies we watch, but the social networking sites we visit and use to interact with others. Facebook, Twitter, Second Life, or other online communities, the media are not stagnant or a stand alone, but in fact interactive, which is why we have a generation of students and adults who are easily entertained and whisked away by what we can do within it.

The media have always been of special interest to me since the day I could turn the television knob. My sister and I would sit, watching TV, with glazed eyes stuck on a little 13-inch, black and white TV. The television was only "on" occasionally at my home, and mostly just for news. Even with that little amount of time, it became quickly apparent the TV could pose a problem for us academically when I was in elementary school. My grades were not as exemplary as they should have been, and the teacher questioned how much time our family spent watching that lovely tube. Although we weren't actually watching a lot, the fact that the suggestion came from an educator propelled my father to ban television during the school week, except for the news. Television for entertainment purposes was allowed on the weekends, which thankfully started on Friday nights.

Admittedly, my sister and I would turn on the TV the minute my parents were out of the house. Yes, we would get in trouble, and I would systematically try to develop techniques for watching TV without getting caught. The one that still makes me smile to this day is this example of my scrupulous mind at work. The TV would get hot from the tubes heating up, (obviously long before digital technology); my father, a wise man, realized that TV activity would happen the minute he left the house. He made it a regular ritual to come in and pat the TV, which of course, if hot, indicated that it had been on and probably for longer than it should. In order to resolve this problem, my crafty mind came up with the plan that if I grabbed a wash cloth, froze it, and then applied it to the TV ten to fifteen minutes prior to the parents arriving, no one would be the wiser for it. This technique would work occasionally, but I still managed to get caught sometimes. This tug of war between the forbidden TV world and my parents' wishes continued until I left for college.

My parents would probably agree with most of today's researchers who claim that television viewing could be an addiction. Television shows were a conversation piece for my peer group. We would start

our Monday mornings at school with, "Did you see _____ this weekend?" or "What happened on the *Dukes of Hazard* or *General Hospital*? I missed it." As middle school students, we were all watching and wanting to keep up with our friends.

Does this show addiction? It might, but what it shows more importantly is that television programming is designed to be captivating and entertaining. The images, the speed, and the content all add up to create hourly diversions for young and old. As its cost is minimal, the influence on a generation of viewers and consumers is high. Why is it that we can remember a tune the first time we hear it or know the product it is selling just from that very jingle? Why is it that so many people can tell you who is the most famous celebrity and a thing or two about their lives, but do not know the vice president of the United States? These two notions explain why media literacy education is so important. It is the difference between accepting media messages at face value and critically considering the ideas presented.

The impact of television on society became a greater reality for me when after college I entered into the world of broadcasting. By the time I was in high school, I had determined that I wanted to be involved in news programming. My thoughts were on the reporting of the news, but instead I worked mostly on the tech end of the news—floor director, cameraperson, and electronic graphics. In these capacities, my job placed me in the middle of a chaotic environment that was recognized by the outside world as news.

This is where the collision course of my life happened—where the need for media literacy education became so apparent. In network news, your work is focused on putting together messages and images for people. Although the news industry will claim that they are a neutral agency of information, an observer of the industry would say otherwise—noting that news is not created without bias or motivation. In my last year in broadcasting, prior to changing into the field of education, the choices that were being made in my particular broadcast house became about ratings and not about accurate reporting. In conversations with the local anchor, we would discuss our worries that people would accept messages at face value. When it came to the young, this anchor specifically worried that they would not be able to discern or qualify messages that they were receiving. Thanks to his influence, my career path changed and I became involved in teaching children about the media.

As a middle school media specialist and then media literacy/technology educator, my district provided me with creative access to teachers and curricula. Media literacy asks students to question

how messages are created, how they are constructed, and how messages sent via the media actually produce different meanings because of economics, race and education. This became my passion. Within grades 5 to 8, I have tested lessons in all curriculum groups: English, Social Studies, Math, Science, Foreign Language, Technology and the Arts. What I have learned is that the media reach quite far, and that some younger children are more readily to believe what they see on the Internet, magazines, television, billboards, and more. Only those students whose parents questioned their choices or motivations, while discussing with them the meanings, were able to distinguish between fact and fiction.

Professionally, teaching about the media has been one of the most exciting and fulfilling aspects of my life. Students take notice and want to talk about their medium of choice. They want to share their likes and dislikes within the context of respect and openness, which in this case means that the teacher is not going to pass judgment on their media choices. Both teachers and students are sometimes surprised that the study of media can be so captivating. For teachers, it is an eye-opener as to how easy it is to integrate the subject into their curriculum areas. For students, they enjoy that the media can be a topic of discussion and evaluation without condemnation within the school environment.

This book is written for teachers, media specialists, librarians, health teachers, curriculum advisors and principals who see the media as a necessary source for educating today's students especially with Web 2.0 tools available and the socialization of their worlds. This book is an affirmation that we can use what students know and are most entertained by to create dynamic lessons and opportunities for learning. Ultimately, this book demonstrates how media literacy *is* a part of our students' lives and belongs within each school curriculum content area.

Acknowledgments

A book such as this one cannot be written without the help and assistance of many others along the way. The journey was made richer by the people who were encountered while on my travels nationally and internationally over the course of this writing.

Grace Small and Michele Simpson are due special thanks for reading this manuscript and providing comments and a general critique. This work was enhanced by their questions, which helped me with clarifying certain pieces and refining the final edits.

A special thanks to Frank Gallagher, Executive Director, *Cable in the Classroom,* who when asked to write the foreword for this book immediately said Yes. Over the years, his contributions to my own work in media literacy have helped me grow within the field professionally and personally. More importantly, his efforts in creating and enhancing the classroom with educational materials regarding media literacy, Web 2.0, and digital citizenship through the cable industry has made his role vital to educators throughout the United States.

My students at all levels: middle schoolers, undergraduates, and graduates both past and present have provided me with much of the practical knowledge which helped in making this book both practical and true to their lives.

I would like to thank Luis Pereira and Dr. Sara Pereira from the Universidade do Minho Braga, Portugal; Sr. Rose Pacatte from SIGNIS in the United States; Dr. David Buckingham from the United Kingdom; Marlene Francis Le Roux from Artscape Theatre in South Africa; Dr. Cristina Ponte from New University of Lisbon; Dr. Vitor Tomes from the Escola Superior de Educação de Castelo Branco—Castelo Branco, Portugal, and Alton Grizzle from UNESCO in Paris, France, who at the World Summit on Media for Children and Youth provided me with new insights and ideas which helped me to finish this work.

I would like to thank the following people and organizations for allowing me the rights and privilege to reprint various images and documents to help supplement this work: Tessa Jolls, President of the Center for Media Literacy; Dr. David Considine, Professor of the Media Literacy masters and certificate program at Appalachian State University; iKeepSafe for providing the C3 matrix, which is a document that many schools should be using to supplement their own online educational programs; ISTE for creating the NETS standards, which have been used nationally to create technology curriculum; the *Denver Post* for the Facebook editorial cartoon; and Phillip Niemeyer

of Double Triple of New York City for the wonderful symbology illustration.

My sincerest thanks to the publisher Peter Lang for believing in the concept of this book—most especially to Chris Myers and Sophie Appel, who kept this book on schedule, provided advice when needed, and helped guide the whole process.

Finally and most importantly to my family, my father and mother, Jose and Francelina De Abreu; my sister and brother-in-law, Grace and William Small; and my husband, Jay Lindberg—for keeping me updated, in tune, and in synch with the media world events.

Introduction

Somewhere around the early part of 2009, it began to feel like the world had shifted a bit on its axis with what felt like a leap forward with the pace of technology. Wherever you went—airports, trains, malls, shopping plazas, and schools—technology was being used by adults or children alike. The cellular telephone with all its new features, known as "apps," or the access to the social networking sites meant people were connected, and turned on—24/7.

Historically, the past decade has seen the great boom of technology. Computers have become smaller and smaller while going faster and faster. The increase in technological uses has grown as has the number of users. Even our language has changed to accommodate the new technologies. We now can "google" it, or we have various forms of shorthand which are used with relative ease. Some of the more popular ones are "LOL" and "OMG." New technology has also created additional words to grow our language, such as the iPhone, iPad, the Droid. The world has been introduced to a whole different way of seeing and hearing that has widened our global connections, created what some people term a generation of "multi-taskers," and also offered us a new world view. In January of 2010, the *New York Times* printed a symbology illustration representing the verbiage, logos, fads, etc. documenting the changes faced in our society over the past ten years (*New York Times*, "Picturing the Past 10 Years," pp.2–3).

With all of these changes, the value of reviewing what our children are watching and learning has also grown in importance and in urgency. Through the use of media literacy education, how can we implement creative content programs which we currently call Web 2.0 and other participatory networks in order to foster critical thinking among our students? At the same time, how can we use these skills to develop educators who are confident and willing to use these new media literacies?

This rapid movement in technology has caused our schools to undergo some drastic changes which they were not prepared to handle and issues that they are still tentatively approaching related to technology uses and abuses. In fact, at the World Summit for Media on Children and Youth, the discussion and many panels were looking at how the message of media literacy needs to be included in the curriculum, but moreover how it can be used to grow educators in their own self-awareness of these communicative technologies. Schools need to begin by looking at how they bring in the technologies that students are using in their homes and for their personal use and bridge opportunities for learning in the classroom. However it is more than just using the technology, it is about understanding where the future exists

Year	IT!	NEWISH	BUSINESS	FEAR	MAVERICK	CHAMPION
2009	The Economy	Iran on Twitter	Stimulus	H1N1 / Swine Flu	Goldman Sachs	27 / Yankees, Again
2008	The Election	Moms on Facebook	PLEASE BUY THIS HOUSE / Foreclosures	Credit Freeze	REVOLUTION / Ron Paul	Michael Phelps
2007	Baby Boom	Rock Bands	flip this HOUSE / Housing Boom	322 9/10 / Peak Oil	T. Boone Pickens	Tiger Woods
2006	Watching TV on Computers	Tsunami	¥ / China	H5N1 / Avian Flu	Sincere Beards	Barbaro
2005	Katrina	Self-Portraits	Blackwater	George Bush doesn't care about black people. / I.E.D.'s	Kanye West	Lance Armstrong
2004	Abu Ghraib	Wiretaps	GOOG 85.00 / Google I.P.O.	24 / It's Too Late	AIR AMERICA / Al Franken	Mia Hamm
2003	Bring 'em on. / Iraq	Friendster MySpace	Credit-Default Swaps	SEVERE HIGH ELEVATED GUARDED LOW / Everything	We're ashamed the president… is from Texas / Dixie Chicks	Steroids
2002	Flag Pins	Guántanamo	$650 / 1BR. A.C. WIFI. W/D. RR. NO-FEE. COZY / Craigslist	Snipers	Al Jazeera	Patriots
2001	9/11	Airport Security	Dot-Com Crash	Anthrax	NO / Russ Feingold	Dale Earnhardt Sr.
2000	Florida Recount	Tiniest Phone	EDISON / Rolling Blackouts	More Is Not Enough	STRAIGHT TALK / John McCain	Shaq & Kobe

IT! NEWISH BUSINESS FEAR MAVERICK CHAMPION

Year	CULTURE	COUPLE	FAD	LOGO	NOUN	VERB
2009	Lady Gaga	+8÷2 / Not Jon & Kate	VV / Vampires	citi	Auto-Tune	crowd-source
2008	The Art Market	Federer & Nadal	I'm NOT A Plastic bag / Canvas Totes	Obama	hope	go rogue
2007	Writers' Strike	Brangelina & Family	Crocs	LUKOIL / Russian Moguls	surge	blog
2006	yummo! / Rachael Ray	I can't quit you. / Heath Ledger & Jake Gyllenhaal	Ironic Mustaches	Apple	chatter	text
2005	M.M.O.R.P.G.'s	Tom Cruise & Oprah Winfrey	Movies in the Mail	Fox News / News vs. News	truthiness	Google
2004	Camera Phones	Demi Moore & Ashton Kutcher	Brownie & Big Time & Rummy & BoyGenius & Condi. / Nicknames	W04 / Dubya	friendly fire	Swift boat
2003	HEY YA! / OutKast	Gigli / Bennifer	Tuscany	Oprah	spider hole	punk'd
2002	"American Idol"	Europe & Money	Collagen	BADA BING! / HBO	freedom fries	download
2001	Wikipedia! / *According to Wikipedia	Harry Potter & Voldemort	JONATHAN FRANZEN CORRECTIONS / Oprah's Book Club	FDNY NYPD / First Responders	news cycle	outsource
2000	Pokémon	Carrie & Mr. Big	Going Viral	Starbucks / Lattes	glitch	I.M.

for our children. As UNESCO representative Alton Grizzle stated, "it is not enough to teach Reading, Writing and Arithmetic....To be literate in other skill sets is most important!" In fact, knowing that the child's voice has a place and how they use that voice need to be recognized through other networks such as Facebook and blogging. The technology should enable students to express themselves creatively or artistically and to use media to communicate, but it is not primarily a matter of training them to use the newest programs, but to realize their extensions in a critical thinking context. Thus, creating learners who are constructing information and providing understanding for the reality in which they live in today and the one they will be creating for the future.

The goal of this book is to take on what we know about the media and review media literacy education as a foundation of thought, then extend it to the technological world to include social networks and Web 2.0. In essence, we are looking at the traditional school house and designing one that takes a multidimensional look at media literacy education and opening its doors to allow students to be creators and producers of the global society of transformational education as shown in the image below.

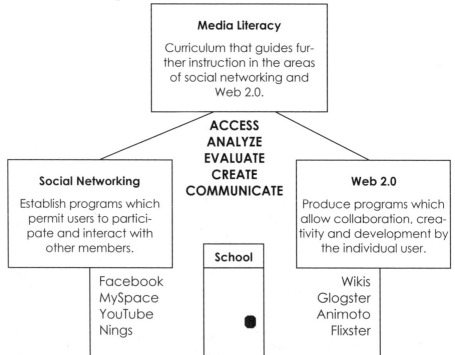

Media Literacy

Curriculum that guides further instruction in the areas of social networking and Web 2.0.

**ACCESS
ANALYZE
EVALUATE
CREATE
COMMUNICATE**

Social Networking

Establish programs which permit users to participate and interact with other members.

Web 2.0

Produce programs which allow collaboration, creativity and development by the individual user.

School

Facebook
MySpace
YouTube
Nings

Wikis
Glogster
Animoto
Flixster

The advantages of using this model in the classroom are detailed in each chapter along with the model of media literacy education, which is to access, analyze, evaluate and produce. Why this book and why now? Our focus in the media literacy education world needs to change to provide a forum for the participatory culture of this generation's youth. They need to be empowered to be the newest generation of critical thinkers in the worlds that they already live in, and not the ones that our schools have continued to create despite the fact that the world has changed and the industrial model of education no longer is applicable.

The benefit to the classroom is real and vital for the continued growth of our students and our societies. This book provides a glimpse of the potential these new digital tools offer in schools through the perspective of a media literacy education foundation.

Part A: Media Literacy

Chapter 1: Pedagogy and Methods

"The more I grasp the pervasive influence of media on our children, the more I worry about the media literacy gap in our nation's educational curriculum. We need a sustained K-12 media literacy program—something to teach kids not only how to use the media but how the media uses them. Kids need to know how particular messages get crafted and why, what devices are used to hold their attention and what ideas are left out. In a culture where media is pervasive and invasive, kids need to think critically about what they see, hear and read. No child's education can be complete without this."

—Michael Copps, FCC Commissioner

Media literacy is learning in motion, meaning that words and images are on a continuum which necessitates a constant flow of analysis or evaluation (Kubey, 2002a). Many would argue that there is no stopping the media and their influences (Quesada, 2000). With the digital world growing and expanding daily, media saturation has been reached over and over again. While television programming as well as other forms of media were designed to be captivating, the new social technologies have allowed the user to actually get included in the message delivery and development. Yet, the old forms of media are still ever-present and adapting to this new digital world order (Potter, 2005).

All these changes create a certain questionable quandary: Do the media ask us to live by certain prescribed rules? Are we predisposed to certain attitudes by how ideas and pictures are presented to us in various media? The answer is reflective of how media have been brought into each of our lives. From the moment radio was introduced into our living rooms and when the first picture box was delivered, the media have influenced our lives increasingly (Grace & Tobin, 1998). What is the difference between accepting media messages at face value or critically considering the ideas presented (Alvermann & Hagood, 2000a)?

The media have brought us some of the most amazing stories of our times. They have become both a learning instrument and an idea producer. They have also become a source of mixed messages that have produced both negative and positive influences on our youth (Flores-Koulish, 2005).

Media literacy is vital to the growth of our students' perception of the world around them. In a recent Kaiser Family Foundation

study, the average usage time for the various media in 8- to-18-year-old lives has increased from eight hours a day in 2004 to over ten hours a day (Rideout, Foehr, & Roberts, 2010). Victoria Rideout, the Foundation president stated, "The bottom line is that all these advances in media technologies are making it even easier for young people to spend more and more time with media" (Rideout, Foehr, & Roberts, 2010).

Our students are "connected" whether it is through mobile phones, the web, or the newest gadgets, and this suggests that the media dominate the lives of today's children. They learn more from what they see or hear through the variety of media environments. For our youngest children, the television is still the most popular form of entertainment. For our teens, texting through mobile phones and social networking sites are of most interest to them. They learn more using these mediated environments than they do in the classroom. Yet, what they learn is not always accurate, reliable, free of bias, or fair (Buckingham, 2003; Baird, 1998).

Today's schools are obligated to help students learn and understand their media-saturated world (Alvermann, 2002). We ask students to be critically literate in our content subject areas, but very often forget to ask them to be just as literate about the media. Since the nature of media is so enticing and our students acclimate so readily to this material, there is no question that there is a need for further understanding. This is not to say that the role of the teacher is to criticize our students' choices of media, but instead to ask students to think about those choices and their impact (Considine, 2002a). Increasingly, students are swamped with information overload, and they are making decisions and selections based upon what they are told by the media or through the media.

Schools may and should provide opportunities for discussion on many media topics. Sometimes our hands are forced into the topics because the news is extremely devastating or the topic is all encompassing. Yet, many times, instead of discussing some of the issues, teachers tend to shy away from various media topics (Flores-Koulish, 2005; Hobbs, 1998). At several conferences and even in professional development workshops, or college courses in which media literacy is the theme of learning for educators, there are participants who want to engage their students and just as many that would prefer to ban the use and discussion of the newest technologies. Understandably, popular culture texts can sometimes be difficult to discuss either because the content is problematic or it requires a judgment call by the educator as to its appropriate use in the public

education classroom. New technologies also tend to make teachers fearful. Nonetheless, students are in need of teachers who can venture into their "play" areas in order to grasp what they are experiencing. Educators can no longer ignore how our teen/young adult audience negotiates meaning from these media environments (Quesada, 2000).

Media literacy provides for a wide spectrum of ideas to be exchanged in which a student is sometimes the leader/guide and the teacher takes a step back and allows the student to take a step forward (Buckingham, 2003a). While this concept may seem natural for some teachers, for others this is most difficult, as was discovered in the Flores-Koulish study:

> Teachers out there do not know how to teach media literacy. And when you're afraid of something, like technology or something that's unfamiliar to you or something that you're uncomfortable with, then you're not going to teach it. You're going to shy away from it, until someone comes along and says, "this is media literacy; this is what it is; this is how we teach; this is how you can integrate it into your classroom." (Flores-Koulish, 2005, p. 95)

In media literacy, the teacher becomes more of a guide, one that may pose the question that needs to be discussed, but also the one who will redirect the conversation in order to open different avenues of thinking (Scheibe, 2004). This way of teaching is not always comfortable, nor is it easy. However, for those practitioners in media literacy, they suggest that the best way to know that the material covered in the classroom is reaching students is to see how motivated they are to be in charge of their learning, especially on topics that are of most interest to them (Scharrer, 2003).

Media literacy education is an opportunity for learning that provides the openness by which both student and teacher can converse and respectfully give divergent opinions. The media give us those teachable moments that illustrate some of the more crucial topics we want students to learn, such as character, dedication, honesty, and more. Several years ago, a *New York Times* reporter, Judith Miller, imprisoned after refusing to reveal her source on a news story which revealed the name of a CIA operative (Liptak & Johnston, 2005). This one incident provided many lessons in my classroom on censorship, on the trustworthiness of the news industry, discernment on journalistic practices, and certainly a look at our political system. This topic discussion in

the classroom allowed students to lend their voice to the conversations that were taking place nationally. These kinds of teachable moments, provided by the media, are afforded to us regularly (Duncan, 1997).

Media literacy lessons are central to the growth and development of this generation and future generations of students. Without teaching these vital lessons, we stand to have future citizens who are unwilling to question the thinking behind media messages. Let's begin the process by understanding what it all means.

Defining Media Literacy

What is media literacy? This question has been asked in several academic circles, and most of the time it is suggested that it needs to be mixed with questions of critical thinking and critical literacy (Cervetti, Pardales, & Damico, 2001). Some academics suggest that it is an extension of other literacies such as reading and writing, except that the text looks different (Kane, 2003).

The first part of the term: media. "Media" includes newspapers, magazines, cinema films, radio, television, photographs, the Internet, billboards, books, CDs, DVDs, advertisements, social networking sites, video gaming, and other forms of online publishing (Buckingham, 2007; Potter, 2005). The growth of media formats is in a continued state of flux. Whereas messages were once transmitted primarily by the most common formats such as television and radio, they are now being transmitted via iPods and mobile phones (Lenhart, Madden, Smith, & Macgill, 2007).

Literacy in its most basic form is defined as the ability to read and write (Kane, 2003). This explanation is traditionally found in school curricula and is fundamental to the growth of students in preparing them to understand the world around them. Combining the two terms "media literacy" becomes a bridge that reveals the way students read the world, which has changed very much from its early beginnings (Hobbs, 1998). Media literacy requires that we look beyond texts, thereby validating ways in which media play a huge role in our students' lives.

Silverblatt (2001) provides one of the most comprehensive definitions of media literacy:

> Media literacy emphasizes the following elements: a critical thinking skill that allows audiences to develop independent judgments about media content; an understanding of the process of mass communica-

tion; an awareness of the impact of media on the individual and society; the development of strategies with which to discuss and analyze media messages; an awareness of media content as "text" that provides insight into our contemporary culture and ourselves; the cultivation of an enhanced enjoyment, understanding, and appreciation of media content; and in the case of media communicator, the ability to produce effective and responsible media messages (Silverblatt, 2001, p. 120).

While this definition may seem complex, there are four basic tenets that can be taken from it. Media literacy is the ability to access, analyze, evaluate, and communicate information in a variety of forms and formats. These terms are ones that most educators will recognize as being a part of Bloom's taxonomy, which promotes the concept of critical thinking at its highest level (Anderson & Sosniak, 1994).

Fig 1-1. Media literacy Messages

Media literacy promotes critical thinking beyond the traditional literacies of reading and writing, including the visual and com-

puter literacies. Potter (2005) suggests that these literacies are the key components of media literacy:

> Media literacy is a set of perspectives that we actively use to expose ourselves to the media to interpret the meaning of the messages we encounter. We build our perspectives from knowledge structures. To build our structures, we need tools and raw material. These tools are our skills. The raw materials are information from the media and from the real world. Active use means that we are aware of the messages and consciously interacting with them. (Potter, 2005, p. 22)

In essence, media literacy is a continuum that does not stop once the skills are learned. It weaves through the lives of the individuals who are participating in the media experience. In the cycle of learning, they can be on opposite sides of the spectrum or they can share the knowledge of media (Kubey, 2002). In most cases, no two people will experience the same media environment in exactly the same way. Therefore, media literacy educators must accept differences and divergent thoughts in order for an open discussion to take place within the classroom (Considine, 2002a).

One of the greatest benefits of teaching media literacy is giving voice to the student (Buckingham, 2003; Luke, 2000; Bazalgette, 1997). This is perhaps not unique to media literacy, as opposed to any of the other areas of literacy, but it is more obvious in the area of media literacy because the "message" is vitally important to students' lives (Considine, 2002a). Students can provide a more personal perspective on how the media have been a part of their consciousness. A discourse in media can potentially serve to be a transformative component of traditional literacies in the classroom, whereby a significant connection can be made from literature to film to television (Flores-Koulish, 2005; Considine, 2002a). This connection, above all, demonstrates a change in the current educational paradigm.

Media Literacy Education

In media literacy circles across the country, the standard by which media literacy skills are taught are based on the five core concepts and five key questions that have been developed by media literacy educators at the Center for Media Literacy in Los Angeles, California (Jolls & Thoman, 2005). Each of these concepts and related questions are detailed below.

Fig 1-2. CML's Q/TIPS

**CML's FIVE CORE CONCEPTS AND KEY QUESTIONS FOR CONSUMERS
AND PRODUCERS
Media Deconstruction/Construction Framework
CML's Questions/TIPS (Q/TIPS)
©2002–2007 Center for Media Literacy, www.medialit.org**

#	Key Words	Deconstruction: CML's 5 Key Questions (Consumer)	CML's 5 Core Concepts	Construction: CML's 5 Key Questions (Producer)
1	**Author-ship**	Who created this message?	All media messages are constructed.	What am I **authoring**?
2	**Format**	What creative techniques are used to attract my attention?	Media messages are constructed using a creative language with its own rules.	Does my message reflect understanding in **format**, creativity and technology?
3	**Audi-ence**	How might different people understand this message differently?	Different people experience the same media message differently.	Is my message engaging and compelling for my target **audience**?
4	**Content**	What values, lifestyles and points of view are represented in or omitted from this message?	Media have embedded values and points of view.	Have I clearly and consistently framed values, lifestyles and points of view in my **content**?
5	**Purpose**	Why is this message being sent?	Most media messages are organized to gain profit and/or power.	Have I communicated my **purpose** effectively?

Concept One and Key Question:

All Media Messages Are "Constructed."

Who created the message?

Knowing that media messages exist is one part of learning that is required for students, but understanding "who" is putting the message forth is of greater significance. Media messages are placed in the public sphere with an idea in mind. Marketers spend time collecting data and interpreting messages so that they know immediately how to construct a message to appeal to a particular audience. It is not just happenstance that certain colors for certain cultural communities are used. Words are selected with an idea in mind. Advertisements are placed in certain magazines with the idea of who the audience is and how the reader will perceive the message. For example, ads for glamorous hotels will not be designed in bright orange, greens, or reds; instead muted colors of beige, black, and white are used. Usually those ads will also include the type of people who would fit the image or the concept of the message, much like stereotyping.

Concept Two and Key Question:

Media Messages Are Constructed Using a Creative Language with Its Own Rules.

What techniques are used to attract my attention?

The language of media messages is not so much "creative" as it is "targeted" to a specific audience. In order to understand the message, students must be asked to analyze and deconstruct the message from start to finish. For example, brightly colored letters are usually designated for children. Words that are popping out of an advertisement are trying to reach a selected audience. The fonts used for medication ads are more severe, almost to emphasize the seriousness of the issue.

Television shows are developed with a certain constructed language as well. Programs that have a comedic intent tend to begin with fonts and words that roll or move quickly, almost laughingly. Horror movies have music that lead us to an understanding that a dramatic or frightening event is about to occur. Television dramas are written in ways that make the plots intricate, with three or four stories going on simultaneously within the one drama. The actual script is fast paced and the actors are directed to speak in that way, with

quirky and complex language which in turn makes viewers presume that their television show is more intelligent. Although the list goes on, this concept is not readily taught in schools. The language of media is just as important as the language of literature because the meanings derived are what make the text valuable or not.

Concept Three and Key Question:

Different People Experience the Same Media Message Differently.

How might different people understand this message differently from me?

While this may seem like an obvious statement, most children or young teens are not always aware that another perspective exists. Most of their thinking has been developed by their communities, family backgrounds, racial backgrounds, peer groups, and other influences, which limit their awareness of other perspectives. Because of this, it is easy to see how a child will believe what they see on television as truth and believe it without question. Asking students to consider what someone in a poor neighborhood or a rich neighborhood would think about a product or a television program, or asking if what they are seeing is "real" can foster a provoking conversation. This concept promotes the teaching and understanding of why someone who is Hispanic may be offended by a Taco Bell ad, while someone of another ethnicity may find it amusing, or why a black family would not find a program that hosts only whites as characters endearing or entertaining. Analyzing music and the news and considering that all media representations are not accurate creates invaluable lessons. Furthering the discussion of stereotypes within the context of movies, music, videos and television programs, while examining how the mainstream media subscribes to those stereotypes in order for the audience to recognize the story, plot, or theme, promotes higher-order thinking skills.

Concept Four and Key Question:

Media Have Embedded Values and Points of View.

What lifestyles, values, and points of view are represented in or omitted from this message?

This concept is most significant to parents. Parents' worst fear is that their values and beliefs are not transmitted via the media or at all. In

schools, teachers have a unique opportunity to discuss and decon-
struct the values and messages transmitted via a variety of media.
From this one concept, students are asked to consider that there are
many views on any one topic. When teachers are discussing political
messages or even a basic television advertisement, there is an oppor-
tunity for understanding the audience, the ideal represented by the
message, and who and what is the target. Most importantly, the dis-
cussion of who is omitted from media messages must also be a part of
the discussion of any media literacy curriculum.

News stories in magazines, the evening news, and newspapers
prove time and time again that there is a bias against, and general
underrepresentation of, certain racial groups. These are all contempo-
rary issues that provide valuable implications and lessons for the
classroom.

Concept Five and Key Question:

Media Messages Are Constructed to Gain Profit and/or Power.

Why was this message sent?

Money is a key factor for why media messages exist. While car com-
mercials show wonderful new safety gimmicks, their ultimate motive
is to convince us, the buyers, to purchase the vehicle at a high cost.
Each medium produces messages that are driven by profit motives.
The cost of the product includes a portion of the price of advertising.
Yet, how many students know that very fact? The answer is very few.
The best part of this concept is that talking about money in relation to
goods can be very entertaining for students (Del Vecchio, 2002).

Each of these core concepts and core questions require higher-
order thinking, which is many times associated with critical thinking
(DeVoogd & McLaughlin, 2005; Mraz, Heron, & Wood, 2003). Analysis
and evaluation are the fundamental thought processes necessary for
media literacy (Tyner, 1998; Hobbs, 1996). In the case of media liter-
acy, "analysis" is about deconstructing messages, detecting bias, and
propaganda, but also involves the skills of detecting the construction
of a wide range of media messages, as well as how they construct real-
ity for the viewer (Buckingham 1998; Tyner 1998).

Being literate in the 21st century will require a change in the pe-
dagogy of the current education system that has for so long promoted
very little discourse and even fewer accommodations for new litera-
cies (Luke, 2000). We are in a world in which our student population

is the first generation to have lived with computer technology since birth. They are active viewers and engagers of all popular culture texts in all formats. The role of media literacy in the classroom should not deny that popular culture has prominent importance in the lives of individuals, but instead channel that energy so that it can help to uncover codes and conventions that can be influential, disempowering, and manipulative (Shor, 1999).

Critical media literacy promises hope for understanding and empowerment; moving from cynicism to skepticism and from passivity to power as long as the door is open for all viewpoints to come to the table (Alvermann & Hagood, 2000a & 2000b). In order for media literacy to be considered critical literacy, all voices must be heard. There must be a participatory nature to the language of thought and learning providing for all voices and perspectives to be heard, because that is exactly what is suggested for today's classroom instruction (Buckingham, 2003). Furthermore, there must be connections to the students' prior knowledge, cultural background, and community in order for critical media literacy to work well in and out of the classroom (DeVoogd & McLaughlin, 2005; Freire & Macedo, 1987). Ultimately, the role of the educator many times will be to help students clarify and interpret the media, and, without question, the media require a lot of explanation (Buckingham, 2003; Alvermann, 2002).

At the same time, in order to teach media literacy, teachers must be aware and respectful of the world of children/teen media. Considine (2002b) who coined the phrase, "putting the 'me' in media," testifies to this attitude as evidenced in his many discourses with students throughout the years. This phrase basically means that the media are about the individual child/student and his/her media likes and dislikes, not about whether educators like what media preferences they chose (Considine, 2002b).

Students have a wide variety of choice when it comes to media preferences. They can select different genres of music, different artists, or they can mix and match. Social media sites have provided students with an additional avenue of engagement that allows for more real-time exchanges. Television offers the same wide variety of selections, even if the choices are not always what adults consider to be the best. Clothing, jewelry, and other elements of pop culture become a unique part of choice. Students can easily place themselves in the media sphere and do so quite readily. Because it is such an important part of their landscape, the importance of being able to deconstruct what they see, hear, buy, or select makes the teaching of media literacy valuable (Dyson, 2003; Grace & Tobin, 1998). In the classroom,

the topic of media provides the opportunity for healthy conversation to take place, where students can agree and disagree over content and material, and where an educator can interject and offer another avenue of thinking (Flores-Koulish, 2005).

A direct benefit of teaching media literacy is how readily students want to contribute to the conversation. It is amazing how many opinions they have on a wide variety of topics because it is meaningful part of their environment. In fact, as it is their source of pleasure, the term pleasure has found a foundation within the field of media literacy educators.

The "pleasure principle" is as basic as it sounds (Potter, 2005; Considine, 2002b). Each of us likes and dislikes many different elements of media. For our students, the same is true even if adults don't necessarily "get it." The point becomes less about getting it as understanding why it makes more sense to them and less to parents and teachers. Instead, it provides an opportunity for other ideas to be introduced and discussed, thereby making the exchange of ideas an important part of the process. Literacy training only comes with conversation, and teens, most especially, need a platform for the plethora of ideas that mainstream media have generated (Buckingham, 2003).

One of the main goals of media literacy is to teach students to be critical thinkers about all media textual formats (Petress, 2004). Critical viewing is important and has an applicable and valid place in the today's classroom environments. Children are regularly exposed to media in which the intention is to manipulate their opinions (Kubey, 2002b). Thus, learning to evaluate their own responses to what they are experiencing is very important. They can be encouraged to explore the reasons for their reactions, and the techniques are being used to manipulate them with instructional guidance.

Silverblatt (2001) suggests that "analysis hinges on a reference point of personal experience, through which individuals can examine the impact of the media on their attitudes, values, lifestyles and personal decisions." The prior knowledge of each individual child on any given topic will determine the amount of critical analysis needed (Kane, 2003). A child's background based on religious, economic, and/or political understandings, impacts how a text, or message, is viewed and interpreted.

Students come into the classroom with various backgrounds, which are applied to the reading and comprehension of print and media. The range of knowledge is smaller in the elementary grades; but as children move toward high school, this changes tremendously be-

cause of the exposure students have to a variety of different texts. This does not necessarily mean that what they know is accurate or that each student has had the same amount of background knowledge, but it does mean that their experiences are greater and more varied. While this reference appears to apply only to print resources, the same principles apply to media. For example, a middle or high school student watching a program such as *Two and a Half Men* or *Glee* will be faced with many conflicting issues, such as sexuality, that will not mix well with certain religious beliefs or even economic ones; while other children will not feel conflicted about these behaviors. Family issues are another questionable topic since they are stereotypically shown on television and in other media but certainly do not exist in reality. Interpretations of many of these texts will be based on cultural beliefs. Resultantly they will be offensive to some, but not to others.

Students are exposed to high volumes of mediated messages that have added tremendously to their background knowledge of the world around them, whether accurate or not. From television to radio, magazines, newspapers, billboards, and movies, the bombardment of information is extremely high, yet very few people challenge the messages that students receive. The importance of students' abilities to be critical thinkers has never been more important than now.

Possible Factors Affecting Implementation

Implementing a media literacy curriculum has been a struggle since its introduction into education circles in the 1970s (Kubey, 2003; Singer & Singer, 1976). Whether it be film, television, or music, which dominated much of the conversations on media throughout the 1970s and early 1980s, or the Internet, social network sites, and the iPod which have become more prevalent in the 1990s and 2000s, proponents of media literacy have faced challenges in educational contexts. Deciding to teach about the media in classrooms across the United States and providing places where students can engage in discourse on the various topics suggested by the media have met with both success and resistance.

During the earlier years, many educators and parents balked at the idea of teaching about television in schools when it was seen as mere entertainment, and the studies of its impact on students were not being discussed fully in our society (Gerbner, Gross, Morgan, & Signorelli, 1994). Recently, the issues that are of most concern have been the forms of media that are now populating our culture, the lack

of time in the curriculum for implementation, standardized tests which demand instructional time, the stifling of teacher creativity, lack of professional development, the question as to how to define media literacy, and the fact that some educators still believe that media literacy education is not necessarily important (Rothberg, 2006; Ricci, 2004; Hobbs, 2003; Serafini, 2002).

Already, the 21st century has brought about many technological changes that have shaped the media habits of our students. This technology has altered and changed the ways in which we teach our students (Ellsworth, 1997). In fact, if we were to look at what the classroom of the early 1990s was and compare it to today, there are some significant changes, from how we communicate with our peers to how we provide lessons for our students. In order to understand where media literacy fits into the curriculum, it is important to have a historical perspective on what has been instituted in our school and home environments that has changed life for this generation of learners.

As computers were introduced into our home cultures as early as the 1980s, other technological items such as the walkman and videogames developed by Atari and Coleco also became a standard in our culture. In the 1990s, desktop computers became laptops; videogames became more aggressive, detailed and even violent with newer game systems such as Sony's Playstation, Microsoft's X-Box, and Nintendo's Game Cube. Upon the turn of the 21st century, many of these systems became even faster and more complex. Instead of using floppy disks to transport data from our computers, we have burnable discs and more pervasive flash drives, which are smaller than a tube of lipstick. The walkman has all but left us, while iPods and Mp3 players, with their crisp and clear sound, are what children of all ages are listening to on a regular basis, despite the often high cost (Kist, 2005).

With all of these new advances in the realm of technology, it would seem rather obvious to think that schools have incorporated some, if not all, of these technologies into their curricula. Yet, the only steadfast piece that has continued to be in use is TV with DVR and On Demand, which have made collecting programs easier, although the media literacy component of what could possibly be taught is usually lost (Scharrer, 2003; Tyner, 1998). In many classrooms, films are often shown in their entirety with very little discussion. The opportunities for analysis and evaluation can be easily neglected. While our students have gained access to many different programs, schools are hampered by financial woes or gaps in the teaching community which have not been overcome (Greaves, 2007; McHugh, 2005).

In the global community, the United States is also looked upon as being latent and even regressive in the integration of media literacy into the classroom curriculum (Kubey, 2003; Tyner, 2003). While in countries such as Canada, England, and Australia, media literacy has become a defined area of study, in this country the work has just begun (Kubey, 2003; Tyner, 2003).

Marshall McLuhan, a Canadian academic who published *Understanding Media* in 1964, has been called the founding father of the study of media literacy and is most recognized by his statement, "The medium is the message." McLuhan (1964) predicted that technology and media were growing at a rapid pace, and that schools needed to adapt techniques for students to learn and process the information they were receiving by, at that time, television and radio. As a university professor, he could easily see that his students were very consumed by the media, but that he had not kept up. In many ways, this observation changed his life and his belief that the media were to change all our lives (Tyner, 1998).

UNESCO has also addressed some of these media education needs in their report "Mapping Media Education Policies in the World." As they indicated there are many reasons to integrate media literacy education and the following are the ones they consider the most important:

- There is a great flood of information that children receive outside school, much of it from the media. Schools should be where all this information flows together, albeit often contradictory and confusing at times for students.
- The media and technologies grant access to contexts and realities that we would otherwise miss out on. The media, and more recently Internet, propose new concepts of time and space, which schools must teach kids to understand.
- The media and technologies construct a picture of the world on the basis of which each of us builds our own. It is important for schools to teach students to critically analyze the way media represent reality, so students are better prepared to build their own images, representations and opinions.
- For many children and young people, pop culture gives them meaning to construct their identity. They learn to talk about themselves in relation to others. If school is to get closer to them, to narrow the gap between school and youth culture, it must integrate pop culture, which wields such weight in constructing their identity.
- In Latin American societies, access to the media and technologies is quite uneven and the digital divide is very deep. Schools can (and must) achieve a better distribution of information and knowledge, above all, among those with the least access to them.
- Information for information's sake is not enough. Only schools can turn information into knowledge. Teaching to read, interpret, analyze, and evaluate

messages broadcast by the media is a task that, for many students, only the educational system can handle.

- We live in a multicultural society, because we live alongside various languages and cultures. Young people must learn to read a hard-copy text (books, newspapers, magazines) but also to make use of the multiple languages circulating socially: visual, audiovisual and hypertext language.

- Media education, finally, reinforces students' social and civic education. Teaching them how to read (in the broadest sense of "reading") the media and technologies in school, and reflecting critically will help educate well-informed students, sensitive to social issues, critical of the information and messages they receive, self-reliant in the decisions they make in a participatory manner. (Meigs & Torrent, 2009, p. 182)

Further addressing some of these issues related to change within schools is the Partnership for 21st Century Skills which is both a guide and a group of individuals from the private and public sector (Salpeter, 2003). This cohort gathered together to address concerns related to what they believed a 21st century student should look like and what schools should be doing in order to accomplish the goal of educating him/her. In their first report, presented in 2002, they indicated that educators have a growing community of learners that use technology on a regular basis, but our schools, while attempting to, are unable, or in some cases unwilling, to reinforce the skills learned (Partnership for 21st Century Skills, 2006). Students understand podcasting, know how to blog, instant message (IM) each other on a regular basis, play intricate and detailed video games, and so much more (Lenhart, Purcell, Smith, & Zickuhr, 2010; Kaiser Family Foundation, 2005). Yet, if a classroom teacher, or a library media specialist, were asked to demonstrate the same knowledge, many do not have the same skills/knowledge (Kist, 2002 & 2005). Thus, many teachers will need training if they are to feel confident enough to use new media as part of their curriculum (Kubey, 2003).

Summary

Texts and literate practices of everyday life are changing at an unprecedented and disorienting pace (Alvermann, Moon, & Hagood, 1999). The research presented suggests that media literacy education can help students decipher the massive amount of information sent through the various media channels if teachers and pre-service teachers receive media literacy training (Scheibe, 2004; Scharrer, 2003; Schwartz, 2001). At the same time, the research has clearly shown that the pressures of standardized testing faced by schools today have created some roadblocks (Rothberg, 2006). Indeed, most schools today

are feeling the enormous weight of carrying their current subjects and providing balance to their core curriculum (Flores-Koulish, 2005). Added to this pressure are the economic tensions nationally and internationally which created severe cuts in state and municipal funding resulting in the loss of school programs. The idea of teaching another form of literacy or its introduction into the current curriculum causes many teachers to feel apprehensive, and furthering the divide is a lack of instructional training or tools to implement such a change (Luke, 2000).

In order for the media literacy education to move forward, support from the administrative and teaching staff must be present (Flores-Koulish, 2005). Along with support, there must be an acknowledgment that popular culture and the media have a place in schools' everyday curriculum (Scheibe, 2004; Kubey, 2003; Tyner 2003). Educators must also understand the powerful influence these lessons can have in changing the classroom dynamic (Buckingham, 2003; Considine, 1997). There are many lessons to be learned from how students are adapting and interacting with the media.

Chapter 2: Linking between Media Literacy, Social Networking, and Web 2.0

"Media education provides the critical knowledge and the analytical tools that empower media audiences to function as autonomous and rational citizens, enabling them to make informed use of the media.... [M]edia literacy is one of the principal new tools that provide citizens with the skills they need to make sense of the sometimes overwhelming flow of daily media and in particular, new media and information disseminated through new communication technologies. These forces are reshaping traditional values while transforming them into contemporary new ways of understanding life, society, and culture."
—*Thomas Tufte (ed.) and Florencia Enghel (ed.). The International Clearinghouse on Children, Youth and Media's Yearbook 2009, November 2009*

From what we know about students' usage of social networking sites it can be determined that they are online and in constant communication. The question then becomes what are they learning while on these platforms? There is a difference between the student who can sit and play a game versus a student who can critically evaluate the information that he is seeing online. Media literacy education provides the tools for learning which allow for the discussion of the Web 2.0 mediums and social networks to be useful, thoughtful, and productive.

In its simplest form, these online technologies are media. They are on computer platforms and mobile technologies and they are everywhere. Their growth continues with the new innovative technologies and the race to make the smallest, the best, the fastest, and the newest gadget which will attract the attention of a multitude of users. As this book is being written, the iPad has been introduced into society with great fanfare and great trepidation (Pogue, 2010). There are those who think Apple's product is going to change the world just by the way we communicate --our use of books and other materials. Still others see the potential for issues, such as technological glitches, which will need to be worked out as this is the first generation of this product. In the classroom, the change toward using technologies and gadgets which are adaptive to the classroom environment has begun. There are schools that are converting from textbooks to e-books and

others who are thinking of having students purchase items such as the Kindle and placing all of their textbooks on this small tool (*Scholastic Administrator,* 2009). Yet, these are just functions of making the materials available in print more accessible on these new platforms. The engagement of these platforms in the curriculum areas is where most educators are struggling to see their value and understand their placement.

There are three ways in which media literacy education can assist in student learning while delving into these new platforms: critical thinking/literacy, creation, and collaborative growth.

Critical Thinking

The word "critical" indicates careful, exact evaluation and judgment of the elements around us (Paul, 1995). Critical understanding is needed in all subject areas, but more importantly in understanding the written word, and in the case of today's children, the visual world. For this generation of students, the visual world consists of a mediated world which is documented by advertisements, billboards, and a variety of symbols that can be found in television, newspapers, magazines, films, music, and more recently blogs and podcasts (Considine, 1997).

The word "critical" describes one's attitude while evaluating different pieces of information. This attitude is best described as "detached assessment," meaning that you weigh the rationality of the wholeness of its data, and so on, before you accept or reject it (Norris, 1985). As individuals, we look at the world as all the messages presented within it, whether it is written, visual, or oral. Each of these pieces of information that we collect on a daily basis becomes a part of our being, and transforms our thinking. Our thought process, however, is limited at times to what we see. We are not thinking of being critical when processing these ideas, and yet the need to be so is more necessary than ever (Considine, 2002a). To be critical is a part of our growth from child to adult and transforms our ideas through the space and time continuum as it exists within our own lives. Critical thought and literacy is now a state of being that is required in many fields of study, from medicine to education. It is considered by many practitioners in various fields to be a necessary part of how we function and understand the variety of ideas in our society (Facione, 1998).

Each author reviewed in the subsequent text evaluated specific areas and made conjectures about this idea of "critical" thought and how it enables us to understand the natural thinking process of a learner. Critical thinking relates to how an individual thinks deeply.

It requires using knowledge and intelligence to arrive at a reasonable conclusion.

Bloom, Englehart, Furst, Hill, & Krathwohl (1956) were the first to clearly delineate the cognitive domain into levels of thinking, by creating a taxonomy of educational objectives. According to Bloom et al. (1956), the levels of intellectual behavior in learning are knowledge, comprehension, application, analysis, synthesis, and evaluation. The "knowledge" level involves the most basic understanding of the concepts, whether it is terminology or specific facts or abstractions. At this level students can be asked to tell, list, describe, or relate. "Comprehension" is the understanding of the informational material presented via a variety of texts (although the original thought of text was related to print), and translating the ideas back into one's own words by explaining, interpreting, and discussing. "Application" is the use of previously learned information in order to solve problems. "Analysis" is the taking of each component of the text and breaking it apart so that assumptions and conclusions can be evaluated. "Synthesis" is the ability to take all the learned individual pieces and recombine them so that it forms a new, original concept. Verbs that help to distinguish this concept are create, invent, and predict. "Evaluation" is the judging of materials based on values, opinions, or the result of an investigation (Bloom, Englehart, Furst, Hill, & Krathwohl, 1956).

Petress (2004), in his review of definitions about critical thinking noted that what was left out most commonly was the "how." The definition is not clear about how an individual would examine assumptions, and what perspective an individual would take when assessing conclusions. Petress suggested that critical thinking is based upon one's preconceived notions and prior encounters with a mode. The thinking then goes beyond to see the other side. In order for critical thinking to be considered thoughtful, one would need to be open-minded yet skeptical. The purpose of critical thinking is to not accept everything at face value, but neither to assume all ideas are always invalid (Petress, 2004).

Facione (1998) claimed that that there are six cognitive skills that are considered critical. Those skills include the following: interpretation, analysis, evaluation, inference, explanation, and self-regulation (Facione, 1998). These are similar to Bloom et al. (1956), but add the important concept of self-regulation. Self-regulation is to be aware of where thought is leading and the cognitive approach to answering one's questions (Facione, 1998).

Halpern (1996) evaluated the thinking process needed for critical thinking by suggesting that it needs to be directed to a desired out-

come. The reasoning for how a conclusion is made is just as important as the evaluation of the text. Understanding the process by which one achieved an understanding and the purpose is critical thinking. In Halpern's (1996) definition there is an obvious indication that time, energy, skill, and dedication are required for critical thinking to be a part of one's cognitive abilities. Irwin (2006) would agree that meta-cognition is an important aspect of critical thinking. The ability to be self-reflective and act on the knowledge of cognition to modify those processes and strategies is another way in which critical thinking is evaluated.

Many of these authors have found agreement in their definitions of critical thinking. Each believes that critical thinking is an integral part of learning. All believe that analysis and evaluation is the process which further promotes higher-order thinking. More importantly, critical thinking appears to be logical and necessary for free expression and interpretation of a variety of texts.

Media literacy requires critical thinking. Kubey (2002b) stated that analysis and evaluation are the fundamental thought processes necessary for media literacy. In the case of media literacy, "analysis" is not only about detecting bias and propaganda, but also involves the skills of detecting the construction of a wide range of media messages as well as how they construct reality for the viewer. For instance, television viewers might recognize that certain programs show bias related to certain groups or that advertisers use specific propaganda (Hobbs, 1996).

In addition, Kubey (2002b) states for young adults, there is a need to learn how the media construct our understanding of issues, products, people, gender, and race. The images and messages presented from television, pictures, or advertisements are constant and continuous. These media texts are significant to the daily lives of teens, and education about those messages is inconsistent in schools (Kubey, 2002, p. 5).

"Evaluation" in media literacy is described as "learning to appraise the value of media products for themselves and for their society," which can later lead to autonomy in the assessment of media messages (Kubey, 2000, p. 5). Learning to assess the media in terms of accuracy, clarity, and source credibility will help students engage in more critical, interpretive, and evaluative modes of media appreciation (Considine, 2002b).

In media literacy, each of these terms is used as another word for analysis as defined by Bloom. This approach in critical thinking allows students to incorporate their own understanding and interpretation of what they have seen, heard, read, and watched while at the

same time taking into the account why it is that they find pleasure in a program, film, or other media (Considine, 2002b).

One of the goals of media literacy is to teach students to be critical thinkers about all media textual formats. Martin (2003) stated, "Critical viewing has a legitimate place and holds pedagogical promise in the classroom" (p. 289). Children are regularly exposed to media in which the intention is to manipulate their opinions. Thus, learning to evaluate their own responses is important. They can be encouraged to explore the reasons for their reactions, and the techniques being used to manipulate them (Martin, 2003).

Further, Silverblatt (2001) suggests that "analysis hinges on a reference point of personal experience, through which individuals can examine the impact of the media on their attitudes, values, lifestyles, and personal decisions" (p. 66). The prior knowledge of each individual child on any given topic will determine the abundance of critical analysis imposed or the lack thereof. What a child has been brought up with due to his religious, economic, or political background impacts how a text or message is viewed and interpreted (Silverblatt, 2001). For instance, students come in with various backgrounds on many subject areas. Those backgrounds are applied to the reading and comprehension of text. The range of knowledge is smaller in the elementary grades, but as they move towards high school it changes tremendously because of the exposure students have had to a variety of different texts. This does not necessarily mean that what they know is accurate or that each student has had the same amount of background knowledge, but it does mean that their experiences are greater (Kane, 2003). While this reference is mostly to print resources, the same is true of media. Students are exposed to high volumes of mediated messages and that has added tremendously to their background knowledge of the world around them. The Kaiser Family Foundation found the average family, nationally, has their television on nearly seven hours a day. Recently, the time that families spend with media, including cell phones and computers, in general has increased to almost ten hours a day (Rideout, Foehr, & Roberts, January 2010; March 2005). With very few people challenging the messages directed at our youth, the need for critical thinking increases.

Critical Literacy

Critical literacy is praxis—meaning that individuals are actively processing information and actively focusing on the issues presented

in any given text. This dynamic engagement consequently gives power to the reader of the information (Freire, 1970).

Critical literacy involves textual meaning making as a process of construction, not exegesis; one imbues a text with meaning rather than extracting meaning from it (Cervetti, Paradales, & Damico, 2001). Different from critical thinking, critical literacy has a social theory background which is grounded in the theory of oppression and exploitation (Freire, 1970; Shor, 1999). The struggle of power, status, knowledge, and economic exploitation are all a part of this idea of critical literacy. The belief is that through critique the meaning behind language can be exposed and then reconstructed, thereby revealing fallacies. There is a concern with the social framework of how the word—language—is imposed, how meaning is derived, and how the world has been affected over time by language (Cervetti, Paradales, & Damico, 2001).

Critical literacy is fundamentally different because it asks the audience/reader to take a stance. Shor states:

> Critical literacy thus challenges the status quo in an effort to discover alternative paths for self and social development. The is kind of literacy—words rethinking worlds, self-dissenting in society—connects the political and personal, the public and the private, the global and the local, the economic and the pedagogical, for rethinking our lives and for promoting justice in the place of inequity. (Shor, 1999)

Critical literacy is about change. Transforming history, that is, changing what we say, what we do, and how we do it is all a part of this method of reading and writing the world. Critical literacy is social action. It is about challenging the traditional discourse regularly and understanding that there is always some form of an agenda in place. This form of literacy requires the individual to ask questions and to use language to question the power and knowledge within society (Shor, 1999).

The English Literature community states that "critical literacy involves the analysis and critique of the relationships among texts, language, power, social groups and social practice. It shows us ways of looking at written, visual, spoken, multimedia, and performance texts to question and challenge the attitudes, values and beliefs that lie beneath the surface" (Department of Education Australian Curriculum, 2009). The theme of how thought and word can be manipulated and formed in order to persuade, dissuade, or even unmotivate society is of fundamental importance to how the critical literacy is transferred into a learning environment. Without the knowledge of power, under-

standing how people, governments, or organizations create power and become powerful forces there is an untapped venue for knowledge.

Critical literacy is a concept that is long past due in our school systems and it is one that is not agreed upon by educators. "To be literate is not to be free; it is to be present and active in the struggle for reclaiming one's voice, history, and future" (Freire & Macedo, 1987). In order for this to happen in a school system learning must become active, and students cannot be passive believers of materials that are taught in a classroom. A consciousness of the world needs to be apparent and explored with just as much rigor as learning to read text. Freire and Macedo (1987) who wrote about this need to read the world so that the context is not limited to just the word would also describe this as a universal motivator for thinking and for politicizing the way we accept all elements of society. Critical literacy as described here requires that teachers be equipped to teach students with a new set of skills, which will enable them to locate, analyze, evaluate, and synthesize the vast amounts of information available. In many ways, students must be a part of the information age, by being information managers (Shapiro & Hughes, 1996).

Critical literacy seeks to understand the problem in all its complexity. It asks the viewer/reader to raise questions and seek alternative explanations for any given situation. Therefore, critical literacy is a dynamic format for teaching and learning. It requires both student and teacher to be the code breakers, meaning makers, text users, and text critics. Further, critical literacy requires a student to examine all information from a variety of perspectives, discovering diverse beliefs while evaluating positions taken by user and producer. Critical literacy also asks the text user to consider who is missing from the text by examining who or what is not represented in the information provided (McLaughlin & DeVoogd, 2005).

Those who are activists in the field of media literacy would wholeheartedly agree that media literacy is important in order for the political paradigm to shift and change and therefore involve critical literacy (Silverblatt, 2000). Similar to critical literacy, media literacy incorporates social justice teaching and explanation of bias, demonstrating that media conglomerates are imposing their thinking on the public psyche and showing how advertisers and the business of media are powerful. While these examples mentioned are conversations typical in the media literacy field, this is indeed critical literacy as described by Freire (1970), Shor (1999), Cervetti, Paradales, and Damico (2001). They discuss critical literacy as challenging the status quo in an effort to discover alternative paths for self and social development. This kind

of literacy, Shor (1999) states, "words rethinking worlds, self-dissenting in society—connects the political and the personal, the public and the private, the global and the local, the economic and the pedagogical, for rethinking our lives and for promoting justice in place of inequity" (p. 1). In media literacy this is considered activism and an important part of the teaching of this literacy (Lewis & Jhally, 1998).

Kubey (2002b) mentioned that Walter Cronkite, a prominent news anchor, supported this form of education for years because it fostered a critical mind in citizens and future voters (p. 4). There is a need for an informed electorate. In schools, critical literacy and media literacy would succeed in social studies classes where civic engagement can be fostered (Considine, 2002b). Shor would agree with this approach in how he describes a Deweyan education that seeks to find a reflective democratic individual (p. 7).

> Critical literacy involves questioning received knowledge and immediate experience with the goal of challenging inequality and developing an activist citizenry. (Shor, 1999, p. 8)

This involves a classroom where both teacher and student are involved and participating in discussion, where sometimes the learner is the student, but the reverse is true so much more often. Media literacy encourages this repertoire of thought. It is an engagement of ideas that does abet the other, but promotes perspective and allows for personal meaning to emerge as a viable tool of thought (Alvermann & Hagood, 1999).

Being literate in the 21st century will require a change in the education system that has for so long promoted little discourse and even less accommodation of diverse thought (Alvermann & Hagood, 1999). Critical media literacy is concerned with more than just the idea of pleasure, it also explores how culture plays into the choices of media used by all of us. Donna Alvermann of the University of George, states,

> From a cultural studies perspective, critical media literacy is concerned with how society and politics are structured and work to one's advantage or disadvantages, and how issues of ideology, bodies, power, and gender produce various cultural artifacts. From a postmodern perspective, critical media literacy pertains to how individuals take up cultural texts differently, depending on their interest and positioning in various social and historical contexts. Finally, from a feminist pedagogical perspective, critical media literacy focuses on how popular culture texts function to produce certain relation of power and gendered identities that students may learn to use or resist as part of their everyday school experiences. (Alvermann, 2002, p. 194)

This definition indicates and maintains that viewers of all ages are active and engaged in the popular culture texts they are most interested in, and this once again engages the idea of pleasure as being a primary function of critical media literacy. The role of media literacy in the area of critical literacy is not to negate that popular culture has prominent importance in the lives of individuals, but instead to channel that energy so that it can help to "uncover codes and practices that work to silence or disempower them as viewers, readers and learners in general" (Alvermann & Hagood, 1999, p. 194).

There is some controversy within the field of media literacy as to how deeply this critical social theory should go because it has become a place of alienation, and has evoked emotions that have produced less learning and more disagreement. In media literacy, those who are activists distribute their opinions in formats that have produced condemnation from all sides (McCannon, 2002; Hobbs, 1996). For example, the Media-L listserv which is open to anyone interested in media literacy has become a platform for chastisements and personal attacks. The dispute among some well-known members of the field of media literacy is based on the fact that some of these leaders accepted monies from media organizations such as AOL and Time Warner for media literacy work. Others have also accepted money from organizations such as Channel One, which has supplied many schools on a national level, although most significantly in urban areas, with televisions, VCRs and DVD players. Channel One's gift is not without recompense. As part of their providing these items, they stipulate that students must watch ten minutes of programming, including commercials, at the start of each school day. This has created a furor within the field of media literacy and produced a break that resulted in development of two organizations, the National Association of Media Literacy Education (NAMLE) formerly known as the Alliance for a Media Literate America (AMLA) and the Action Coalition for Media Education (McCannon, 2002). As a result of these disagreements, while claiming to be organizations open to all voices, the opposite has been true. The understanding of audience and subject has been disregarded along with little thought as to how audiences negotiate meaning (Considine, 2002a).

Critical media literacy promises hope for understanding and empowerment; moving from cynicism to skepticism and from passivity to power as long as the door is open for all viewpoints to come to the table. In order for media literacy to be considered critical literacy, all voices must be heard. There must be a participatory nature to the language of thought and learning because that is exactly what is suggested for today's classroom instruction. Alvermann states, "In participatory class-

rooms a mix of textbooks, magazines, student-generated texts, hypermedia productions, visual, and so on are used to support and extend the curriculum" (Alvermann, 2001). This must be true for thought and ideas and in reaching a balance between political right and left or anywhere in between, and any thoughts generated outside of this frame. Furthermore, there must be connections to the student's prior knowledge, cultural background and community in order for critical media literacy to work well in and out of the classroom (Alvermann, 2001).

Besides the controversy within the field of media literacy, there is controversy within schools, which are uncertain if discussion of power is purposeful or meaningful. There is a fear by many educators that to give voice to a child is to diminish the teacher's voice, which has so dominated the educational system in this country. There is also a sense of fear that comes from the ideas generated from the context of critical literacy and critical media literacy, specifically, bridging the knowledge gap, which has so evidently been a part of the system of haves and have nots. Freire (1970) would consider this a fight for which educators who truly believe in these thought processes must contend with daily even to their own detriment (Freire, 1970). The topic of fear will come up again in later chapters as we discuss the technology used today.

Media literacy, thus, can be defined within critical thinking or the critical literacy context, as exemplified by Fig. 2-1 below.

Fig. 2-1. Critical Literacy and Critical Thinking within Media Literacy

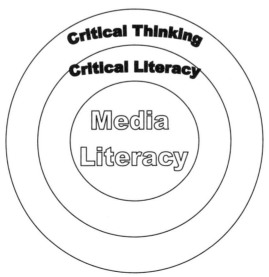

Media literacy is an extension of critical thought, which, as noted, incorporates analysis, evaluation, and understanding, while including traditional visual and computer literacies. As Alvermann and Hagood (2000b) state, texts and literate practices of everyday life are changing at an unprecedented and disorienting pace. Media literacy provides skills that can help students decipher the massive amount of information sent through the various media. This conclusion is agreed upon by the Partnership for 21st Century Skills whose charge was to find curricular connections to media literacy. As the Partnership for 21st Century Skills (2006) commented in their report, the question paramount to educators everywhere is how public education can better prepare students for the 21st century. They provided a comprehensive framework which developed co-curricular ideas in all the core subject areas, which they hoped would benefit students and teachers alike in the classroom (Partnership for 21st Century Skills, 2006). There are 15 partner states that are part of the state leadership initiative and are revising their own state curricular frameworks and professional development to infuse 21st Century Skills into teaching and learning: Arizona, Illinois, Iowa, Kansas, Kentucky, Louisiana, Maine, Massachusetts, Nevada, New Jersey, North Carolina, Ohio, South Dakota, Wisconsin and West Virginia (Lang, 2010). Moreover, the framework has also been adopted by many organizations and groups in order to show that media literacy is feasible within the current content areas.

Media literacy is without doubt a continuum of learning, as is critical thinking and critical literacy. Perhaps a new definition of media literacy needs to be in place; one that states: "Media literacy is a tool for teaching critical thinking and critical literacy from the perspective of all 21st century media texts with the purpose of providing competencies in global, civic, technological and information literacy, thereby closing the knowledge gap. Media literacy teaches metacognition, creativity and intellectual curiosity for lifelong development." It is possible to even consider that media literacy could replace or become the umbrella term for all previously discussed literacies.

Creation

One of the most important aspects of media literacy education is the creation of a product or production, whether it is digital or through various multimedia programs. The second media literacy key concept, "Media messages are constructed using a creative language with its own rules" fits in directly with the whole idea of students learning to

use programs and platforms to create media productions (Thoman, 1997). In fact, it is the best way in which students can see for themselves how detailed the creator's efforts must be to produce any type of program. While talking about movies, films, television, and other media environments is valuable, the hands-on approach to creating media places the student in the role of web designer, digital photographer, editor, director, or producer. In essence, this ensures that the students become the creators and providers of media. It is a role-reversal, but one that is most educational as it forces the students to consider audience and point of view, which furthers their understanding of the media.

By creating their own media productions, students begin to conceptually think about how special effects are designed and how difficult they are to replicate. Through trial and error, students learn what works on camera, or on screen. As they are manufacturing what they will present to the viewer or reader, they must now learn to conceptualize and critically think while being reflective of how audience's view text.

This exercise in learning allows students to see how media messages are constructed based on imagination and understanding. Students take ownership for what their minds can create and express using a digital video camera, a flip camera, or any other multimedia platform. Students have the ability to learn how to properly use a camera, understand shot composition and then view the images they captured. All they need to process and create are the tools, time, and space in order for them to explore. They learn about the operation of various equipment and digital platforms while at the same time realizing that these pieces of production are difficult, requiring dedication and collaboration. They are, in essence, the voices and the image makers and the new generation of media makers. The production level extends to the Web 2.0 programs such as Animoto, Flixster, Survey Monkey, wikis, and more.

Media production can be used with various pieces of technology. Scripting and storyboarding are the outlines of any media program, video production is the tool that designs the work, and editing is the editorial process that happens in our everyday writing lives. But even that has changed. We have moved forward with what production can entail and in most cases it is now online through various Web 2.0 or social networking sites. These new technologies are placing a reinforced opportunity for change within the context of today's society. As is evident from walking through schools, the struggle to keep up with these changes is still present. Technology moves faster than educa-

tion. As part of that change, new forms of communicating are introduced regularly and certainly more quickly than ever before. This fact is apparent from how our written and oral language has changed significantly in the last three years. We now use "google" as a verb in our conversation instead of just a noun as in "Go google it." While we still talk about wikis, podcasting, and blogs, we talk more about the iPad, Kindle, and texting. Before, we would discuss the digital divide in terms of technology and economics; we now look at it as a disconnect of miscommunication from student to student and adult to student and vice versa (Prensky, 2001). The changes in technology mean schools must seek to become acquainted with the new jargon and the new platforms in order to integrate them more fully within the schools curriculum structure.

Still at issue with any of these technologies is time and money. Schools may not have the equipment for using any of these products. Moreover, educators are not equipped with the knowledge of using this equipment and instructing students on their use. This is reflective of the comment made by George Lucas,

> When people talk to me about the digital divide, I think of it not being so much about who has access to what technology as about who knows how to create and express themselves in the new language of the screen. If students aren't taught the language of sound and images, shouldn't they be considered as illiterate as if they left college without being able to read and write? (Daly, 2004)

This is one of those cases where the best model for education is to just jump in and try it. Making mistakes becomes a part of the learning, and the best teachers are the students (Buckingham, 2003; Considine, 2002a).

Collaboration

Collaboration in today's 21st century classroom is essential to the continued progression of media literacy learning in and out of the classroom. Without question, it is another important outcome of media literacy education. In productions, many people work together. Whether it is in the development of a video project or working on a wiki, there are many roles that can be delineated. When creating a video production those roles appear to be obvious: camera operator, scriptwriter, props, lighting, or talent. The same is true when using a Web 2.0 platform or another web-based program. Someone can take the lead and then coordinate the pages which need to be developed.

Mastering collaboration skills requires the ability for students to work with a multitude of different people of different backgrounds effectively. Students learn to make necessary concessions in order to further their learning and achieve the final result of their final projects.

One of the best definitions of collaboration came from a former student of mine who put it quite succinctly, "Collaboration is intentionally designed, jointly developed cooperative work among two or more participants in which goals, responsibilities, and accountability are shared." The framework of media literacy education opens up to furthering the experiences of students through the use of media while at the same time growing their sense of self through group work as demonstrated in the Fig. 2-2 below:

Fig. 2-2. Collaboration, Technology, and Leadership

The *Information Power* Logo

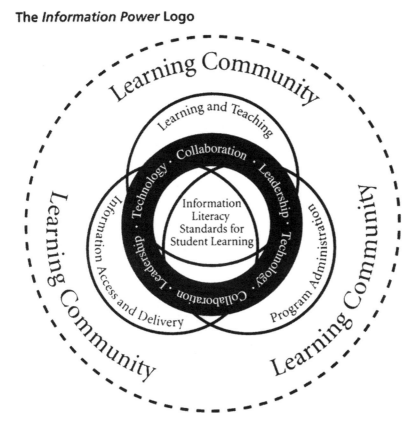

The workforce of today requires that students are able to work in this context. As times have changed, the end result is that those who succeed in our changing economic times are the ones who can be adaptable, flexible, and work well with other people with a common goal in mind. Media literacy education through the production phase provides students with a real-world experience that can help them in their future. Ultimately, working collaboratively benefits students in many ways: improves student motivation, increases academic performance, encourages active learning, helps prepare students for today's society, improves students' self-confidence; widens network of friends; improves communication; and helps build inclusive learning environment (Hamm & Adams, 1992).

Lastly and more importantly, collaboration provides for an opportunity or "teachable moment" in which students are reminded of the importance of finding a common ground while using the democratic process.

Part B: Social Networking

Chapter 3: Participatory Culture

"In large measure, we've got a situation when kids are walking in the front door of the school, they're being asked to power down. School doesn't look at all like the reality in which we live, and while it is easy for people to ban, block, or filter all these new technologies, what they are doing is not embracing the tools of this generation."

—Ann Flynn, Director, National School Boards Association

Engaging, fun, thousands of friends are all descriptors used by teens to refer to their favorite social networking sites. Whether it is MySpace, Facebook, or the less popular Friendster, these sites have changed the way students speak, communicate via text, or share their lives (boyd, 2008). In fact, it is this change in their thinking and learning that is of most interest to today's researchers. Furthering the interest is the curiosity of how this type of learning affects the K-12 classroom and the implications it may have in teaching the current student population.

Social Networks

The past ten years have shown a growth of websites that allow for people to interact on a very personal and at times superficial level. Individuals participate in sites which are self-created for the purpose of meeting other people primarily, whether it be just to make a basic connection such as finding friends, to create business partnerships, or even the possibility of a romantic relationship. Through the set-up of a profile, the user is able to seek out people of interest on this public and, at times, private space. Supplementary to this socialization is when the user steps in and engages in other activities which promote the interest of the individual through either gaming, chatting, or growing the list of connections which are deemed as "friends." This is all part of the growth of the social networks.

The history of social networking is as new as some of the host websites, but their popularity is huge and growing everyday. The leader in the concept of social interaction online was America Online (AOL) which began the concept of chat rooms in the early '90s (Klein, 2003). Subscribers of AOL had the opportunity to interact and share information with people that they knew or wanted to know through created chat rooms that were designated by hobbies, professions, romantic interests, and more. AOL dominated a whole socialization process that was unique to its own customers. In retrospect, the way

subscribers interacted within the chat rooms are in some ways what brought about the way in which current social networks are used.

Fig 3-1. Social Networks and Knowledge

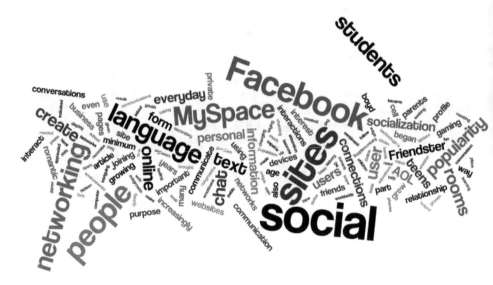

One of the first social network sites, Friendster, began in 2002. This site took on this idea of chat rooms, but then through a series of questions asked of the user helped to create profile pages so that each user could display their personal information. Primarily it catered to men and women who were seeking some form of relationship (boyd, 2008). When MySpace came into the picture a year later and took on the motto of "a place for friends," it extended what Friendster provided by including popular culture into the development of their sites. Rock bands and other musicians took a specific interest in this site because they saw a connection to their fans. MySpace also provided its users with the opportunity to personalize their pages in a much more user-friendly fashion because they did not need to rely on html, but could use basic cut and paste functions which were already known to computer users. Whereas, Friendster seemed to be more adult in its approach, MySpace decided to reach out to the teen population. As teens began joining this social networking site, its popularity grew at an increasingly rapid pace. Following MySpace was Facebook, which launched in 2004 as a creation of a Harvard University sophomore who wanted to connect his classmates, and then later other Ivy

Leaguers. The popularity of this site grew almost as quickly as MyS-pace, and this was once again almost by word of mouth or connections via the web. The minimum age for joining Facebook is thirteen years old which meant that the site became accessible very quickly by middle school students. There are over 500 million people worldwide that use this one site (Fletcher, 2010). There have been other social networking sites that have bridged over to business or other groups, but none have had the impact of MySpace or Facebook. It is this popularity of these two sites, and the fact that so many of the users are under eighteen years of age, which began to catch the attention of educators. The socialization of the sites was not even what was most intriguing; it was what students were capable of doing, learning, and creating while on these sites that began to resonate with people who work with technology and youth (Warlick, 2008).

One of the primary and most important outgrowths from these social networking sites is the text-based language made up of symbols and letters, a shortened form of communication, and emoticons which help teens to communicate a sentiment or feeling without the need for words at all. This text language has become a part of students' communications whether it be online, in everyday conversations, or even in the submission of their homework assignments. The online language has transformed the way students use information and also how they make connections with other people. Middle schoolers are using this form of conversation on an everyday basis and in many ways for the sole purpose of having private conversations which adults may not be able to follow (De Abreu, 2007). This is true of how text language is engaged when using a cell phone. A *New York Times* article discussed the issue of text language and the disconnect felt by parents who are not sure what their children are saying.

> Children increasingly rely on personal technological devices like cell phones to define themselves and create social circles apart from their families, changing the way they communicate with their parents. (Holson, 2008)

While the article applauded the innovation that has brought about the use of such language, it also indicated a cultural shift that was taking place which needed to be recognized as a result of these social networking devices.

A secondary outgrowth is how online gaming provides for students to create and design their own environments and interactions, some for real-life purposes and some for fictitious fun (Goodstein, 2007). All

social networking sites have given teens a platform for identification, creation, communication, and collaboration. It is a very important part of this generation's everyday interactions (boyd, 2008).

Our Students—Their Worlds

Teenagers are in the middle of the most social time in our history, and they are active partners in this movement that is shaping their identity and their connection to the world. These young adults in restaurants, walking to classes, or even with their families, can usually be seen either chatting on their cell phones or more likely texting each other. While most teens are already social beings, social networking has added another dimension to their scope of thinking, learning, and their global relationship to the world.

Students have always been noted for learning new technology at a more rapid pace than most adults, but it is significantly apparent now (Warlick, 2008). Adding to the allure of the technology is their uncanny ability to handle more than one of these forms of technology at once. Researchers call much of what these young adults are doing, multitasking (Foehr, 2006). If they aren't using their cell phones, then they are IMing or finding other forms of communicating. The inside key to many of these kid's modes of learning has to do with the process of socialization presented by the various technological platforms presented by these social networking sites. Their relationships and their form of sharing information depend on the continuous flow of information that they are connected to regularly. Teenagers take what they learn and then bring it to the attention of their friends. Those friends in turn pass it on to other friends, and the cycle continues. In order to understand how prevalent the use of social networking is to teens, it is important to understand the behaviors of teens within their social sites.

88% of teens ages 12–17 engage at least occasionally in some form of electronic personal communication, which includes text messaging, sending email or instant messages, or posting comments on social networking sites (Lenhart, Purcell, Smith, & Zickuhr, 2010).

This number demonstrates the medium that is of most interest to students. It also shows how important it is for students to be engaged with their peers. Socializing which was once via telephone or one-to-one interaction still exists, but instead of it stopping at the doorway of

their homes it continues through the constant texting which can be done at all hours. Middle school students indicate that this is their most popular form of communicating and sharing information (Foehr, 2006). High school students, as well as college students, have indicated that their ability to stay connected is also what keeps them motivated and interested even in classrooms where teachers are engaged in instruction which is still primarily lecture (Eberhardt, 2007; Engdahl, 2007). The easy availability and accessibility to computers, cell phones, and newer technologies continues to create opportunities for students to chat or text. This suggests that online communication will continue to grow in the future.

73% of wired American teens now use social networking websites such as Facebook or MySpace (Lenhart, Purcell, Smith, & Zickuhr, 2010).

Teens are interested in the social aspect that is provided by these sites. The sharing of their trials and tribulations, their relationships or favorite color, TV shows and pictures becomes a fundamental part of their daily lives. Socialization amongst teenagers is not uncommon. However, new to their already full lives is this other avenue for them to make friends and create more connections with people locally or all over the world.

The other main difference provided by these social networking sites is the number of people they can connect with, how global a network they can create, and the time frame that they can be in communication. Students, when asked, will indicate that they have over 100 "friends," yet the meaning behind that very word has been changed by the purpose for which it is used within these sites. "Friends" can in fact just mean mere acquaintances or even less than that—another person who wants to link to their site. The stretching of the word "friend" to cover a mere acquaintance is also one of the stressors related to why educators and parents have taken issue with the use of these sites.

These sites are constantly accessible, thus creating a continuous, open source of communicating which supersedes time and space.

83% of online teens have uploaded photos where others can see them, though many restrict access to the photos in some way (Lenhart, Purcell, Smith, & Zickuhr, 2010).

The sharing of photographs is a very popular way of socializing used by teens and adults. Using sites such as Flickr or even through Kodak to upload images to share with family and friends has transformed the way people view their worlds. Sharing images and moments that have transformed the lives of individuals is happening regularly. The increase of small, compact digital cameras has made uploading images a common phenomenon. Cell phones with cameras, email, and web capabilities have also contributed to the increased use of online photo distribution. Teens will post their photographs, providing tags for their friends who may be in the photos which can then be linked to all of their sites on MySpace or Facebook. Teens will create captions, sometimes manipulate the photograph, and even crop the photo to make them represent something else to change their identity or create a new one (Kelsey, 2007).

The second most significant part of this statistic is that some students have a strong awareness of the importance of privacy. While many students provide an excessive amount of information about themselves and their families, slowly there is a change in how much is too much. Programs such as *Dateline's* Online Predator series has brought to light some of the consequences of teens who meet with strangers, and how easy it is to become a target (Cook, 2007). Moreover, the Pew Research Center's Internet & American Life Project in 2009 found that 4% of cell-owning teens ages 12 to 17 had sent sexually suggestive images or video of themselves while text messaging. This is a practice which has become known as "sexting." Teens in this study also indicated that they have been on the receiving end of such images (Lenhart, 2009).

The use of camera phones and digital cameras has made it easier for people to take pictures and send them up the Internet pipeline. The accessibility of these images has also proved to be a source of contention for teens, and even beyond them, for celebrities of all ages because they are captured by fans and their images posted online. The availability of images taken by young fans has also attracted the attention of tabloid magazines, which are at the point where they are willing to pay for these images from rogue fans even though their clarity is minimal. The idea of privacy has become a place of controversy for all involved with socialization on the web (boyd, 2008).

25% of online teens have posted videos on YouTube (Rideout, Foehr, & Roberts, 2010).

This number seems to still be surprisingly low considering that more and more people are able to create very short, simple videos. Yet, posting capabilities are still hindered by technological issues related to transmission. While cell phones are prevalent and computers seem to be everywhere, there are still students who do not have either because of economic factors, and/or location. Cost factors related to Internet and cell phones are also holding back the numbers of teens who post. High-speed capabilities are still an issue in many locations across the country (Robinson, DiMaggio, & Hargittai, 2003). However, the basic know-how of placing a video online is changing significantly. A recent study from the University of Minnesota suggests that the digital divide, which has been given quite a bit of attention, may not be as great as previously thought (Walsh, 2008). Working along with this idea is the increased use of the social networking site YouTube.

81% of online teens say that they watch videos on video sharing sites such as YouTube (Rideout, Foehr, & Roberts, 2010).

YouTube has become one of the most visited places online for students to post and view videos. Students have found ways to use this platform to share videos of their friends, families, political beliefs, ideas, and other concepts. It has become a way for them to take their text and make it a more visual component to their learning.

YouTube provides individuals with a unique way of communicating information that may not always get transmitted. For example, at concerts people all over a stadium or a music hall can be seen recording pieces of information to share with friends or to post. Teens have been witnesses to life events that they want to record and share. There have also been moments when teens have created videos that have helped groups to raise money or even promote ideas. The important part of this site is that it makes the videos readily available and they can be embedded within other social networking sites such as MySpace, thereby gathering a greater audience (boyd, 2008).

67% of teens report playing computer or console games (such as Xbox or PlayStation), and 49% of those teens say that they play games online. (Lenhart, Purcell, Smith, & Zickuhr, 2010).

The information collected demonstrates how important this form of socializing has become to teens and its relevancy to their daily lives. The online environment has become a place where teens can create content either through blogging, video uploads, gaming, and much

more (Goodstein, 2007). It has become a place for them to identify themselves and even create a new persona.

> On Social Networking Sites members create profile pages, post pictures of themselves, display their friendships and allegiances, and indicate their tastes and preferences for different cultural products. They position themselves in these and other ways in the eyes of their friends—their actual and imagined readers. (Merchant, 2010, p. 59)

The gap is not only with parents, but also with educators. With this online and text environment has come a separation from adults who do not participate or use these tools (Buckingham, 2007). Student creations and language have taken on a life of their own, and in doing so has left behind those who believe there is no purpose in them except child play. The opposite has become true, and educators are beginning to take notice.

Exemplifying this point further is how popular mainstream music as well as advertisers has come to incorporate the text language and these social networking sites in their own marketing formats as a means of communicating to youth (Holson, 2008). A song by Mariah Carey which was quite popular for some time had the following lyrics,

> If there's a camera up in here then it's gonna leave with me when I do (I do). If there's a camera up in here then I'd best not catch this flick on YouTube (YouTube). 'Cause if you run your mouth and brag about this secret rendezvous I will hunt you down. (Carey, 2008)

Carey sings about dating and having her relationships displayed on another popular social networking site, YouTube. It is amazing to think that just a few short years ago many of us would not even know the meaning behind the lyrics. Yet, today, almost every child, teen, and most adults has heard, previewed, or posted on YouTube (Goldstein, 2007).

Advertisers have been quicker than parents or schools to jump on the social networking trend. Degree Girl deodorant launched a campaign with teen superstar Ashley Tisdale with the text, "For Your OMG Moments." The campaign included Tisdale vlogging with teens on her own OMG moments. Vlogging is a combination of video and log which allows Tisdale to be present in person while also texting. Degree deodorant is not the only one who has been interested in the teen speak and the text language which is innate to teens' communication, McDonalds has created a campaign with the text, "R U Ready." The cell phone companies have provided the service that allows for teens

to text, which has created advertisement campaigns emphasizing this new text language. AT&T is on the forefront with their "IDK, My BFF Rose" campaign that reaches from teens to the aged using a subtitled conversation between mom, daughter, and grandmother on the overuse of text via their cell phone which is costing them money (Holson, 2008).

These social networking websites have in fact helped to create an online culture where the teens create content and where all participate in its creation. Henry Jenkins of MIT would say that social networking supports a participatory culture with "relatively low barriers to artistic expression and civic engagement, strong support of creating and sharing one's creations, and some type of informal mentorship whereby what is known by the most experienced is passed along to novices" (Jenkins, 2006).

The Internet is still the source for a lot of what students learn, and they use it to their advantage. They can create wikis and certainly think that Wikipedia is the best encyclopedia out there. They are interested in information, but once again it is based on their personal interests and not necessarily about academics. Our youth are learning every day, and their learning is alive, but it does deviate from the structure of many core curriculums in school across the United States (Kelsey, 2007).

Schools

Do these content creators and social networks have a place in the classroom? Yes, but the evidence collected demonstrates a lack of usage by many teachers. A study by the National School Boards Association (NSBA) suggests that "district leaders are skeptical at this point about the educational value of social networking" (NSBA, 2007, p. 7). They specify that only 29% believe that social networking could help students with reading and writing. In contrast, 36% believe that social networking might help students to work together, think globally, and solve problems (NSBA, 2007).

Educators who discount the value of social networking tend to fall into two categories: those who are not using it or those who are not sure how to (Richardson, 2004). Those who are not using it need training and the time to actually play and experiment with social networking tools. A new beginner to social networks would be mindful in using the most structured sites such as those that offer potential for blogging which teachers can relate to journaling or wikis which have a semblance to websites. Each of these formats, blogging and

wikis, offer privacy and security, which are of utmost importance to schools and educators (Knowledge@Wharton, 2006).

Since collaboration is a theme that ties in with past and current core curriculums in many schools this also suggests where social sites can best fit (Richardson, 2004). The idea of putting students into groups on some of these platforms and working on a science experiment or developing a context for reading groups under a blog are very real ideas that provide opportunities to bridge informal and formal education. Students who work and create within social networks are building a community. While making connections, they are also finding other uses for this site which will bring them and their peers together (Hargardon, 2008).

Researchers are beginning to look at the potential of learning processes, whether informal or formal, which are taking place through online chat or instant messaging.

> ...online chat and instant messaging require very specific skills in language and interpersonal communication. Young people have to learn to "read" subtle nuances, often on the basis of minimal cues. They have to learn the rules and etiquette of online communication and to shift quickly between genres or language registers. (Buckingham, 2007, p. 100)

Teachers from various curricular areas have begun to see the text language shift from popular culture to the written homework, and some of them look upon this with grave concern. Certainly the line between classic written language and the syntax of text language is beginning to crossover. Yet, the potential for learning exists and tapping into that area opens teachers to new teaching possibilities, given the chance. Canadian linguists have found that these new forms of speech allow youth to show what they can do with language (Wilson, 2008).

The greater issue for many teachers is that they do not actually know how to use social networking sites and furthermore do not understand how to tie it in with their already full curriculums (Willard, 2006). They understand that their students use it, enjoy it, and spend a great deal of their time involved in it, but they haven't found insight into this part of their students' lives. This is really where the work in K-12 education has to begin, as the increase of knowledge would also help breed confidence in working in these areas which are dominated by youth (Buckingham, 2007).

For those K-12 teachers who participate in social networks with their students, they are using blogging, EduSpaces, Flickr, iGoogle, Second Life, SchoolTube, TeacherTube, and Wikis predominately.

Most of these sites are used by middle and high school teachers (Willard, 2006). The use of the mainstream social sites such as MySpace and Facebook are not acknowledged as much by educators, although a search would find more colleges and universities using these social networking sites versus the K-12 educators. College professors are using these social spaces to blog and to also create a class space outside of the classroom. The social nature of the structure would allow students to add and update information while at the same time keeping up with the work that has been designed for the class (Yan, 2008; Eberhardt, 2007).

At the elementary level, Flickr, SchoolTube, and TeacherTube have seen usage, but even that is limited by Internet access, and teacher knowledge. The idea of using a social networking site like MySpace is not seen as appropriate at that level by these educators (National School Board Association, 2007).

There are other possibilities for creating learning prospects within the constructs of social networking sites. E-portfolios are another way in which educators can connect to their students. At the Rhode Island School of Design they have been experimenting with this method for involving students, faculty, and even prospective employers to browse through their students' work (Yan, 2008). Students post their designs and any work that they would like for either professors or future employers to comment on. The goal is to get more and more people interested in the work that they have generated in the hopes of getting noticed or be hired. The e-portfolio also allows for students to receive critiques that will help them adjust their work or ideas in order to improve their creations. Overall, nurturing the ability of students to communicate using these platforms is a part of the curriculum schools are trying to foster.

> Students using social networking sites are actually practicing the kinds of 21st century skills we want them to develop to be successful today. Students are developing a positive attitude toward using technology systems, editing, and customizing content and thinking about online design and layout. They're also sharing creative original work like poetry and film and practicing safe and responsible use of information and technology. (Walsh, 2008)

As schools continue to look for ways to connect with students and bridge the gaps that currently exist, social networking sites will be among one of the core technologies to look at in motivating and changing the classroom structure.

Protection or Censorship?

Although technophobia and inexperience may play a role, there are other barriers to teachers' ability to use some of these platforms. Some of the more common issues have to do with school Internet policies, educators discounting the value of using social networking classroom, educators not finding it to be an effective communications tool, and just lack of knowledge of the social networking tools used by their students.

School Internet policies have been a source of contention, especially for high school teachers who really do like to incorporate cutting-edge online media into the classroom curriculum (Cook, 2007). Teachers who would like to use YouTube for instructional purposes have found the sites blocked on many occasions. They have resorted to finding other means of downloading the content they would like to show or make copies at home and bring it into the classroom. Sites such as MySpace and Facebook have been blocked because of the threat of harm that is most commonly what parents have found to be so problematic (Goodstein, 2007). There is little understanding of the potential of these sites as a means of educational growth when there is so much fear surrounding its security. The biggest of these fears involves the idea of predators engaging with students on these platforms. Yet, there is much work done in these areas where the safety of students can be taken under consideration and whereby the "imagined" dangers can be kept at bay so that students could have use of the potential benefits of some of these sites (National School Board Association, 2007).

The Future

"A social networking site is only effective as an instructional tool if a school district has a plan for using it...a school district needs to look at a social networking site as a part of a full technology plan" (O'Hanlon, 2007). Whether it be cell phones with their text features, or social sites such as MySpace, Facebook, or Friendster, this generation of youth has created another platform for communicating and learning which is not used in many schools across the United States. At a recent conference an educator stated, "we have 19th century schools, 20th century teachers, and 21st century learners, and that is the dilemma in schools of education everywhere."

In a recent article Adam Newman from *Outsell*, a market research firm serving publishers and information providers, stated,

There are two ways to think: "How do you protect the kids from the technology?" OR "How do you unlock the creativity of the kids by engaging them with technology?" If you assume that students will get their hands into the cookie jar, you're thinking about it the wrong way. (Ramaswami, 2008)

Newman's words clearly make the point that educators need to seek out the doorways into these social networking sites and other platforms which keep students occupied, and engrossed in the world beyond school. Teachers need to find a way into these worlds in order to connect with students and leverage their existing skills and passion for educational purposes.

Chapter 4: Engaging the Student in the Classroom

"The new media literacies should be seen as social skills, as ways of interacting within a larger community and not simply as individualized skills to be used for personalized expression."
—Henry Jenkins in *Confronting the Challenges of Participatory Culture*

Who is this generation of students? This question is one that causes some anxiety amongst adults who work with them and certainly the parents and educators who try and engage them. They are one of the most involved groups of individuals who deal with technology in a peripheral way—mostly for socializing and connecting with their friends. For some people, this appears to be the worst possible way for students to become involved with each other. In a recent New Horizons report it stated, "The majority of school districts ban social networking (70%) and chat rooms (72%)" (Johnson, Smith, Levine, & Haywood, 2010). This is a huge number and is in part based on fear and a complete misunderstanding of the potential for how these tools can be used. This is evident by an email that was sent out by a principal in a Ridgewood, New Jersey, school system to parents of his student body:

> Please do the following: sit down with your child (and they are just children still) and tell them that they are not allowed to be a member of any social networking site. Today! Let them know that you will at some point every week be checking their text messages online! You have the ability to do this through your cell phone provider. Let them know that you will be installing Parental Control Software so you can tell every place they have visited online, and everything they have instant messaged or written to a friend. Don't install it behind their back, but install it! It is time for every single member of the BF Community to take a stand! There is absolutely no reason for any middle school student to be a part of a social networking site! Let me repeat that—there is absolutely, positively no reason for any middle school student to be a part of a social networking site! None. (Young, 2010)

This letter is certainly one of the more extreme measures taken by a school system. As his letter was an urging for parents to shut down these services, the meaning is clear. This principal sees no valid use for these sites at all and no learning component to engage students. Once again the topic of fear is ever present. It is one that will be discussed further along in this chapter. However, the problem with a

statement such as this is that it does not consider the learning possibilities that exist with the use of social networking tools. It also does not look at the wide use of social networks by this generation.

As of September 2009, 79% of online American teens ages 12 to 17 used an online social network as reported by the Pew Internet & American Life Project. This number has continued to increase since 2006. Furthering the statistic is the number of students under the age of 12 who also have found sites such as Facebook to be entertaining and a valuable form of communicating. The numbers represented here suggest that there is a growing need for educators to understand why students delve into these areas, what learning comes from their participation in these areas, and what knowledge is gained and shared.

> Youths need skills for working within social networks, for pooling knowledge within a collective intelligence, for negotiating across cultural differences that shape the governing assumptions in different communities, and for reconciling conflicting bits of data to form a coherent picture of the world around them. (Jenkins, 2009)

Social networks provide a glimpse of a society that exists, but is usually not met by the hometowns of each of the students. The World Wide Web has made global communications a necessity. More importantly, it has made the ease of connecting real and ever-present. The end result is that this generation of students is characterized as being the first generation to be fully integrated into Information Communication Technology (ICT) since birth (Considine, Horton, & Moorman, 2009)—a fact that cannot continue to be ignored by schools, administrators, or teachers.

Educators using social networking sites have seen increased participation from students. Twitter is a perfect example of how students and teachers can engage in a dialogue with very short brief comments. Twitter is most known for providing 140-character blurbs to an audience of followers. As a social network it has been experiencing a huge growth period since the beginning of 2009 with over 11.5 million accounts created by primarily adult users including celebrities (Ryan, 2009).

In a classroom, a hashtag, which is a keyword or term preceded by the number sign, #, can be assigned to a course and then students can post questions to the teacher as a discussion is taking place live as well. This is called a backchannel. Students can tweet comments and questions through the use of mobile technology or computers that they are using. A feed can be displayed at the front of the room with the questions and comments so that everyone can see and participate.

In many college classrooms across the United States this has become a tool for reaching students, especially in lectures which hold 100 students or more. Twitter provides a format for communicating and one that allows everyone to participate forming a community of learners which would normally not have existed if they were just one of many in the classroom (Ferenstein, 2010). Furthermore, it assists the child who is shy or afraid to raise his or her hand in class to ask the question by providing a voice.

Twitter is a very convenient way of teaching notetaking skills. At conferences today, Twitter is up and running so that many participants can log in and post the interesting pieces of information they learn throughout the day. It allows for those attending to not miss any kind of information, especially if they are in sessions that are going on concurrently. Additionally, it is another way to engage people so that they can learn from each other. If we were to take that idea and place it in a middle or high school classroom, there is potential whereby a student who is absent or is away can still receive information learned in class through a hashtag that has been set up for the purpose of capturing the classroom questions and comments.

There are other programs which can grow students' learning that also are categorized as social networks. Nings, which are set up to look much like a Facebook and MySpace location, allow for students to collaborate via forums, discussion boards, image/video uploads and such. A Ning is a social networking site. The difference and most appealing virtue of this site is that it can be self-created or generated by people who have their own specific interests. They can be driven by educational needs or personal ones, but they serve the purpose of the originator's idea of its visual design and choice of features. One of the more popular sites used today by a variety of media literacy educators, college professors or those who are interested in popular culture is Making Curriculum Pop (MCPop). This Ning was developed by Ryan Goble, a doctoral candidate in Interdisciplinary Studies at Teachers College, Columbia University, in New York City. This Ning serves a community of over a thousand by providing them with resources, lessons, various materials, and a voice to discuss popular culture trends that can be infused into the classroom.

There are several other tools which will be discussed in more detail in Chapters 5 and 6, but these two in particular provide just a small glimpse of the possibilities of what can be used and repurposed in the classroom curriculum.

Fig. 4-1. Making Curriculum Pop

Meaningful use of educational and information technology is what social networks can provide for today's technologically invested students. This is recognized by the U.S. Department of Education, which released their draft for the National Education Technology Plan stating, "The challenge for our education systems is to leverage technology to create relevant learning experiences that mirror students' daily lives and the reality of there future (National Education Technology Plan, 2010). Indeed there is finally recognition that students' education takes place beyond the brick walls of a school building, and that learning is taking place despite what is going on in the classroom.

Here is where media literacy shifts in its importance because it is not just about thinking critically about information, but more about critically thinking about how to utilize these socialized networks in a way that is productive and valid for a classroom. "Schools are places where students can learn to transform society. In a classroom that embraces a pedagogy of critical media literacy, space is made for student to analyze and critique dominant narratives" (Gainer, 2010). Those who want to empower students realize that learning and teaching about media is about delving into that transformation and further engaging the pleasure principle, which determines how and what we choose to watch within the media. Those educators who carry this role are not interested in telling students that what they watch is wrong or inappropriate, but in understanding why these choices are made by young adults. The broadness of their choices provides the educator with the opportunity to learn from his or her pupil.

Students of this generation are motivated to look at the tools available differently. Even their exploration through sites such as YouTube can provide the educator with some valuable resources which could be later used with other classes. At the same time, observing and participating in the items that are engaging today's students supplies the educator with insights into the teenage mind as well as likes and dislikes. Of course, in order for this type of sharing to happen there needs to be an open source of communication with mutual respect that will lend itself to this type of dynamic.

When the Internet was introduced into public schools across the United States, the struggle began about if, when, and how to teach with it. Firewalls and other filtering programs became a normal placement and even a requirement by the federal government in order for there to be access points to the Internet. When social networking and various Web 2.0 tools were introduced within the Internet, an explosion took place that extended even beyond the imaginations of those administrators who worked to filter out any resources that they deemed inappropriate. These mediums were spilling over into the classroom, and not just through the computer, but also through the cell phone and other gadgets. The alert level seemed to increasingly grow and the fear surrounding these tools began to clash with the idea that there might be potential for learning.

Most educators take the approach of being protectionists in these socialized environments. Their knowledge of many of these tools is often minimal or it is used infrequently in comparison to their students. Or if it is used, then it is looked at as being entertainment and not educational. Their fear borders on paranoia as it diminishes the role of the child as a citizen or as one that has some true semblance of proprietary knowledge of the technology they are using (Byron, 2008). These fears are not just from parents, but also from educators. The fear of what could be found online or what might be discovered causes the teacher, technology coordinator, and school administrator to remove or eliminate, in many cases, anything that they might consider to be detrimental to the health and well-being of the child. But, the question becomes: what is detrimental, who decides, and how is this enforced? At the same time, when do we allow children to have some privacy in order to grow and what are we teaching them by these actions?

The fear factor has been undermining the process of progress in using a variety of technology tools. The fear of the unknown or what the media project as potential danger has been hyped up to a greater degree than is actual truth. At a recent conference of the Family Online Safety Institute (FOSI), the discussion on this topic caused quite

a flurry. The comment that the danger to students is no longer about predators, but about peers, was a bit surprising to the audience of parents, but not so much for educators. The relationships that students are developing online are creations made in low barriers— meaning that the boundaries that exist with true, traditional, real-life friendships are vastly different than the ones created in the online world (Palfrey, Grasser, & boyd, 2010). Comments that would never be made publicly are freely done through a computer screen. There is a vortex encapsulated through the transfer of data which is taking place from computer to computer. On each end of that spectrum are teens primarily, who are pushing the boundaries without a context of proprietary roles. In fact, the alienation of adults in this online world has in some respects propelled the teen user to surface without questioning or discerning the appropriateness of their interactions or relationships as discussed in the report "Living and Learning with New Media: Summary of Finds from the Digital Youth Project" sponsored by the MacArthur Foundation.

> Youth using new media often learn from their peers, not teachers or adults, and notions of expertise and authority have been turned on their heads. Such learning differs fundamentally from traditional instruction and is often framed negatively by adults as a means of "peer pressure." Yet adults can still have tremendous influence in setting "learning goals." (Ito, Horst, Bitttani, boyd, Herr-Stephensons, Lange, Pascoe, and Robinson, 2008)

Through media literacy education, as its approach to learning is through critically thinking about and evaluating the messages, there is a vehicle for considering the delivered messages and the constructs of each medium. As technology is progressing, the hours of use by children and teens has also increased (Rideout, Foehr, & Roberts, 2010). Yet, the increase of instructional time related to these tools has not, and in fact, remains non existent in many places. That instructional time extends even to parents or guardians, who are unfamiliar with the tools or toys their children are using despite the fact that they were the purchaser of these items.

The disconnect in educational circles has widened and created some additional problems with educating our students. Many educators are dealing with disciplinary actions versus aggregating the information that students are receiving or interacting with as useful to the classroom environment. The letter from the principal in New Jersey emphasizes this point in a most dramatic way. Schools in the United States and in other countries have taken the approach of shutting down whole websites or banning many of the social networking tools (Byron, 2008). Teachers become in essence the enemy to students when it comes to the newest tech-

nologies. That role tends to push students away and creates headaches for the student learner and the teacher who seeks to provide resources which are now locked by system administrators. This approach to the new media technology borders on practicing censorship.

The technology of today, whether it is the Web 2.0 tools, the social networking sites, or the newest gadgets provides school with a unique opportunity to foster an understanding of the power of the information world and the Internet through media literacy education. Media literacy education is in fact the direct opposite of censorship. Censorship reinforces the fear, confusion, and uncertainty many teachers worry about when media-related topics come about in the classroom. It is much easier for one to ignore the digital world than to participate or interact with it within the context of the classroom setting. As Jenkins states,

> Wouldn't we be better off having teens engage with MySpace in the context of supervision from knowledgeable and informed adults? Historically we taught children what to do when a stranger telephoned them where their parents are away; surely, we should be helping to teach them how to manage the presentation of their selves in digital spaces. (Jenkins, 2006)

Media literacy education instead delves right into some of the toughest topics and bridges discussions which can at times be controversial. The platforms represented by the social networking technologies allows students to create and produce ideas, topics, and subjects which can later be presented in the classroom allowing for some directed conversation to take place. This includes topics which many students have questions about, but are afraid to ask their parents the answers.

"Youths' participation in this networked world suggests new ways of thinking about the role of education. What would it mean to really exploit the potential of the learning opportunities available through online resources and networks?" (Ito et al., 2008). Protecting the student from the digital world is not a realistic goal. Censorship is at times driven by that motive. Yet, the digital world is available to them inside their homes, via their cell phones, or through the video games they play either in the privacy of their bedrooms or when meeting up with friends in their homes. One does not need to look further than the library to know that open source technology is available everywhere. Monitoring of this technology is not always reasonable. In fact, schools cannot guarantee that their filtering system will protect children from the items that they see online; neither can home monitoring systems. It is the most benign term that will trigger a flood of inappropriate material. The lesson then becomes how do we teach children to navigate around such negative information and how to appropriately handle the positive and negative

nature of the World Wide Web. After all, in most homes and schools, throwing away the computer with all its technology is not a viable option or one that any educator would or should support.

While the Kaiser Family Foundation was able to show statistical growth of usage, the transformation can also be seen in education circles by a revised Bloom's Taxonomy which considered the impact of technology on this current generation. The change in the formula presented shows an effort to meet and match the evolution of change with students in the 21st century.

The biggest modification evident is that terminology which emphasizes the active voice and follows the thinking process fits in well with today's participatory culture (Anderson & Krathwohl, 2001; Churches, 2008). This is visually represented in the following way (Fig. 4-2).

Fig. 4-2. Bloom's taxonomy—existing vs. new.

EXISTING	VERBS	NEW
Designing, constructing, planning, producing, inventing, devising, making	CREATING	Programming, filming, animating, blogging, vlogging, mixing, remixing, wiking, publishing, videocasting, podcasting, directing/producing
Checking, hypothesizing, critiquing, experimenting, judging, testing, detecting, monitoring	EVALUATING	Monitoring, commenting, reviewing, posting, moderating, collaborating, networking, refactoring, alpha & beta testing
Comparing, organizing, deconstructing, attributing, outlining, funding, structuring, integrating	ANALYZING	Mashing, linking, tagging, validating, reverse-engineering, cracking
Implementing, carrying out, using, executing	APPLYING	Running, loading, playing, operating, hacking, uploading, sharing, editing
Interpreting, summarizing, inferring, paraphrasing, classifying, comparing, explaining, exemplifying	UNDERSTANDING	Advanced searching, Boolean searching, blog journaling, twittering, categorizing, commenting, annotating, subscribing
Recognizing, listing, describing, identifying, retrieving, naming, locating, finding	REMEMBERING	Bullet pointing, highlighting, bookmarking, social networking, social bookmarking, searching, googling

Recreated by B. De Abreu

Recently Jonathan Douglas, the director of the National Literacy Trust, told BBC News, "Our research suggests a strong correlation between kids using technology and wider patterns of reading and writing. Engagement with online technology drives their enthusiasm for writing short stories, letters, song lyrics or diaries. Our research results are conclusive—the more forms of communication children use, the stronger their core literary skills" (Kleinman, 2009). While many educators are not as certain of the final results of a student's capacity for engaging in the written form through these networks, there is a growing body of research which states that it has great potential.

Each instance where an online format can be used does not denigrate the need for good learning. The opposite is true. The prevalence of each of these tools forces the educator to consider a forum for which new technologies would work best with the classroom curriculum while maintaining high academic qualifications. Just because text language is the mode of speech does not necessarily mean that it should be found within a research paper or more formal writing. Yet, it does have a place within the context of a more informal piece; this type of language can be productive. Twitter is a wonderful communications tool, but it does need a directed purpose within the classroom. As part of this discussion there needs to be conceptualization of what a digital citizen looks like. Topics which reinforce and uphold online behaviors will continue to be necessary. The more involved students become with these online environments, the more reinforcement they will need. As a participatory culture, the importance of their growth is also based on how they treat others. As was discussed in the most recent *Learning and Leading* magazine produced by the International Society for Technology Education (ISTE),

> Quality online participation should entail demonstrating respect for self and others in the digital common, including knowing how to adjust privacy settings, download music and other files legally, post messages that are respectful to the online community, and encourage others to practice responsible online behaviors. (Greenhow, 2010)

Another way of looking at the social networking generation is to consider who they are as young adults and future citizens of the world. Teens especially crave the freedom and autonomy. Psychologically, this is a period of time when they are testing waters and learning to grow (American Academy of Child & Adolescent Psychology, 2006). The new media that they engage in provides them with this opportunity. They can communicate with peers, learn from them, and explore different applications which allow them to create in a digital format that is

friendship driven and interest driven (Ito et al., 2008). Pamela Rutledge, the director of the Media Psychology Research Center states,

> I urge all of you parents and caring adults out there to learn about new technologies so that you can make judgments that are contextually relevant and so that you can provide guidelines that make sense to kids in THEIR world, not yours. That is, in fact, where they have to live. In their world, if you don't know how to use technology you are at a severe disadvantage--and not just socially. The 21st century skills that our kids will need include technological and media literacy and I mean that in the broadest sense. Media literacy today is not just the ability to think critically about content. It is the ability to think critically about use and production in a networked society. (Rutledge, 2010)

Teachers and adults do impact students. While peripherally it may seem to not be true, in fact it is the opposite. Students want the opportunity to share with their teachers what they know and what they learned while being online. They like the teacher who is open to their ideas and respects their knowledge in these digital platforms. They like to demonstrate their technology prowess. All they need is an opening for that to happen in the classroom. In turn, educators can influence their thinking and direction. Through the use of the digital media, they can contribute to their learning goals and objectives. Furthermore, educators can open a line of communication which is usually closed because the conversation is streaming in one direction.

Lastly, there have been many articles of late regarding how much information is too much information? The answer to that question still needs to be determined. The point is that these tools serve as extensions of important classroom notes or thoughts. In essence, these backchannels for conversations that are taking place serve as a valid case for new learning possibilities in the classroom. The reinforcement of media literacy education is delineated by the current National Education Technology Plan,

> We want to develop inquisitive, creative, resourceful thinkers; informed citizens; effective problem-solvers; groundbreaking pioneers; and visionary leaders. We want to foster the excellence that flows from the ability to use today's information, tools, and technologies effectively and a commitment to life-long learning. All these are necessary for Americans to be active, creative, knowledgeable, and ethical participants in our globally networked society. (National Education Technology Plan, 2010)

This encapsulates the idea of where educators need to be in order to provide 21st century learning in the classroom.

Part C: Web 2.0

Chapter 5: New Technologies

"One of the most interesting challenges and opportunities in teaching Digital Natives is to figure out and invent ways to include reflection and critical thinking in the learning (either built into the instruction or through a process of instructor-led debriefing but still do it in the Digital Native language."

—Marc Prensky, Educational Leadership

As this chapter is being written, there is a realization taking place that Web 2.0 may soon be known as Web 3.0 or by another name. "The amount of new technology information is doubling every two years and it is predicted to double every 72 hours" from this point onwards (Darling-Hammond, 2010). What that will look like is not clear, but what is certain is that what we recognize today as Web 2.0 applications have the potential for creating change in the classroom. The user-friendly programs and their similarity or the possibility of social interaction creates an environment for creativity and growth for each student as long as there is an Internet service and a willingness to connect them.

What is Web 2.0? While there are many educators who are becoming in tune with Web 2.0 terminology, just as many are left with uncertainty and questions. In its most basic form, Web 2.0 is defined as

> An online application that uses the World Wide Web as a platform and allows for participatory involvement, collaboration, and interactions among users. Web 2.0 is characterized by the creation and sharing of intellectual and social resources by end users. (Johnson, Smith, Levine, & Haywood, 2010)

Some of the programs that are categorized as such are: Google Apps, Open Office, Animoto, wikis, blogs, and more.

Web 2.0 fits in well with the participatory culture and creative connection which is described by Jenkins in his work on *Confronting the Challenges of a Participatory Culture in the 21st Century*. He states that 64% of teenagers have produced digital work and they have done it through the use of mobile technology and social networking sites (Jenkins, 2009). It changes the classroom from passive to very much involved with the lessons and learning. It allows for the propagation of the message that learning is a two-way street and sometimes even multidimensional. Furthermore, it brings the world closer together through the global connections which can be made through the use of any of these tools. As was indicated in the Horizon report, Web 2.0 tools provide communities of learning that are engag-

ing, interactive, and participatory. Everyone is provided with a voice because of the nature of the work performed on these platforms (Johnson, Smith, Levine, & Haywood, 2010).

In 2006, *Time* magazine carried a cover and centerpiece story which focused on the 21st century. In the article a hypothetical story was relayed to the audience:

> There's a dark little joke exchanged by educators with a dissident streak: Rip Van Winkle awakens in the 21st century after a hundred-year snooze and is, of course, utterly bewildered by what he sees. Men and women dash about, talking to small metal devices pinned to their ears. Young people sit at home on sofas, moving miniature athletes around on electronic screens. Older folk defy death and disability with metronomes in their chests and with hips made of metal and plastic. Airports, hospitals, shopping malls—every place Rip goes just baffles him. But when he finally walks into a schoolroom, the old man knows exactly where he is. "This is a school," he declares. "We used to have these back in 1906. Only now the blackboards are green." (Wallis, 2006)

While this is a disturbing statement reflecting our schools today, it also forces all those involved in education to realize that schools need to adjust to the pace of learning that has been created by the variety of technology tools. We can no longer have classrooms which are static, and teach only to the test, although that is what is forced upon many of our educators today. Even President Barack Obama, during his campaign, commented on the structure of schools and their need to move forward,

> As we bring our school system in the 21st century, we also have to bring our schools into the 21st century. Because while society has transformed just about every aspect of our lives—from the way we travel, to the way we communicate, to the way we look after our health—one of the places where we failed to seize its full potential is in the classroom. (Obama, 2008)

Learning transformation is needed and Web 2.0 platforms provide the educational world with a means for seeing how this change can happen within the current curricular system. Web 2.0 is suggested to provide students with the following:

- Keep students interested and engaged in school
- Meet the needs of different kinds of learners
- Develop critical thinking skills
- Develop students' capabilities not possible through traditional

methods
- Provide alternative learning environments for students
- Extend learning beyond the school day
- Prepare students to be lifelong learners (Bosco, 2009).

All of these statements reflect current beliefs for students' success in any school. Web 2.0 appears to be able to satisfy all of those requirements and also revolutionize our classrooms. It provides the latest and most innovative online tools which can then be utilized to transform and develop the learning experience of each child in the classroom (Warlick, 2006). Web 2.0 also contributes to the necessity for bringing students into the 21st century and also providing them with opportunity for growing as a digital citizen. The goals for educators are:

- move students beyond "searching for information" to using it and creating it;
- get better results from students' projects and research;
- provide more equitable access to digital tools and resources;
- integrate 21st-century skills into the curriculum;
- foster more collaboration with teachers to benefit students' achievement;
- create a website in seconds and post information, images, video, hyperlinks, and sound;
- share information (and labor) with your colleagues online;
- do more in less time and make your budget go much further than you—or anyone else—thought you could (Baumbach, 2009).

Web 2.0 tools appear to be the most effective way educators feel that they can actually bridge the students' interests in social networking with platforms which provide direct connections to the classroom curriculum. The programs supported by the Web 2.0 platforms provide for a new form of a participatory medium which is idyllic for supporting multiple modes of learning (Brown & Adler, 2008). Moreover, through the use of the Internet, Web 2.0 has contributed to social learning, which is what our students enjoy most about the programs. The concept of social learning has already existed in our classroom through the advent of study groups and even cooperative learning.

The emphasis on social learning stands in sharp contrast to the traditional Cartesian view of knowledge and learning—a view that has largely dominated the way education has been structured for over one

hundred years. The Cartesian perspective assumes that knowledge is a kind of substance and that pedagogy concerns the best way to transfer this substance from teachers to students. By contrast, instead of starting from the Cartesian premise of "I think, therefore I am," and from the assumption that knowledge is something that is transferred to the student via various pedagogical strategies, the social view of learning says, "We participate, therefore we are." (Brown and Adler, 2008)

Web 2.0 Programs

There are several applications which are used today that can evoke study, discussion, and interaction. Before starting a more in-depth look, educators should be aware that those companies who are in charge of open source programs are interested in hearing about educators' experiences. Open source programs are defined as computer software that can be used, improved, changed, redistributed or rewritten free of charge. It is usually created by people voluntarily.

Google and Oracle's Open Office Docs have become the two leaders in distributing a reformulated version of Microsoft Office Suite. The main difference is that it is free and available for all to use under the open source licensing. The programs can be copied and distributed over and over. As towns and communities are struggling with the cost of supporting different technologies, they are looking for innovative and affordable ways of using what they already have, but in a different format. The answer to resolving many schools' budgetary programs has been this open source software. Leading the way in using these programs is the State of Oregon, whose Department of Education has eliminated Microsoft Office at a savings of 1.5 million per year (Bertolucci, 2010). They have chosen to use Google Apps schoolwide in the coming years. Google Apps is a service from Google featuring a variety of Web applications, and also providing a format of office suite. The service features include: Gmail, Google Calendar, Talk, Docs and Sites. The only items needed for using the service is a web browser and a gmail account. As it provides a means of collaborating and sharing, Google Apps has a potential for overtaking learning in a powerful and productive way in the educational realm (Educause, 2008).

Most companies that have developed open source programs will work to create a separate entry point for educators that allows them to work away from the general public. This is an important aspect, as parents of children in schools are continuously worried about the sites that their child is visiting and using.

Some of the more common examples of Web 2.0 tools are blogs or vlogs, which allow for the sharing of ideas and, at the same time, a

place for students to respond to the comments made. A blog is a written approach to sharing ideas, whereas a vlog provides a visual component, as it is done by videotaping the ideas and then posting them online. Both of these offer the possibility of journaling, but not via paper and pencil. The most common blog site used is Blogger—www.blogger.com. All that is needed is a gmail account, which is free and available to anyone. A site that can be used primarily with young students is Kidblog—www.kidblog.org. Kidblog is intended for elementary and middle school students and is designed for simplicity for the user. It has

- simple login menus that allow student to select their names from a list of students in the class, eliminating the need to memorize user names;
- a clutter-free design so that students spend less time fussing with widgets and options and more time publishing;
- a central blog director and simple navigation links to make it easy for students to find classmates' blogs (Meech, 2010).

Blogs allow people to connect through the distribution of their ideas. People are allowed to provide commentary on the topics generated. Many television shows are now using blogging as a means for the audience to communicate with the actors or the producers of a particular program and other viewers.

Wikis are the best way for collaboration to be seen in the classroom, as it can be used with multiple users simultaneously or asynchronously. Much like the idea of "Wikipedia," students are able to log on with multiple users and create, interact with, edit, and administer a document that can be both in text and images. Furthermore, the wiki provides the educator with another teachable moment when it comes to discussing Wikipedia and the varied uses of this tool, while also providing a bit of a cautionary reminder that the materials in this location are not always accurate or suitable. Jenkins has stated,

> Educators need to adopt an "informed skepticism" rather than a dismissive attitude. Wikipedia is a very rich site for teaching young people about many of those things that have historically been at the heart of the media literacy movement but we can only capitalize on its potential if we understand how it works and what it is trying to do. (Jenkins, 2007)

Helping this along would be the development of ideas and programs which could be used on such wiki sites as PBworks—www.pbworks.com, Wetpaint—www.wetpaint.com, and Wikispaces—www.wikispaces.com. There are of course others sites, but these seem

to be the ones used primarily by most educators. Each site provides a basic or free version for the educator. In the case of Wetpaint, the site tends to come with advertisements unless there is a specific request for educational privileges; then ads will be removed.

Animoto has become one of the best tools for combing video, text, images, and sound. It has been recognized by *Discovery Education, School Library Journal,* and *NASA Images.* Each of these organizations has provided testimonial for the use of this program in the classroom. In each case, these organizations attested to the ease of use, "the ability to create new visual contexts, and an exciting way to bring the universe into the classroom" (Animoto, 2010). In a recent conversation with a 7th grade teacher, they stated,

> "In a nutshell, it is the simple creativity pieces that enable us to interact with information more readily. From being able to produce the videos on Animoto to readily share with students who can then comment on it so that a greater understanding can be had." What was described by this teacher and other is that Web 2.0 enables students to be more active with the curriculum. Therefore, what they read might have more meaning if they associate with their own creations. (De Abreu, 2009)

Teachers can apply at http://education.animoto.com for a free "All-Access Passes," which will give students unlimited ability to create full-length video creations. Students can then work individually to put together a video and then submit it to the Animoto staff, who will edit it together with music they have already preselected on their site. The length of the video can be predetermined or will be adjusted based on the information submitted. If teachers do not sign up for the unlimited version, only 30-second videos can be created for free.

Just coming out of the corner and competing with Animoto is a newer program entitled Flixtime, www.flixtime.com. It is another simple way of mixing images, text, and video with a variety of soundtracks. Videos are limited to one minute, but it is free to all who register. Video applications such as the two mentioned are just beginning to take on the education world, and in the future it is almost guaranteed that more programs will be created to compete, which will benefit teachers and their classrooms.

Along with using these free video editing programs, the Flip Camera has begun to be used widely. The Flip Video Camera (www.theflip.com) is pocket sized, which makes it a small, easy-to-use device that fits the hands of even the smallest child. More interesting to see has been the lack of wires and tapes associated with most digital video cameras. These cameras in particular allow you to record up to

two hours of video, then upload the collected information, it is hooked up to the computer via a pop-out USB connector. The Flip Camera does come with its own software that allows the user to make simple edits. The Flip Camera's price ranges from $200 to $300. These cameras are improving with each new version, including increasing video capacity to up to four hours. More importantly, while schools are facing severe economic cuts, these cameras are still relatively affordable. The Flip Video has a provision set up for educators. According to their website:

> Flip Video is committed to making video accessible to all K-12 teachers. Individual teachers can sign up to receive 2 for 1 pricing on the Flip Ultra 2 hour standard definition camcorder through a distribution partnership with Digital Wish. Teachers can enlist the help of parents and other community members to help fund purchases. Orders are limited to 4 units per teacher. (Flip Video, 2010)

Social bookmarking has become one of the most useful Web 2.0 programs to be developed for anyone who is working on the web. Social bookmarking allows the user to create, share, organize, and manage bookmarks of all their web resources. One of the more notable reasons for why this is so important has to do with the purchase of new computers. Each time a new computer is bought and information replaced, the bookmarks or favorites that were saved on the hard drive disappear with an upgrade. Social bookmarking allows the user to bring their websites with them wherever they go. It also means that bookmarks can be added or updated at any location as long as a connection to the web is established.

One of more popular sites used by educators is Delicious, http://delicious.com/. Delicious allows the user to collect their bookmarks in one spot. Through a tagging feature, users can supply different subject headings which can then be organized by the program. Additionally, the tags created will be matched up with others who may be interested in similar interests. The site also lists on its home page the most popular bookmarks. Another social bookmarking site which has made its mark is Diigo. Diigo, http://www.diigo.com, takes on the online social bookmarking, but then adds to it a little twist. Diigo allows you to:

- Highlight and add sticky notes on webpages. Diigo highlights and sticky notes are persistent in the sense that whenever you return to the original web page, you will see your highlights and sticky notes superimposed on the original page--just what you would expect if you highlighted or wrote in a book!
- Privacy control: private, public, or shared with a group.

- Archive pages permanently and make them searchable.
- Upload bookmark page and capture a snapshot, even if it is dynamic or hidden behind the password protection.
- Tags and lists in order to organize information (Diigo, 2010).

Diigo is a viable way of teaching students how to create personal learning networks (PLN) so that they can connect with other sites and users when locating information. A PLN is "a community of individuals around the world who are learning together" (Ferguson, 2010). The future of classroom is to teach students to develop their own PLN's and this website provides them with such an opportunity.

Flickr, www.flickr.com, is a site which allows for the upload and sharing of pictures. Flickr is an online photo management program. It contains over 100 million photos which have been shared by thousands. Flickr works well in the discussion of visual literacy as it allows for the user to crop, manipulate, or change a photograph. The most obvious application of Flickr photography is to use it in the design of lessons that promote and build visual literacy skills in students. As a tool for instruction, Flickr can enhance the classroom through the use of photographs as writing prompts or digital storytelling. Flickr images can contribute to students' presentations and also provide opportunities for creating virtual field trips.

YouTube, TeacherTube, and SchoolTube originated from the same premise: people creating videos to share and later publish for public viewing. YouTube, www.youtube.com, is open to the world and is owned by Google. There are versions in the U.K., Spain, and other countries. Video files that are uploaded include personal files and clips of programming. More interesting is the number of people who have created a video for the purpose of starting a music career. The most famous example is Justin Bieber who became a YouTube sensation and whose career literally took off from the performances seen on this platform. His YouTube videos attracted millions of viewers (Hoffman, 2009). Unfortunately, in many schools this site is blocked due to content. As its community is wide and open, school districts find it difficult to control and thus many have blocked it.

On the other hand, TeacherTube, www.teachertube.com, is video sharing, but it is directed toward the educational community. This website was created by a former Texas principal with the idea for teachers to generate their own online community. Teachers and students can upload videos, documents, and lessons. It is a site that continues to grow as more educators contribute work. More importantly,

the material posted is safe and user-friendly and open in most school communities (Melago, 2007).

SchoolTube, www2.schooltube.com, is another video sharing website that is offered to students and educators. It is free and safe, as it is regulated by the organization. Everything is moderated. For teachers and parents, this is great relief, as they do not have to worry about the content shown on the site. Moreover, it has been recognized nationally by many leading educational associations including the National Middle School Association and the Consortium for School Networking.

Glogster, www.glogster.com, is a program that takes the idea of posters to a new level. Instead of students cutting and pasting items to oaktag paper or cardboard, students can now cut and paste items digitally. Further, the poster becomes active as live images and voice recordings can be incorporated as part of the whole presentation. Glogster can be added to the front page of websites, incorporated into wikis, or even added to various social networking sites. More importantly, the creations can be easily shared among students and teachers. Recently, this Web 2.0 application assisted the education community by creating a secondary location which is suitable for educators in a K-12 classroom. This site works on the same platform as the main site, is safe and provides private access for educators and students; however, it also means that a few extra registration steps must be done before presenting the program to the students (Dyck, 2009).

Goanimate, www.goanimate.com, is just as the name designates: an animation program that is open to all. It is free and there is no limit to how many videos one can produce. Users can create characters or use the ones that have been previously generated. Students learn about storyboarding and scene selection. The best part for the educator is that the learning curve is minimal as the program only requires basic computer knowledge. There are some negatives, as some of the actions provided by the program have some adult themes such as drinking and fighting. Also, it isn't a private site, although they have created a different area entitled the Domo Animate, http://domo.goanimate.com, a platform which does not contain any inappropriate content.

Second Life, www.secondlife.com, is a virtual learning platform that is used by educators from the K-12 environment as well as colleges and universities. Linden Lab is the company that created Second Life as well as a teen grid which is open to 13 to 17 year olds. There is a verification process in place and privacy guidelines set. As indicated:

For educators looking for new ways to engage their students, MUVEs (multiuser virtual environments) offer a great opportunity for creative teaching and learning. In addition to content-rich explorations, students in a virtual environment learn social, technical, and practical life skills in a setting that keeps them engaged, inquisitive, and playful. The platform also makes possible international collaboration and ambitious goals, such as dealing with human rights issues and improving the global environment. (Yoder, 2009)

Second Life does require a download from the site and uses up quite a bit of broadband access. It is a platform that if used in schools should be checked with the technology department as it can slow a system down tremendously. Residents of Second Life create an avatar which is their virtual self. The avatar can walk, fly, and teleport to a variety of sites on the platform. There are several educational sites which have been created for assisting teachers, including one by the American Chemical Society, which has an interactive museum on the site, Virtual Harlem and The Holocaust Museum (Waters, 2009).

Wordle, http://www.wordle.net, is a platform that allows the user to create word clouds. These clouds are produced through the words that appear in a text with the words used more frequently given more distinction, such as the one shown.

Fig 5-1. Web 2.0 Wordle

The wordles created are open and available to all. They are also licensed under Creative Commons, which means that they can be displayed and included in a variety of materials and resources for free. As the site states:

> You may take a Wordle, put it on your book cover, your t-shirt, your campaign poster, what have you. You may get rich off it. Just tell people how you made the image, or, if you're using one from the gallery, where you got it. (Wordle, 2010)

These are just some of the more prominent Web 2.0 platforms used in schools, but there are others which are beginning to grow and will be showcased briefly in the next chapter (Ch. 6). All of these tools offer amazing possibilities for classroom lessons. The fact is, however, that they are just tools until they are made to come alive by educators who are able to see their practical application, thereby transforming the classroom.

Chapter 6: Purpose and Placement

"We owe it to students to provide opportunities for them to benefit from an instructional approach that carefully considers the collaborative design of research units to help develop the skill sets needed and fully engage in meaningful learning experience."
—*Susan Ballard, "Beyond Barriers"—VOYA*

Each of the tools explained in the previous chapter lends itself to the varied curriculum areas found in today's school systems. The keyword is that they are "tools" for extensions of lessons which have the possibility of bringing about collaboration and learning in a completely new way. The process of creating lessons in the classroom would not change. Instead it is the way that students use their creative minds to generate products that are no longer stationary or flat. Many of the programs discussed have the potential for audio and visual components in order to complete a new idea or follow the printed word. As each curriculum is defined, the work within the areas themselves can be expanded to a creative level that would fit the 21st century learner.

Open source software has become an important part of school systems, as costs of instructional programs become unaffordable when budgets are cut. In order to save jobs, technology specialists are looking to find ways in which they can replace costly programs with ones that are accessible via the Internet. As mentioned previously, the two most popular that will be replacing Microsoft 2007 are Open Office and Google Apps. Each of these programs is free to the educational community and the community at large. Several school systems have begun the process of switching their student population as well as their faculty from office programs to these open source software programs. One district in Connecticut estimated that removing Microsoft Office 2007 would save the town almost $78,000, which equals approximately two newly hired teachers' salaries (Zaretsky, 2010). With figures such as these and the need to cut costs ever present, this type of transference will be happening much more frequently in many other communities.

For teachers, the question becomes how to use these new programs to facilitate learning. As with any new software, the learning curve is dependent on the person who is involved in the process of understanding the applicable use of each open source program. The learning curve will be higher for those who are already reluctant to use new technology in education but less for those who already see the value in its placement within the curriculum.

Delving further, in earlier chapters it was established that media literacy education should be incorporated into core subject areas; so too must Web 2.0 and the lessons of social networking. We already know and understand the connection between our students and these networks. They are engaging, collaborative, dynamic, game driven at times, and all exist under this new media ecology which permits an exchange of ideas and creative power to manifest itself into productive learning. Our students are capable of so much more if we allow them to grow and learn outside of the constructs of the "test."

Web 2.0 is a shift in learning and education. This is best exemplified by this list compiled by Steve Hargadon, founder of Classroom 2.0. The shift, as he explains is:

- From consuming to producing
- From authority to transparency
- From the expert to the facilitator
- From the lecture to the hallway
- From "access to information" to "access to people"
- From "learning about" to "learning to be"
- From passive to passionate learning
- From presentation to participation
- From publication to conversation
- From formal schooling to lifelong learning
- From supply-push to demand-pull (Hargadon, 2008).

In each subject area, there are a variety of Web 2.0 programs which could be used to promote writing skills, critical literacy, and creative thinking. In order to understand how this can happen, an in-depth look at some of the more popular Web 2.0 and social programs will be shared and discussed in terms of usage and applicability. In each area, the standards that fit best with Web 2.0 tools will be displayed based upon the overseeing core subject organization. The strands provided are typically designed to complement the national, state, and local standards for classroom activities and curriculum.

English

The National Council of Teachers of English (NCTE) Standards has been published jointly with the International Reading Association (IRA). These standards selected are ones that best fit the Web 2.0 tools application.

1. Students read a wide range of print and non-print texts to build an understanding of texts, of themselves, and of the cultures of the Unit-

ed States and the world; to acquire new information; to respond to the needs and demands of society and the workplace; and for personal fulfillment. Among these texts are fiction and nonfiction, classic and contemporary works.

4. Students adjust their use of spoken, written, and visual language (e.g., conventions, style, vocabulary) to communicate effectively with a variety of audiences and for different purposes.

5. Students employ a wide range of strategies as they write and use different writing process elements appropriately to communicate with different audiences for a variety of purposes.

6. Students apply knowledge of language structure, language conventions (e.g., spelling and punctuation), media techniques, figurative language, and genre to create, critique, and discuss print and non-print texts.

8. Students use a variety of technological and information resources (e.g., libraries, databases, computer networks, video) to gather and synthesize information and to create and communicate knowledge.

12. Students use spoken, written, and visual language to accomplish their own purposes (e.g., for learning, enjoyment, persuasion, and the exchange of information (IRA & NCTE, 1996).

The English classroom is where students are required to think, read, and write in order to enhance and grow their skills with each item read and analyzed. Embracing the technological tools provided by the Web 2.0 platforms appears obvious and also offers possibilities. The most obvious of tools would be blogging and vlogging. In a subject area where reading and writing is necessary to further learning progression, finding other avenues for students to be creative with their thinking and also the output of their thinking seems to be a potential area for growth.

Blogging is journaling, but just via an online platform. The classroom teachers will have to decide how much leeway they are willing to provide the student user in freeing their text. That is, will the student be allowed to use text language or emoticons? Will they be able to write freely or will they need to be conscious of all the rules of the English language? When students write in text form or in informal ways, the use of capitalization and other punctuation seem to fall to the wayside. Keep in mind that texting is a huge part of students' lives. The Nielsen Company found that U.S. kids, 13 to 17 years old, sent an average of 2,272 texts per month (Nielsen, 2009). Texting does not have to happen when working on these sites, but those rules need to be established prior to the student beginning their online writing.

Vlogging allows student to produce video journals of their thoughts and experiences as they are working on selected readings, writing journals, or other projects. A flipcam has the greatest potential in a scenario such as this one, as it is convenient, portable, and provides students with the opportunity to find their own setting or destination to create their vlog.

Voicethread (www.voicethread.com) is another excellent tool for use in the English classroom. This tool allows students to work collaboratively in creating commentary on one or several topics. A whole class can participate in this storytelling method or just a group. Even better, the voicethread can be offered to people outside of the classroom for commentary such as parents or administrators. It is a wonderful reflective tool as well. Using PowerPoint, digital images from a site such as Flickr or Picasa can be uploaded. Once uploaded, all contributors can comment on the posted media. This is a great tool for social studies teachers as well.

Glogster (Fig. 6-1) is a poster program which can serve as a tool for creating book reports in which audio and video images can be included.

Fig 6-1. Glogster Website

The Glogster program can be used in conjunction with a lesson on film advertising. Movie posters and movie trailers can be evaluated with the objective being to help students understand and analyze how images are used in these formats to attract an audience of moviegoers. The trailers helped students to see how images were cut and edited so that some of the best scenes were shown to entice a person to see that movie. Students discuss the role and importance of such advertising and what captivates them. In turn, students can design their own poster through the use of the platform.

Flickr can be used to create magazine or book covers on a topic similar to a book report. A slideshow is also possible with this program which would be useful in the creation of a final product. Flickr encourages student collaboration and participation. Through the program students can provide comments on the image itself, and add text in the image, and use the notes or description feature.

Wordles provide the teacher with an opportunity to create poetry with words whether it is a Shakespearean sonnet or a children's favorite such as Dr. Seuss. It can be a way for students to introduce themselves to the class, a way to summarize texts and other pieces of information. Wordles can be used as a tool for a guessing game in which the descriptive words are all provided and the students are given an opportunity to guess what the wordle is actually about. It can help with providing keywords, ideas, and themes on any given class topic. Teachers can brainstorm and pull together the words identified from the discussion. The Wordle can be the visual representation of the heart of dialogue. The wordle has huge potential in all core areas (Anderson, 2009).

A Ning is a formulated social networking site that can be created for an individual class. The good news about this site is that it provides a variety of formats for communication such as forums, conversation threads, chat, and board postings. The bad news is that the Ning group has decided to charge for their service. At the time of this writing, educators were still able to access the site for free, but that could very well change shortly. The benefit of a Ning is that it assists in community building on an online platform. A classroom can be set up so that information transference is available by the teacher or student via text or video uploads. As discussed in an earlier chapter, Nings already exist for educator communities, but they can do so much more for students in a classroom, as it is a service that is open to all and is accessible to the quietest student or the most gregarious one.

Social Studies

The National Council for Social Studies (NCSS) has created ten thematic strands for promoting excellence in social studies which were revised and updated. Their strands encompass elementary, middle, and high school.

Standards:

1. **Culture:** Social studies programs should include experiences that provide for the study of culture and cultural diversity;

2. **Time, Continuity, and Change:** Social studies programs should include experiences that provide for the study of the past and its legacy;

3. **People, Places, and Environments**: Social studies programs should include experiences that provide for the study of people, places, and environments;

4. **Individual, Development and Identity:** Social studies programs should include experiences that provide for the study of individual development and identity;

5. **Individuals, Groups, and Institutions:** Social studies programs should include experiences that provide for the study of interactions among individuals, groups, and institutions;

6. **Power, Authority, and Governance**: Social studies programs should include experiences that provide for the study of how people create, interact with, and change structures of power, authority, and governance;

7. **Production, Distribution, and Consumption:** Social studies programs should include experiences that provide for the study of how people organize for the production, distribution, and consumption of goods and services;

8. **Science, Technology, and Society:** Social studies programs should include experiences that provide for the study of relationships among science, technology, and society;

9. **Global Connections:** Social studies programs should include experiences that provide for the study of global connections and interdependence; and

10. **Civic Ideals and Practices:** Social studies programs should include experiences that provide for the study of the ideals, principles, and practices of citizenship in a democratic republic (NCSS, 2010).

Reflecting on the social studies standards, it is clear that there are so many opportunities for using Web 2.0 resources. Not only do the tools have a place, but the discussion and learning that comes from being a digital citizen also fits in nicely with the already created strands.

Voicethreads are a wonderful tool for this area of study as well. Oral histories can be developed through images posted and reflections by the class. Issues related to the global society can be discussed

through images and text. The oil spill in Gulf can be viewed from an upload, and everyone can provide ideas or suggestions or even thoughts on how this is affecting our society in the future. Any historical documents can be posted. A debate can be conducted through the use of Voicethread. Each person is given a topic and can upload different mediums that will help substantiate his/her argument. Later other students can contribute their comments on the progression of the debate.

Animoto is a tool which allows a student to create a short video on any given topic. Geography classes can use this tool as a way for creating images that support the themes of direction and global connections. Students can also create videos of historical events or to illustrate themes. The program is incredibly simple and easy to use which means that students have an opportunity to be creative in how they put their images and text together.

Fig 6-2. Museum Box Website

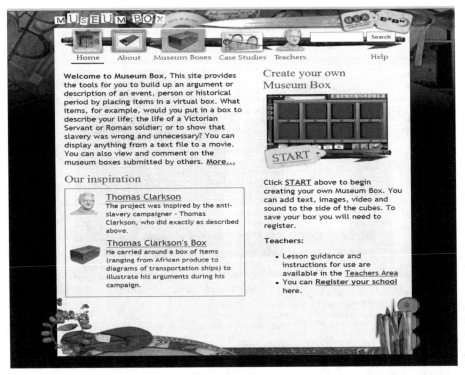

Many history teachers have used the computer program *Timeliner,* which allows a student to create a timeline for a particular event or period in history. This program was done primarily through

text and images. Dipity, www.dipity.com, has a similar functionality except that it is interactive. Students can now upload video files and input audio excerpts to follow the dateline that they have created.

One of the newer Web 2.0 programs is Museum Box, http:// museumbox.e2bn.org/ (see Fig. 6-2). The concept for this application is a box used to create information on an event, person, or historical time. The faces of the cube are used as a virtual demonstration and you can select how many sides you would like. The user can add text, video, audio, links, files, PowerPoint presentations, and more. Once the boxes are completed other students can comment on the items presented and the contents.

Math

The National Council of Teachers of Mathematics has created a series of standards that are based on mathematical concepts that have application to the real world. There are several categories of standards such as Number and Operations, Data Analysis and Probability, Problem Solving, Communication, and Connections. The following are the strands found within some of these concepts which most connect with Web 2.0 tools.

Instructional programs from prekindergarten through grade 12 should enable all students to:

- Understand numbers, ways of representing numbers, relationships among numbers, and number systems
- Compute fluently and make reasonable estimates
- Analyze characteristics and properties of two- and three-dimensional geometric shapes and develop mathematical arguments about geometric relationships
- Apply appropriate techniques, tools, and formulas to determine measurements
- Formulate questions that can be addressed with data and collect, organize, and display relevant data to answer them
- Select and use appropriate statistical methods to analyze data
- Develop and evaluate inferences and predictions that are based on data
- Understand and apply basic concepts of probability
- Build new mathematical knowledge through problem solving
- Solve problems that arise in mathematics and in other contexts
- Apply and adapt a variety of appropriate strategies to solve problems

- Make and investigate mathematical conjectures
- Develop and evaluate mathematical arguments and proofs
- Select and use various types of reasoning and methods of proof
- Communicate their mathematical thinking coherently and clearly to peers, teachers, and others
- Recognize and apply mathematics in contexts outside of mathematics
- Create and use representations to organize, record, and communicate mathematical ideas (NCTM, 2009).

Second Life offers the math teacher one of the best and innovative ways of teaching Algebra and Geometry. During an initial orientation to Second Life, the person leading the group through the interface demonstrates how each person can create squares, triangles, and even the design of a home. The first thought that came to mind is that this would be perfect for teachers to take their classes into this virtual world and set up spaces where students could considerably grow and learn geometry, algebra, and measurements. It has a huge potential to offer any educator who is willing to set up a visionary system within Second Life a way of teaching these subjects in a way which would involve the students and create a distinctive form of integration. Students would be fully engaged in a way that cannot be duplicated in the classroom. They could work on pieces collaboratively or individually. They have the potential for creating meaningful contributions which could also be then duplicated in real-life.

Survey Monkey is a tool which allows students to literally do as the name suggests: survey information. Giving the students a topic about which they can create questions, submit them to people for response, and then collect the data will help them to understand data collection and processing, which is a key concept. This platform allows for the user to see the variety of formats in which questions can be asked. The program then generates the questionnaire giving the user a link which can be forwarded via email. The program collects the data on-site and then specifies through percentages the totals of respondents and the ways in which they answered the questions. Survey Monkey is a valuable tool for demonstrating to students how information is gathered for research or distribution on different subjects, how numbers can be manipulated, and why surveying people helps mathematicians and scientists in their reporting of the world.

Science

The science standards are detailed and specific about a variety of concepts. However, each of the standards is formatted to fit within three specific themes:

SCIENTIFIC INQUIRY

- Scientific inquiry is a thoughtful and coordinated attempt to search out, describe, explain and predict natural phenomena.
- Scientific inquiry progresses through a continuous process of questioning, data collection, analysis and interpretation.
- Scientific inquiry requires the sharing of findings and ideas for critical review by colleagues and other scientists.

SCIENTIFIC LITERACY

- Scientific literacy includes speaking, listening, presenting, interpreting, reading and writing about science.
- Scientific literacy also includes the ability to search for and assess the relevance and credibility of scientific information found in various print and electronic media.

SCIENTIFIC NUMERACY

- Scientific numeracy includes the ability to use mathematical operations and procedures to calculate, analyze and present scientific data and ideas (National Science Teachers Association, 1998).

Student inquiry is a major component of science instruction; Web 2.0 programs can assist in this instruction through the use of Google Apps collaborative environments as well as other tools. Data can be collected, shared, and analyzed through various programs. Furthermore, data can be worked on across platforms and through multiple schools.

Wikis allow for work to be done in multiple locations simultaneously. As described earlier, PB Works, www.pbworks.com, can assist with this type of work. Students can use this tool when they are ready to complete their lab reports, as they can create blogs and share the information they have discovered. The wiki becomes a repository of information. Comments can be left in this location on the different pages created.

Survey Monkey can be used as an initial form for setting up a diagram for collecting data. Students can collaborate to generate the in-

formation they would like to obtain from the persons taking their survey. The information gets collected and analyzed on the spot. Then students can write their reports attaching the charted data.

iGoogle is a management program that is supported through Google at http://www.google.com/ig. This tool can be used in the science area to classify the information on this particular topic. Students can create widgets related to science, calendars, notepads, and also set up news feeds related primarily to their subject area. The site can also be changed regularly to accommodate the different science topics that come up throughout the year (Boss, 2009).

GoAnimate is a creative tool that works with the concept of animation. Students can demonstrate an experiment, produce safety instructions or demonstrate through the characters available the scientific method. The possibilities for constructing creative pieces are endless.

World Language

The world language standards are set up to look at what and how the student is learning within a cultural context. There are five goals for this curriculum area:

- Standard 1–Communications: Communicate in languages other than English: interpersonal, interpretive, and presentational.
- Standard 2–Cultures: Gain knowledge and understanding of other cultures: practices and products.
- Standard 3—Connections: Connect with other disciplines and acquire information: across disciplines and added perspective.
- Standard 4—Comparisons: Develop insights into the nature of language and culture: language and culture.
- Standard 5—Communities: Participate in multilingual communities at home and around the world: practical applications and personal enrichment (Phillips, 1999).

One of the greatest aspects of a foreign language classroom is that global education is embedded right within the classroom curriculum. Discussing topics that bridge two worlds is a necessary component for today's 21st century citizen because the digital world has made issues and people closer to us than ever before. It is not enough to know that other countries exist, but students must also understand the similarities and differences in order to have effective communication with a wide spectrum of individuals.

The Global Education Collaborative is a ning, http://globaleducation.ning.com, that has been established to assemble groups of educators, parents, students, higher education professionals to work together to find common interests related to global education. A "ning" is an online platform that is a social networking community. The Global Education Collaborative mission:

> To bring people together in order to build the professional relationships necessary for effective collaboration. Collaboration can take many forms, and it is our intent that people will partner on projects and start conversations on topics related to global education. (Gray, 2010)

Many projects and ideas have come about through this form of collaboration. Members come from all over the world as is exhibited on their website (Gray, 2010).

Voicethread is a wonderful tool for bringing the world closer together. The idea would be to become penpals or e-pals with another school. The school can be in another country or one within the United States, but through their foreign language course. Students could practice their communication skills by introducing themselves and images would follow along. Other students can add comments or share their thoughts. Besides using their oral skills, it would also serve as an icebreaker while at the same time help all the students involved to gain personal knowledge and understanding of each others' cultures.

In the last several years, there have been several web tools which have emerged to assist students in foreign language classrooms to learn to speak more fluently. LiveMocha, http://livemocha.com, is one such place which was designed to promote practicing conversational skills. This site claims to have over 5 million registered members and thirty-five languages that one can choose to learn. Their claim:

> Rapid globalization has created a tremendous need for people all over the world to better understand and interface with different cultures in the course of their work and travels. Foreign language learning, therefore, has emerged as a pressing need that's critical to the success of emerging economies and global trade. (Livemocha, 2010)

The idea that a student can gain language proficiency online through this immersive technology is one that many schools and teachers would consider using for their classroom. Participants can practice with a native speaker or submit writing samples for the native speaker to edit (Oliver, 2010).

Media Arts

In closing out this segment, it is clear that the media arts need to have application and cannot be ignored. Each of the arts areas carries its own standards and themes, and yet again, Web 2.0 programs offer great possibilities such as using Wordle to deconstruct song lyrics, GoAnimate to demonstrate a specific art concept such as colors or pencil drawings, Flickr to share artists' work or student art work, or Voicethread to teach students how to assemble an instrument or review posture or instrument positioning while playing instruments. The topics that can be bridged, shared, and produced within these Web 2.0 applications are numerous.

Fig 6-3. Go Animate Website

Looking through the curriculum areas, it is clear that many of these tools can overlap into other content areas. The idea was to provide a glimpse of the possibilities that each of these programs offers the teacher and student and what it could be like in the classroom. Some Web 2.0 tools do have requirement specifications, but the instructor who is willing and wanting to use these applications must take the time to test out the program. Inquire about parental and student consent at all times and be aware of the privacy settings or lack thereof in each area. The tools' possibilities are endless, but careful consideration of the potential user—the student—must always be at the forefront of any educator's curriculum planning.

Part D: Privacy, Safety, and the Future

Chapter 7: Cyber Society

"In talks and sound bytes over the past year, I've been saying that—for the vast majority of online youth—digital citizenship is the new Internet safety. And indeed digital citizenship is HUGE, for the very reason that behaving aggressively online more than doubles the risk of being victimized. Still, that's really only the half of it. Media literacy is the other half. I haven't been saying that "digital citizenship + media literacy = online safety 2.0" because it's such a mouthful, and it's important to keep things simple and focused. But media literacy is huge too, because critical thinking about incoming ad messages, compliments, group think, etc. is protective against manipulation and harm."

—Anne Collier, NetFamilyNews.org, Kid-Tech News for Parents

It would be negligent to write a book that ignores the topics of Internet safety and privacy, as the Web 2.0 applications suggested are to be used in classrooms with children of all ages online. School administrators worry constantly about how much freedom they should grant teachers when it comes to these platforms. Parents worry about where their children might be exploited. Classroom educators must be conscious of all these concerns while at the same time bring some perspective to these conversations.

In a society where the media tend to report the most horrendous atrocities, where parents perceive by these reports the need to fear their neighbor or the passerby and in turn impress those fears upon their children, thoughtful, considerate and critical thinking must be given to the mediated messages that are encountered by children and teens. An example of this very idea is the way the media have covered the issue of predators through programs such as *Dateline NBC: To Catch a Predator*. The idea that is reinforced over and over again is that predators are lurking and waiting for their children at any time.

The World Wide Web introduced this fear more predominately because it was open to all. No restrictions are in place, and in fact, there seems to be an "anything goes" attitude when dealing with the Internet. It is the greatest of resources, but it is also one that needs careful guidance, especially when it comes to the young.

While television shows like *Dateline* make NBC quite a bit of money and certainly confirm a parent's worst nightmare, this is not where parents should be focusing their attention. More awareness and discussion needs to be directed in the area of peer-to-peer confrontations most notably known as cyberbullying and, of late, the idea of privacy.

Privacy

Teenagers are foregoing privacy and their identity in order to be "connected" twenty-four hours a day, seven days a week without thinking twice about the ramifications. At least this disconcerting idea is what most people truly believe, including parents and educators. While certain areas of this statement may be true and even in some cases cause for alarm, it poses other questions about how open our society is in the first place with the growth of technology and secondly, what to do about the fact that most of our personal information is already online? When social networks began to become popular with teens in 2007, it appeared that many of them did not have a sense about their privacy online (Lenhart, Madden, Smith, & Macgill, 2007). The problem at hand is how privacy seems to be understood by many young adults. In her blog, social-media researcher danah boyd states,

> I was talking with a teenage girl about her privacy settings and noticed that she had made a lot of content available to friends-of-friends. I asked her if she had made her content available to her mother. She responded with "Of course not!" I noticed that she had listed her aunt as a friend of hers and so I surfed through her to her aunt's page and pointed out that her mother was a friend of her aunt, thus a friend-of-a-friend. She was horrified. It had never dawned on her that her mother might be included in that grouping. Over and over again, I find that people's mental model of who can see what doesn't match up with reality. (boyd, 2010)

The unintended connections that students are not deliberately making are what have caused concern to caring adults as more and more of their world is exposed online. In classrooms observed, this awareness of how the online world competes with privacy was clearly confusing for the students. While students understood the basic idea and could easily state what should not be posted online such as their home phone number or home address, they did not realize the connections that could be made through other features such as photos, comments, and other folks that they felt comfortable enough to share information with.

Yet, the recent news coverage of Facebook and its ever-changing privacy settings has added to the controversy. Facebook has become the social network of choice for young adults and children (Lenhart, Madden, Smith, & Macgill, 2007). Facebook provides them with an avenue for communicating and sharing pieces of information about themselves. In fact, for some young girls it allows them to become the person they wish they could be in real life. In the *Frontline* program "Digital Nation" several students made the following comments to the producers:

Greg Bukata: You need to have the Internet on to talk to your friends because everybody uses it.

Brooke, Freshman: You can be more crazy online because there's no one watching to see what you're actually doing (Dretzin & Rushkoff, 2010).

Many students agree with these comments. However, most recently the trend is starting to shift in a more positive direction. That change came in part due to the controversy surrounding Facebook's decision to change the privacy settings without the user's permission (Fletcher, 2010). Mark Zuckerberg, the chief executive officer argued, "More and broader sharing makes the site better for everyone" (Helft & Wortham, 2010). The users did not agree and the pushback from this decision caused an incredible furor among people who used their service regularly. A campaign was started in protest of this newest privacy change "Quitting Facebook Day" (Paul, 2010). The bad publicity surrounding these events caused the company to reconsider their plan and simplify their privacy guidelines. In the meantime, the mounting concern has begun to register with students.

Fig. 7-1 – Facebook's Personal Information Controversy

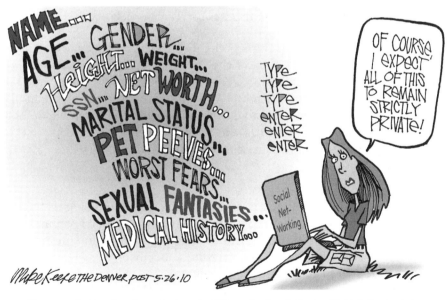

Young adults, far from being indifferent about their digital footprints, are the most active online reputation managers in several dimensions. For example, more than two-thirds (71%) of social networking users aged 18 to 29 have changed the privacy settings on their profile to limit what

they share with others online and are more likely to do so than older us-
ers—55% of SN users aged 50 to 64 have changed their settings. (Mad-
den & Smith, 2010)

Schools are also troubled with how to handle the situation of open-
ing up their Internet in order to provide more open access to their
students. This was discussed in earlier chapters as well, but the real-
ity is that teaching through access to various Internet features is the
best policy. In a recent issue of *Learning and Leading with Technol-
ogy* a debate question was issued that asked, "Is technology killing
critical thinking skills?" One of the respondents answered the ques-
tion in the following way,

> In many schools, we avoid the "teachable moment" in technology. We in-
> stitute filters and walled gardens around the Internet and pretend to
> keep students safe, although all we are protecting them from is thinking
> and learning how to evaluate sources. We lock out Nings, wikis, blogs,
> and discussion forums, and end up preventing student from being pre-
> sented with new ideas and taking part in wider discussion in the process.
> And no instant messaging or email in schools, because they might get
> distracted. Never mind the opportunities for collaboration we are quash-
> ing. And so we close the doors to discussions with each other and the be-
> yond the walls of school. Better to risk inbreeding of thought than to
> teach students how to think for themselves. (Thompson, 2010).

Powerful words remarking on a great disservice we provide our stu-
dents. Thinking must be a part of the process of using technology. Us-
ing technology for the sake of use is not enough and should not be
enough for any educator. Without question, the potential for technol-
ogy is enormous, but we are only seeing glimpses of it when we do not
educate our students to process the good and the bad aspects of the
tools as they come up in the process of their learning.

Cyberbullying

In a generation of full-blown communication and technology, the so-
cialization of our teen culture has been taken to another level as they
seek to begin, grow, and maintain friendships through mobile phones
and social networking sites. The original concept of vast communica-
tion was and still is good, but the problem occurs when teens begin to
use services such as Facebook or MySpace to deal with their friends
in negative ways.

> Research is beginning to reveal that people act differently on the Inter-
> net and can alter their moral code, in part because of the lack of gate-

keepers and the absence in some cases of visual cues from others that we all use to moderate our interaction with each other. This is potentially more complex for children and young people who are still trying to establish the social rules of the offline world and lack the critical evaluation skills to either be able to interpret incoming information or make appropriate judgments about how to behave online. (Byron, 2010)

Sadly, this has been most apparent by a number of recent tragedies that have made national news, in particular the case of Phoebe Prince, from Massachusetts, who in January committed suicide as a result of nonstop bullying perpetuated online by classmates. Horrifying comments were left on Facebook which caused police officials to demand their removal from the site and it was done immediately. Taunting text messages were also sent to her cell phone. The bullying was nonstop. This is not the first case, but it received an incredible amount of publicity which compelled many school communities to create task forces who are looking at how to prevent such things from happening in the future (James, 2010).

The media have also jumped into the picture. Cartoon Network, which attracts many middle schools, plans to launch a campaign against bullying or cyberbullying. They will team up with CNN to create public service announcements and an online curriculum, but more importantly will include anti-bullying message in the cartoon content. The campaign is specifically aimed at students who are considered bystanders, those who see the acts of cyberbullying or physical bullying, but do not report it. The hope is that creating programs such as these will help positively change students' thinking and help prevent further tragedies such as the one of Phoebe Prince (Crary, 2010).

Safety

Of main concern to parents of today's students is their child's safety online. While the project ideas mentioned in this book are worthwhile and certainly fall within the suggested curriculum areas, parents need to see their value in the same way and know that their child will be safe while exploring these tools in the classroom. For high school students, this change in thinking does not seem to present itself with as many problems. On the other hand, for young children and middle schoolers the issue of safety online will rear its head quite often. Parents are worried about their family privacy being invaded and they want to shield their children from danger. This is their right and their duty. Yet, the Web 2.0 programs and even the social network pro-

grams have great learning potential as they allow educators to meet their students in their own personal environments. What is required here is some education for parents on learning outcomes that can be attained through these resources. It requires an extended hand from teacher to parent to student and vice versa. Students need to share their work and creations with their parents in order for them to understand and value their creations derived from the use of these technologies.

By the same token there needs to be relevant education for student about online safety. As discussed earlier, the issues online have become much more focused on peer-to-peer communications; therefore, this also means that socialization among youth has changed. Students need to understand how what they discuss and how they represent themselves online can be detrimental to other people, themselves, and even their very futures. The concept of the digital footprint is real, and it is a topic that needs coverage in the classroom, but also one that needs to be better understood by educators.

> Teaching kids to manage their Digital Footprint really starts with the adults. Teachers can't teach this effectively if they, themselves have not managed their own digital footprint. It is also important not to confuse managing a digital footprint with being hidden or private. Branding our identities has become more and more important in the digital age and if students and teachers aren't actively managing their digital footprint, then who is? Managing your digital footprint starts with asking questions like: Who are you? What do you stand for? What are your passions and beliefs? The important lesson with managing your digital footprint is that everything we do online should represent who we are and what we stand for and we must have the knowledge that this representation will stick with us potentially forever. (Nielsen, 2010)

As more and more of students' lives are exposed online, they can be easily followed and picked up through search engines. Googling their name and seeing the results is a good lesson on how much information actually exists. Employers are using these methods for determining the character of their employees, and in some cases they are asking the job candidate to reveal their Facebook pages to them before employment is granted. The bottom line is that it is important for students to realize that their online activity can be exposed and that there are consequences to actions perpetrated via the Internet.

> Students have been expelled from high school and colleges. Students have been denied acceptances to intern programs, admission to independent high schools, colleges, and jobs at summer camps. Students and

their parents have been sued for slander and defamation of character. All because of the content they have posted in their "private" social network accounts. People are trolling their accounts. (Fodeman & Monroe, 2009)

Slowly, students are becoming aware of this issue and it is in part because of a change in the approach in which Internet safety is handled. Over the years, the customary way has been to tell students of the most horrifying or disturbing events that had transpired with children through various online sites. While this worked in small part, overall it was a failure. Instead the goal for Internet safety now is to get away from the scare tactics and work toward understanding how they can keep themselves safe by learning practically how to work through conflict online and offline in order to survive in a digital world (Mills, 2010).

Joining in this argument are organizations like the PTA and iKeepSafe which have both developed programs to assist schools with curriculum guidelines. In the summer of 2009, iKeepSafe, an organization which works to promote Internet safety, introduced the C3 Matrix which assists schools with integrating cyber-safety, cyber-security, and cyber-ethics into their existing curriculums. The idea being that there are levels of understanding for digital civic behavior online and raising the awareness of best practices online (Hancock, Randall, & Simpson, 2009).

The National PTA, in conjunction with Facebook, is beginning to work on a plan to create a program that will provide information on issues such as cyberbullying, good online citizenship, and Internet security. The plan is just being conceived and the details have not been revealed at the time of this writing (Associated Press, 2010).

Global Society

Throughout the writing of this book an essential and necessary relationship between the new digital technologies, global awareness, and media literacy became apparent. The global perspective, given the accessibility of the world via social networks and the Internet, is much needed for our students and educators. Too often the glimpse of the outside world is not considered due to lack of understanding and knowledge. That lack of knowledge can be at times picked up in the most obscure moments. This was most apparent in Sweden during the *World Summit on Media for Children and Youth*.

Each evening the participants would gather together to watch the World Cup, which while important here in the United States was

massive overseas. This event became an eye-opening experience on the global disconnect. The World Cup was taking place in South Africa and it was very clear that the people in the stadium were quite cold, as they were wearing heavy winter coats. A comment was made from an American that this couldn't be South Africa because it is always hot. The people sitting at the table laughed. They were all from other countries other than the United States and knew that it was actually winter in this country. The American at the table was quite embarrassed by his lack of knowledge, but in a later conversation there was a discussion on how mediated American's perspectives were of South Africa and Africa in general. The images in films, television shows, and even the news always referenced the heat and devastation. None had actually ever seen a picture of winter in Africa. In fact, the experiences they all had were of wars, famine, and the Safari. This conversation in itself showed how much the media had influenced their perception of the world. It also demonstrated a disconnection with the other members of the global world as their knowledge was based on having a more open look at the society around them. Perhaps in part it is because they were themselves connected by various countries and cultures. The United States stands alone for the most part. While connected to Canada and Mexico, the transcontinental knowledge is limited. Bridging understanding of other cultures either requires traveling across the Atlantic or Pacific or doing so via the Internet, where everyone is afforded the opportunity to view other cultures.

Framing this idea further was a recent presentation given by a technology expert and leader in educational technology at the ISTE conference in Denver, Colorado, in which he referenced two international incidents. The first was his own experience while traveling to Denmark where he was asked to present on the growth of technology. He wanted to show how much YouTube had influenced students' understanding of World War II and the Holocaust through the reading of Lois Lowry's book *Number the Stars*. He showed a clip which had an image of Denmark during the war. What he did not realize was that the particular image was actually disturbing to the group of people gathered to watch. The members of the audience were very upset with him, as they felt he showed a lack of sensitivity. However, it was a lack of knowledge regarding that time period and the differences of experiences when related to historical information.

In his talk, the presenter remarked that this was a moment that would never be forgotten because he had not expected that the cultural differences of such an image would have this type of impact. In-

deed his remarks related to the importance of knowing other people from other worlds as context is very important. The idea of empathy became the dominant focus of his talk as related to all things, but especially cultural sensitivity. He further stated, in his presentation, that overseas educators are worried about relationship building—people to people—creating cultural sensitivity online. The direction of education, he believed, was to create and focus on globalizing the curriculum. Children should work with people all over the world, both teachers and students, with the idea of creating a personal learning network that would allow them to tap into the world for the rest of their lives. One of the recommendations that this presenter made on how this could be done was simply through the basic application of Google; specifically looking at this search engine from the viewpoints of other countries, which can be easily done just by changing the locational structure of Google.

The second story he shared was regarding the British tourists who visit the United States, specifically Boston, Massachusetts, to follow the Revolutionary War trail. The British want to see the location of where the first shot was fired in the war—known to us at the Battle of Lexington. However, their purpose for viewing this event is far different from that of an American, as their historical account of this war is enhanced in some respect by detail that is not found in our textbooks. The British understand the reasoning for the first gunshot to be quite different from the one that is understood by us. The presenter pulled up several sites on the British version of Google, www.google.co.uk/, and showed a series of articles which represented their version of the events of that particular day. Then he took us to Google Maps. The audience erupted in laughter as they realized there is a tavern in the location in which the Battle of Lexington began—Buckman Tavern. It was then surmised that the reason for the first shot was not because of the stress related to waiting for the British, but in fact because the soldiers may have been at the pub all night and fired accidentally. British tourists come to visit the site in order to see the pub. His point was directed at how even when we look at information through such sites as Google that we tend to see it from an American perspective, but by just switching the placement of Google a different viewpoint can be obtained easily.

All of these examples demonstrate why a global perspective is most necessary when relating to the world. It also provides a wider glimpse of the stories that have been told to us historically or even through the media. How much of our historical knowledge is accurate or even our day-to-day mediated messages? Most of us are looking at

information on a peripheral level. Certainly our textbooks provide us with a limited perspective, and even our news media provide us with a limited point of view. Even with the cable industry's claim to 24-hour news, most of the news is national in scope and moreover based in part on stories that hold our attention based on their bizarre, glitzy, or even sparse representations. In order to get a better view of the world, students and adults would need to seek information from non-mainstream sources or international news agencies such as the BBC. The Internet has provided that avenue for all of us to experience a more globalized view. Through alternative news agencies which publish much of their work online and through even the word of mouth of friends that have been gathered through online platforms another perspective can be gained.

Moreover, by teaching students how to collect online information and to create better search key terms, web literacy, their access to the world can be unlimited. Further assisting their growth would be critical media literacy education, which would help them to question and consider the topics and ideas represented online. Expanding this concept is United Nations Educational, Scientific and Cultural Organization (UNESCO), which is working to bridge the idea of an individual's right to communicate and express information through including information literacy as part of the working definition of media literacy. UNESCO is working to promote "media and information societies and foster the development of free, independent, and pluralistic media and universal access to information and knowledge" (UNESCO, 2010). Their idea is to bring a more holistic approach to literacy, which they believe will create successful learners in our working communities, but also for life.

The Future

With all the technology already available and the fact that most educators are not using just these resources, it is hard to believe that newer technology could still be ahead. It will be as it has been in the past. While the iPad is new, the possibility of what it could become is already on people's minds, especially as this is just the first generation. What could it look like in schools is already a conversation starter and one that is sure to continue.

Mobile technology is beginning to be seen in mainstream education. As cell phones have become more advanced and the applications or "apps" become more innovative and fitting, there are candid conversations going on in educational circles as to how this can be repur-

posed as a tool in the classroom. It already attracts students and encourages the text language development, but it could also be much more.

Along with cell phones are other mobile technologies such as the netbooks, which are reduced in price, compact, and lightweight. Schools are beginning to introduce them to their students. Furthermore, there are initiatives taking place in various states regarding the adoption of a one-to-one laptop program, such as has been in operation in the state of Maine. The information collected thus far from Maine has demonstrated that the one-to-one laptop program was a positive and motivating technology for students. Teachers reported that students were more attentive and engaged in classroom learning. Many other states are looking at this model and deciding if this is the approach they will be taking into the future (Silvernail & Lane, 2004).

As schools are getting away from purchasing regular bound textbooks, there is more thought to the electronic book. With the Kindle, Sony Reader, and iPad all selling to consumers the electronic version of books, the conception of a universal reader is already under consideration. For students, educators, and adults in general there is recognition that these reading devices are a real possibility for the classroom. Besides the fact that it reduces the weight of backpacks students already carry on their backs, it is environmentally friendly and could potentially save towns and schools funds.

Lastly, one of the main themes that has come across through the most recent research from the New Media Consortium and the Educause Learning Initiative is that digital media literacy must be of key importance in every discipline and profession (Alexander, 2010). Media literacy education would assist students' learning through the use of these programs, by helping students to understand their complexity, and change the viewpoint to include the idea of the participatory culture of this generation. Henry Jenkins of MIT emphasizes this idea in his last report for the MacArthur Foundation,

> We would add new complexity and depth to each of these questions (media literacy key questions) if we rephrased them to emphasize the individuals' own active participation in selecting, creating, remaking, and critiquing and circulating media content. One of the biggest contributions of the media literacy movement has been this focus on inquiry, identifying core questions that can be asked of a broad range of different media forms and experiences. (Jenkins, 2009)

Indeed the success of students' ability to comprehend, translate, and create while being good digital citizens will be dependent on their wil-

lingness to grow and adapt in understanding of the technology that will always be competing for their attention. However, before this can happen, the educator in every discipline must be prepared to teach effectively about cyberspace and direct their students on this new frontier of learning.

AIME (amount of invested mental energy/effort): This is the concept, developed by educational psychologist Gavriel Salomon, in which teachers show media only after preparing students by sharing cues and information to look for. Most effective with short clips and exercises afterward which highlight the visuals which were seen.

Asynchronous: A method of online communication which does not rely on everyone being present at the same time. Much of Blackboard and Moodle instruction is done in this way. Allowing the users to come online when they are ready to use the resources.

Avatar: A graphic, picture or cartoon character used for representing oneself online in various communities.

Back channel: A secondary way to have continuous conversation in the classroom where everyone is invited to discuss the topics at hand; similar to a private chat room, it can be set up via Twitter, iChat, or Chatzy.

Bandwagon: Advertising technique relating that everyone is doing it or in this case buying it; "in" with the crowd.

Blocking: The denial of access to particular parts of the Internet. Usually a message will be shown on screen to say that access has been denied.

Blog: Interactive web journal or diary, the contents of which are posted online and then viewable by some or all individuals. The act of updating a blog is called "blogging." A person who keeps a blog is called a blogger.

Bookmarking: Called favorites or Internet shortcuts in Internet Explorer, which basically allows the user to keep track of the places on the web they like to visit. Bookmarks are normally accessed through a menu in the user's web browser, and folders are commonly used for organization.

Brand: Name used to distinguish one product from its competitors.

Brand loyalty: Consumer's commitment to a product demonstrated by the continued repurchase of brand; also demonstrated by word of mouth positive recommendation.

Camera angles: Various positions of the camera with respect to the subject being photographed, each giving a different viewpoint and perspective.

CIPA (Child Internet Protection Act): Passed in 2000 by Congress to protect students from harmful effects of the Internet.

COPPA (Children's Online Privacy Protection Act): Gives parents' control over what information websites can collect from their kids under 13. It also sets out specific guidelines for website creators which must be included in their privacy policies.

Consumer behavior: Study of how people behave when obtaining, using, and disposing of products.

Collaboration: Working in groups, in this case, online to develop, create, or produce a final product.

Cyberbullying: Bullying or harassment that takes place online usually between students and peers.

Cyberspace: A term used to describe the electronic universe created by computer networks in which individuals interact.

Cyber-stalking: Harassment that includes threats of harm or is highly intimidating and intruding upon one's personal privacy.

Cyber-threats: Electronic material that either generally or specifically raises concerns that the creator may intend to inflict harm or violence to others or self.

Darknet: An online service that lets users send and receive files and information over the Internet without fear of being monitored or logged.

Digital citizenship: Behaviors expected from digital natives online and through the use of the technology.

Digital footprint: Evidence of a person's use of the Internet. This includes anything that can be linked to his or her existence, presence, or identity.

Digital immigrant: A term used to describe people who did not grow up with digital technologies and are more uneasy about using these tools.

Digital literacy: This term refers to the ways we communicate using electronic means, and includes knowledge of and access to concepts and skills.

Digital native: A person, under the age of twenty, who has lived with and used technology since the day he was born.

Disclaimer: A legal statement which in this case states that the pharmaceutical drug advertised may have some negative side effects on some people who have taken the drug.

Domain name: This is the name that identifies a website. For example, "microsoft.com" is the domain name of Microsoft's website.

Editor: The person often responsible for the outcome of a production.

Ethics: A set of moral principles or values, or in other words, the principles of conduct governing an individual or a group.

FCC (Federal Communications Commission): Regulates what is seen or not seen on television, and they are the grantors of licenses.

Filtering: The applying of a set of criteria against which Internet content is judged acceptable or not. For example, a filter might check the text on a web page with a list of forbidden words. If a match is found, that web page may be blocked or reported through a monitoring process. Generally speaking, it lets data pass or not pass based on previously specified rules.

Firewall: Hardware or software that blocks unauthorized communication to or from your computer; helps keep hackers from using your computer to send out your personal information without permission.

Flaming: Sending angry, rude, or obscene messages directed at a person or persons privately or an online group. A "flamewar" erupts when "flames" are sent back and forth.

Global education: Teaching and learning about the world; providing a cross-cultural awareness and perspective from around the globe. In this book, it is discussed in relation to how the Internet has made a world without borders.

Google jockeying: A participant in a presentation or class who surfs the Internet for terms, ideas, websites, or resources mentioned by the presenter or related to the topic. The jockey's searches are displayed simultaneously with the presentation, helping to clarify the main topic and extend learning opportunities.

ICTs: Acronym seen in national technology standards which stands for "information and communication technologies." In essence, the term encompasses a wide range of technologies for gathering, storing, retrieving, processing, analyzing, and transmitting information.

Information literacy: An individual's ability to find, evaluate, and use information effectively to complete any task or make any decision.

Instant message (IM): A program which allows instant text communication between two or more people through an online network.

IP address: Stands for "Internet Protocol" address. It is a unique address assigned to a computing device that allows it to send and receive data with other computing devices that have their own unique addresses.

KPC: Acronym used for text messaging or Internet slang that stands for **K**eep **P**arents **C**lueless.

Literacy: "the ability to identify, understand, interpret, create, communicate, compute and use printed and written materials associated with varying contexts. Literacy involves a continuum of learning in enabling individuals to achieve their goals, to develop their knowledge and potential, and to participate fully in their community and wider society" (UNESCO).

Malware: A term increasingly being used to describe any form of malicious software such as a Trojan Horse.

Millennials: Generation of learners/students that was born after 1982 and grown up since the emergence of the World Wide Web and related digital technologies. They are characterized by core values that include confidence, civic duty, sociability, morality, diversity, collective action, and pleasure through teamwork.

Mobile learning: Any form of learning that is "digital" in nature and not confined to a traditional classroom. Many educational researchers believe this is where educators need to start focusing their attention.

Network: A central point of operations that distributes programming to a number of television stations; for example, NBC headquarters distributes programming to many affiliates all over the United States.

Newsworthy: Explains an event that is considered suitably interesting to be reported in a newspaper or the nightly news.

Nielsen rating: A measure of what U.S. audiences are watching on television. One point equals one million households.

Open source: Describes computer software for which the source code is freely available.

Participatory culture: A term coined by Henry Jenkins, while he was the Co-Director of the MIT Comparative Media Studies program, to mean the following:

- Relatively low barriers to artistic expression and civic engagement
- Strong support for creating and sharing one's creations with others
- Some type of informal mentorship whereby what is known by the most experienced is passed along to novices
- Where members believe that their contributions matter
- Where members feel some degree of social connection with one another (at the least they care what other people think about what they have created)

Personal learning network (PLN): Professional learning communities that are developed through various online components such as Twitter.

Phishing: When a scam artist sends spam, pop-ups and other text messages to convince the reader to disclose personal, financial, or other sensitive information.

Photo esthetics: The qualities of an artistically beautiful or pleasing image, usually composed of a variety of factors including lighting, exposure, and angles.

Point of view: The vantage point or outlook from which a story is being told through the various media formats.

Privacy settings: Controls which allow individuals to set limits to who can access their profile and personal information. These controls are available on many websites and social networks.

Promotion: All forms of media other than advertising that call attention to products and services in order to get consumers to buy.

Producer: The final authority in the electronic media production process. Sometimes the producer is the person who raises the money to produce media products.

Repurposing: To use or convert for use in another format.

RSS (rich site summary): A format for delivering regularly changing web content such as news, fan sites, and sports blogs.

Sexting: Sending or forwarding sexually explicit pictures or messages through a mobile phone.

SMS (short message service): A communications protocol that allows short (160 characters or less) text messages over cellular phones.

Skype: Computer software that allows a person to make phone calls via the Internet. You can use the computer to "call" other computers, cell phones, and land-line phones, using the computer microphone and speakers; it costs pennies and it can be used all over the world.

Spam: Unsolicited electronic mail sent from someone you do not know.

Spyware: Software installed on your computer without your consent to monitor or control your computer use.

Tags: Keywords used to describe a website, photo, and other web-based content. In turn, these words help the user to organize and retrieve information easily.

Target audience: A specified audience or demographic group which an advertising message is designed to attract.

Transliteracy: The ability to read, write, evaluate and interact across a variety of platforms, tools and media through handwriting, print, TV, radio and film, and digital social networks.

Trolling: Deliberately but disingenuously posting information to entice genuinely helpful people to respond (often emotionally). Often done to inflame or provoke others.

Tween: A young child between the ages of 8 and 12 years old.

Virtual meeting: A place online where everyone can gather simultaneously without having to be present in the exact physical location. Webinars, webcasts, and web conferences all fall under this category.

Virtual reality: Computer-simulated environment, manufacturing either a real world or an imaginary world.

Vlog: Much like a blog, except that it is video-based versus text-based.

Webcast/Webinar: An interactive discussion, lecture or seminar conducted via the World Wide Web.

Widget: A mini application which can be inserted or embedded into a webpage. These mini applications can be found on social networking sites and even through the use of Google Apps.

Resources and Tools

Resources

Action Coalition for Media Education (ACME)

http://www.acme.org
Offers a bi-annual conference and a discussion listserv for members. Local chapters have occasional meetings and regional conferences in Northern California; Vermont; St. Louis, Missouri; New York; and New Mexico.

Alliance for Civilizations

http://www.unaoc.org/
A United Nations initiative created in 2005 under the initial sponsorship of the governments of Spain and Turkey. Currently, there are 77 member states and 13 intergovernmental organizations associated. Their goal is to develop a variety of programs and initiatives that encourage international cross-cultural dialogue around the four main areas: media, youth, education, and migration.

American Film Institute

http://www.afi.com/
A national institute providing leadership in screen education and the recognition and celebration of excellence in the art of film, television, and digital media. The site offers information on the conservation of films and more.

American Museum of the Moving Image

http://www.movingimage.us
A truly wonderful and interactive museum which advances the public understanding and appreciation of the art, history, technique, and technology of film, television, and digital media. They are collectors and preservers of moving-image related artifacts; screening significant films and other moving-image works; presenting exhibitions of artifacts, artworks, and interactive experiences. They offer a number of educational programs for students and teachers.

Cable in the Classroom

http://www.ciconline.org
Fosters the use of cable content and technology to expand and enhance learning for children and youth nationwide. They are at the

forefront of digital citizenship, a new approach to helping children use digital tools safely and effectively. This positive and proactive approach combines Internet safety and security with digital literacy, ethical behavior and civic engagement with online communities. Their website has a number of lesson ideas, video streaming, and information for both teacher and parent.

The Centre for Excellence in Media Practice

http://www.cemp.ac.uk/about/
The organization has developed a range of online tools which are now widely used in education and in industry. The Centre provides postgraduate courses which are catered to those working in media education. The Centre also aims to influence media education research through projects, publications and conferences.

Centre for the Study of Children, Youth and Media

http://www.cscym.zerolab.info/
A research center based at the Institute of Education, University of London. They undertake funded research projects and consultancies, provide conferences and public seminars, organize networks of researchers and practitioners, contribute to the Institute's MA Media program, supervise doctoral research students, and work with other institutions, nationally and internationally.

Center for Media Literacy

http://www.medialit.org
The Center for Media Literacy provides the educator with a wide selection of teaching tools carefully evaluated for their quality and importance to the field. They are dedicated to a new vision of literacy for the 21st century: the ability to communicate competently in all media forms as well as to access, understand, analyze, evaluate and participate with powerful images, words and sounds that make up contemporary mass media culture.

Children Now

http://www.childrennow.org/
A national organization for people who care about children and want to ensure that they are a public policy priority. The website provides a number of resources about children, but also specifically about media education.

CNN Student News

http://www.cnn.com/studentnews/
A ten-minute, commercial-free, daily news program for middle and high school students. This show is produced by the journalists and educators at CNN and is available free of charge throughout the school year. The site includes a Media Literacy question of the day, useful quizzes, and classroom exercises.

Cyberschoolbus

http://cyberschoolbus.un.org/
Website created by the United Nations whose mission is to promote education about international issues. The site provides resources, curriculum, quizzes, and games.

Edutopia

http://www.edutopia.org
A George Lucas foundation which empowers and connects teachers, administrators, and parents with innovative solutions and resources.

ePals

http://www.epals.com/
In terms of global learning, this organization is offering a classroom matching service through the use of a virtual workspace optimized for collaborating, creating, and sharing educational content. They provide a safe platform to use their Web 2.0 communication tools including email, blogs, wikis, forums, media galleries, and much more. There is a cost to this service.

Fairness and Accuracy in News Reporting (FAIR)

www.fair.org
A news watchdog organization, publishing a bi-monthly magazine (EXTRA!) dedicated to analysis and commentary on the news.

Family Online Safety Institute (FOSI)

http://www.fosi.org/
This organization works to make a safer online world for kids and their families by identifying and promoting best practice, tools and methods in the field of online safety. They also have a strong foundation in the belief in and respect for free expression, which they pro-

mote through the development of public policy, technology, education and special events.

Federal Communications Commission

www.fcc.gov
An independent United States government agency. The FCC was established by the Communications Act of 1934 and is charged with regulating interstate and international communications by radio, television, wire, satellite and cable. Their interest in children and media has been covered regularly by the media. Their website provides up-to-date information on the most current issues and problems in the media environment.

The First Amendment Center

http://www.firstamendmentcenter.org/
Offers one-stop access to information about the First Amendment. The center serves as a forum for the study and exploration of free-expression issues, including freedom of speech, of press and of religion, and the rights to assemble and to petition the government. They also offer a variety of programs for students, teachers, journalists, lawyers and the general public.

Flat Stanley Project

http://www.flatstanley.com/
In terms of giving students a global look at the world while teaching about technology and media literacy, this could be one of the best sites for younger children. The Flat Stanley project was started by a Canadian educator in 1995 and was based on the book by Jeff Brown and Scott Nash. Students make paper Flat Stanleys and begin a journal with him for a few days. Then Flat Stanley and the journal are sent to another school where the students there treat Flat Stanley as a guest and complete the journal. Flat Stanley and the journal are then returned to the original sender. Students can plot his travels on maps and share the contents of the journal. Some teachers prefer to use e-mail only, but with new digital technologies other formats may be used.

The Freedom Forum

http://www.freedomforum.org/

A nonpartisan foundation that champions the First Amendment as a cornerstone of democracy. The Forum provides programs and other sources of information which would be useful for the classroom. Furthermore, the Freedom Forum is the main funder of the operations of the Newseum in Washington, D.C., the First Amendment Center and the Diversity Institute.

Global Schoolhouse

http://www.globalschoolnet.org/
The mission of this organization is to support 21st century learning and improve academic performance through content-driven collaboration by connecting schools around the world.

iEARN

http://www.iearn.org/
With over 30,000 schools and youth organizations in more than 130 countries this organization seeks to empower teachers and young people to work together online collaboratively around the world. In order to participate in any of the over 150 projects, educators must select a project and meet up with their counterparts online.

iKeepSafe

http://www.ikeepsafe.org
Provides families with all the tools, education, and resources they need to stay safe online and to implement an Internet safety strategy in their classrooms and homes. Furthermore, they assist educators in integrating the essentials of cyber-safety, cyber-security, and cyber-ethics (C3 concepts) into existing technology and literacy standards and curricula through the C3 Matrix which is included in Appendix C of this book.

International Media Literacy Research Forum

http://www.imlrf.org/
A global look at media literacy from the research and public policy perspective. The Forum provides a platform to improve understanding of the emerging issues; promote innovative methodologies; and facilitate dialogue between researchers, policy makers, practitioners and regulators worldwide. The Forum is currently supported by leading organizations in the United States, Australia, Canada, Europe,

Ireland, New Zealand and the United Kingdom with more countries expected to follow.

Internet Movie Database

http://www.imdb.com/
A major database of movies, TV shows, and actors and actresses. The site keeps track of box office hits, upcoming movies and events, conferences, and various pieces of information which can be useful in the classroom.

Internet Movie Script Database

http://www.imsdb.com/scripts
Considered one of the best and biggest collections of movie scripts available anywhere on the web. The site lets you read or download movie scripts for free.

International Society for Technology Education

http://www.iste.org/
One of the top membership associations for educators and educational leaders who work on improving teaching and learning through the effective use of technology in PK-12 and teacher education. Their mission statement states, "ISTE advances excellence in learning and teaching through innovative and effective uses of technology." They are also the home of NETS and ISTE's annual conference and exposition. They represent more than 10,000 members worldwide.

Just Think Foundation

http://www.justthink.org
Film, print media, electronic games and the Internet, Just Think is dedicated to teaching young people media literacy skills for lifelong learning.

Kaiser Family Foundation

http://www.kff.org
A non-profit, private operating foundation focusing on the major health care issues facing the nation. The Foundation is an independent voice and source of facts and analysis for policy makers, the media, the health care community, and the general public.

LinkTV—Know the News

http://www.linktv.org/knowthenews
Compare news coverage from around the world, test your knowledge of how news is shaped, and shape some yourself. Know the News is part of the national satellite channel, Link TV's Global Pulse News Service. Global Pulse, Mosaic, and Pulso Latino contrast and analyze news coverage produced by more than 70 national broadcasters. Know The News is funded by the John S. & James L. Knight Foundation.

Making Curriculum Pop

http://mcpopmb.ning.com/
A resource-sharing community for educators interested in best practices and teaching with and about popular culture.

Media Awareness Network

http://www.media-awareness.ca.eng
A Canada based website created for educators, parents and community leaders. The site provides numerous lessons on the media focusing on both the elementary and secondary level. They also serve as an extensive resource on Internet issues.

Media Education Foundation

http://www.mediaed.org/
The mission of this organization is to produce and distribute documentary films and other educational resources to inspire critical reflection on the social, political, and cultural impact of American mass media.

Media Literacy Clearinghouse

http://www.frankwbaker.com/
The mission of this site is to assist K-12 educators who want to teach standards that include non-print media texts, learn more about media literacy, further integrate it into classroom instruction, and assist students to read the media and become media aware while also assisting educators in locating appropriate resources.

National Association for Media Literacy Education (NAMLE)

http://www.namle.net

Formerly known as the Alliance for Media Literate America, it sponsors the bi-annual National Media Education Conference and has a monthly email newsletter for members.

National Telemedia Council

http://www.nationaltelemediacouncil.org
The NTC sponsors occasional international videoconferences of media literacy educators, with numerous U.S. downlink sites. More importantly, it publishes *The Journal of Media Literacy.*

NetFamilyNews.org

http://www.netfamilynews.org/
A non-profit news service for parents, educators, and policy makers who want to keep up on the latest technology news and commentary about online youth in the form of a daily log or weekly newsletter.

New Media Consortium

http://www.nmc.org
The NMC is an international not-for-profit consortium of learning-focused organizations dedicated to the exploration and use of new media and new technologies.

New Mexico Media Literacy Project

http://www.nmmlp.org
Group provides training and materials in support of media literacy. Their mission is to cultivate critical thinking and activism in media culture.

NEWSEUM

http://www.newseum.org/
A wonderful and interactive museum of news information. Provides a behind-the-scenes view of how and why news is made. The hands-on exhibits trace five centuries of news gathering. The Newseum educates the public about the value of a free press in a free society and tells the stories of the world's important events in unique and engaging ways. It is located on Pennsylvania Avenue in Washington, D.C. and it is worth taking students in groups or individually.

Nordic Information Center for Media and Communication Research (NORDICOM)

http://www.nordicom.gu.se
A knowledge center for the area of media and communication research, a cooperation between the five countries of the Nordic region—Denmark, Finland, Iceland, Norway and Sweden. NORDICOM's work aims at developing media studies and at helping to ensure that research results are made visible in the treatment of media issues at different levels in both the public and private sector.

The Paley Center for Media

(formerly known as the Museum of Television of Radio)
http://www.paleycenter.org
This museum can be found in New York City and Los Angeles, California. It is a collector of media artifacts, with a collection of nearly 150,000 television and radio programs and advertisements. The New York location offers on-site classes, videoconferencing classes, and workshops for educators. Field trips with students are encouraged. They also have a scholar's room where researchers can go to study these media and their programs.

The Partnership for 21st Century Learning.

http://www.21stcenturyskills.org
This organization offers a vision for 21st century learning that can be used to strengthen American education. They provide a framework for learning which, as they indicated, "presents a holistic view of 21st century teaching and learning that combines a discrete focus on 21st century student outcomes (a blending of specific skills, content knowledge, expertise and literacies) with innovative support systems to help students master the multi-dimensional abilities required of them in the 21st century." There are four elements to their framework: (1) core subjects and 21st century themes, (2) learning and innovation skills: creativity and innovation; critical thinking and problem solving; communication and collaboration, (3) information, media and technology skills: information literacy; media literacy; ICT literacy, and (4) life and career skills.

The Pauline Center for Media Studies

http://www.daughtersofstpaul.com/mediastudies

Promotes media mindfulness/media literacy education in schools and faith communities. They have a number of resources available including a special interest topic of film.

PBS Kids—Don't Buy It!

http://pbskids.org/dontbuyit/
A media literacy Web site for young people that encourages users to think critically about media and become smart consumers. There are several activities on the site that provide users with some of the skills and knowledge needed to question, analyze, interpret and evaluate media messages.

Pew Internet & American Life Project

http://www.pewinternet.org/
As the site indicates, "a nonpartisan, nonprofit 'fact tank' that provides information on the issues, attitudes and trends shaping America and the world. The Project produces reports exploring the impact of the Internet on families, communities, work and home, daily life, education, health care, and civic and political life."

Project Look Sharp

http://www.ithaca.edu/looksharp
Provides materials, training and support to help teachers integrate media literacy into their classroom curricula. As their site indicates, their primary goals are: to promote and support media literacy education at the community, state, and national levels; to provide teachers with ongoing pre-service and in-service training and mentoring in media education; to work with teachers to create new or revised teaching materials and pedagogical strategies that incorporate media literacy and enhance classroom practice; to develop and publish curriculum materials that infuse media literacy into core content; to evaluate the effectiveness of media literacy as a pedagogical approach to education; to develop a model for including media literacy in the school curriculum at all grade levels and in all instructional areas, and to show how media literacy can help teachers address new and existing learning standards.

Snopes.com

http://www.snopes.com/

An online site to check or verify statements or facts that have been made on the Internet. This particular site works primarily with dispelling rumors and myths. They also are a great resource for visual literacy as they have a section just on photographs and the investigation of the image as true or false.

UNESCO—Media Literacy

http://portal.unesco.org/ci/en/ev.php-
URL_ID=27056&URL_DO=DO_TOPIC&URL_SECTION=201.html
UNESCO's action to provide critical knowledge and analytical tools, empowering media consumers to function as autonomous and rational citizens, and enabling them to critically make use of the media.

Y-Pulse

http://www.ypulse.com/
A website that provides opinions and behavior of tweens, teens, collegians and young adults in order to provide news, commentary, events, research and strategy for marketing, brand and media professionals. They are heavily involved in social networking and provide a weekly newsletter to subscribers.

Listservs

Media-L

A general media education listserv. Provides information on what other educators are doing in the field of media literacy. Also, a list of articles are provided on a daily basis taken from newspapers, magazines, and other programs around the country: http://listserv.binghamton.edu/archives/media-l.html

ACME (Action Coalition for Media Education)

There are two forms—a discussion list and the other one to receive official ACME news only. This listserv has much more of an activist bent to their postings: www.acme.org.

Media Literacy Theory and Research

For media literacy graduate students or those interested in media literacy theory and research. To subscribe to the media literacy theory listserv, send the following message: subscribe mltheory to majordomo@scils.rutgers.edu.

The MAGIC Network

The MAGIC network was set up for professionals and organizations working in the field of children and the media to share information and ideas. It's an offshoot of the outstanding UNICEF website MAGIC: Media Activities and Good Ideas by, with and for Children: http://www.unicef.org/magic/

More Digital Online Programs:

Audacity

http://audacity.sourceforge.net/
A free, open source software for recording and editing sounds. It is available for Mac OS X, Microsoft Windows, GNU/Linux, and other operating systems.

Chatzy

http://www.chatzy.com/
A simple and easy tool for creating a secure back channel in the classroom. There is no registration and no special installation. It is a free service that does not come with any popup ads.

Edmodo

http://www.edmodo.com
A free and safe social learning network for teachers, students and schools on the Web. It looks very much like Facebook which will make the learning curve quite easy for those who are looking for simplicity and adaptability.

Eduspaces

http://eduspaces.net/
Social networking site devoted to education and educational technology.

Final Draft

http://www.finaldraft.com
Online software allows writers to create scripts in the established formats for cinema and television. Useful for a classroom that is interested in teaching film studies or a more in-depth look at scriptwriting.

Flickr

http://www.flickr.com/
An online photo management, organizing, and sharing application.

Google Apps

http://www.google.com/apps/
A collection of web-based online platforms which can help with documents, spreadsheets, and presentations, and you can access your documents from anywhere.

Mashpedia

http://mashpedia.com/
A real-time web encyclopedia enhanced with cutting-edge functionalities and sophisticated features such as multimedia content, social media tools and real-time information; it's free to use and open for public participation, allowing users to discuss specific topics, post and answer questions, share relevant links or contribute in new creative ways.

Moodle

http://www.moodle.com
A course management software that is quite similar to Blackboard. It is a free, open-source software which can help with online learning.

Pecha Kucha

http://www.pecha-kucha.org/
Pecha Kucha (Pe-Chach-Ka or peh-cha koo-cha) is a Japanese word that means "chit-chat." It is a format that transforms boring PowerPoints into short and exciting opportunities for students to practice presentation skills.

Prezi

http://prezi.com/
For those who are tired of the PowerPoint format and want to try something new, take a look at this site.

SecretBuilders

http://secretbuilders.com/

A virtual world for children 5 to 14 years old where they can explore virtual lands, undertake quests, play games, maintain a home, nurture a pet, and interact with their friends. Parents, educators, writers, artists and game developers are involved in this community.

Skype

http://www.skype.com/intl/en-us/home
Known for allowing people to make free calls all over the world. In education circles this tool is now used for virtual author and museum visits. This platform is known for its simple telecommunication platform that only needs Internet access.

Togetherville

http://togetherville.com/
A social network for young children—under 10 years old. It is a place for kids to experience a digital platform safely. It has games and video, cartoons, entertainment programs, etc. Parent can control who their children can interact with on the website.

Cyberethics, Safety, and Security (C3®) Literacy Skills

A Companion to the Augmented Technology Literacy Standards for Students

The vision guiding this document is that all students must have the awareness, knowledge, opportunities and resources to develop the C3® skills they need to pursue life's goals and to participate fully as informed responsible, ethical and productive members of society. This C3® framework is intended to provide guidance regarding Cyberethics, safety and security principles all students should know and be able to apply responsibly and independently when using technology, technology systems, digital media, and information technology including the Internet.

Although this document presents these principles within separated categories, we want to emphasize that they are not distinct and separable; they are, in fact, interrelated and should be considered as a whole. These principles are not meant to be taught in isolation but should be embedded systemically throughout the students' K-12 experience, and applied when meeting learning outcomes in the content areas. They can also be used as a companion and supplement to the various National Technology Literacy Standards for Students created by ISTE, AASL, AECT, and others.

The various levels (basic, intermediate, and proficient) are not identified by grade level. Instead, they represent progressive levels of cognitive complexity at which youth should be expected to understand and practice. The levels are developed utilizing Bloom's revised Taxonomy of Educational Objectives (2001), a hierarchy of six progressively complex cognitive processes learners used to attain objectives or perform activities. Bloom's Taxonomy, the preferred system for articulating program objectives, categorizes cognitive skills by increasing order of complexity. From least to most complex these are remembering, understanding, applying, analyzing, evaluating, and creating.

This taxonomy aids educators, curriculum developers, policy makers, and instructional designers in better defining the desired learning level of a target audience and then developing an appropriate design that will help the learner achieve desired learning goals. Additionally, this taxonomy aids in crafting behavioral assessment instruments.

What follows is a theoretical framework that can be used to inform a national, regional, or local agenda. It uses three dimensions, based on practical circumstances and experiences with educating students and teachers, with input from multiple stakeholders including parents, students, educators, technology coordinators, media specialists, curriculum

resource teachers, Internet safety providers, and industry security specialists. C3® subject areas have common ground, but have significant content that is distinct and important in discussing on an individual basis.

Cyberethics is the discipline dealing with what are appropriate and ethical behaviors, and with moral duties and obligations pertaining to online environments and digital media.

Cybersafety addresses the ability to act in a safe and responsible manner on the Internet and in online environments whereas Cyberethics focuses on the ability to act ethically and legally. These behaviors can protect personal information and one's reputation, and include safe practices to minimize danger— from behavioral-based rather than hardware/software-based problems.

Cybersecurity is defined by HR 4246, Cyber Security Information Act (2000) as "the vulnerability of any computing system, software program, or critical infrastructure to, or their ability to resist, intentional interference, compromise, or incapacitation through the misuse of, or by unauthorized means of, the Internet, public or private telecommunications systems, or other similar conduct that violates Federal, State, or international law, that harms interstate commerce of the US, or that threatens public health or safety." Cybersecurity is defined to cover physical protection (both hardware and software) of personal information and technology resources from unauthorized access gained via technological means. In contrast, most of the issues covered in Cybersafety are steps that one can take to avoid revealing information by "social" means.

The topics listed above cannot be stagnant. Technologies are dynamic and ever changing. For example, cyberethical issues are experiencing vast transformation as a result of factors driven by the multimedia aspects of cell phones and the vast reservoir of information on the Internet.

C3® Framework

Promoting Responsible Use

I. Cyberethics

Students recognize and practice responsible and appropriate use while accessing, using, collaborating, and creating technology, technology systems, digital media and information technology. Students demonstrate an understanding of current ethical and legal standards, the rights and restrictions that govern technology, technology systems, digital media and information technology within the context of today's society. Students will:

A. Understand and follow acceptable polices (school, home, and community), and understand the personal and societal consequences of inappropriate use.
B. Demonstrate and advocate for ethical and legal behaviors among peers, family, and community.
C. Practice citing sources of text and digital information and make informed decisions about the most appropriate methods for avoiding plagiarism.
D. Make ethical and legal decisions while using technology, technology systems, digital media, and information technology when confronted with usage dilemmas.
E. Exhibit responsibility and Netiquette when communicating digitally.
F. Recognize the signs and emotional effects, the legal consequences and effective solutions for Cyberbullying.
G. Recognize appropriate time and place to use digital tools, techniques, and resources.
H. Understand the importance of online identity management and monitoring.

II. Cybersafety

Students practice safe strategies to protect themselves and promote positive physical and psychological well-being when using technology, technology systems, digital media and information technology including the Internet. Students will:

A. Recognize online risks, to make informed decisions, and take appropriate actions to protect themselves while using technology, technology systems, digital media, and information technology.
B. Make informed decisions about appropriate protection methods and safe practices within a variety of situations.
C. Demonstrate and advocate for safe behaviors among peers, family, and community.

II. Cybersecurity

Students practice secure strategies when using technology, technology systems, digital media, and information technology that assure personal protection and help defend network security. Students will:

A. Recognize online risks, make informed decisions, and take appropriate actions to protect themselves while using technology, technology systems, digital media, and information technology.
B. Make informed decisions about appropriate protection methods and secure practices within a variety of situations.
C. Demonstrate commitment to stay current on security issues, software, and effective security practices.
D. Advocate for secure practices and behaviors among peers, family, and community.

Cyberethics

Legal and Ethical Issues

Students recognize and practice responsible and appropriate use while accessing, using, collaborating, and creating technology, technology systems, digital media, and information technology. Students demonstrate an understanding of current ethical and legal standards, rights and restrictions governing technology, technology systems, digital media, and information technology within the context of today's society.

	Basic	Intermediate	Proficient
A. Understand and follow acceptable polices (school, home, and community), and understand the personal and societal consequences of inappropriate use. **B. Demonstrate and advocate for ethical and legal behaviors among peers, family, and community.**	o **Understand and follow** acceptable use policies (school, home, and community settings). o **Discuss** basic issues related to responsible use of technology, technology systems, digital media, and information technology and **describe** personal consequences of inappropriate use.[i]	o **Understand and follow** acceptable use policies (school, home, and community settings). o **Demonstrate** responsible use of technology, technology systems, digital media, and information technology in different settings (school, home, and community settings) and **describe and analyze** personal and societal consequences of inappropriate use.	o **Understand and follow** acceptable use policies (school, home, and community settings). o **Demonstrate** responsible use of technology, technology systems, digital media, and information technology in different settings (school, home, and community settings) and **describe and analyze** personal and societal consequences of inappropriate use. o **Make informed choices** about acceptable use of technology, technology systems, digital media, and information technology when confronted with usage dilemmas. o **Demonstrate and advocate** for legal and ethical behaviors among peers, family, and community regarding responsible use of technology, technology systems,

			digital media, and information technology.
C. Practice citing sources of text and digital information and make informed decisions about the most appropriate methods for avoiding plagiarism.	o **Understand and follow** ethical standards of conduct (AUP, Student Handbooks, Student Code of Conduct, Honor Codes).	o **Understand and follow** ethical standards of conduct (AUP, Student Handbooks, Student Code of Conduct, Honor Codes).	o **Understand and follow** ethical standards of conduct (AUP, Student Handbooks, Student Code of Conduct, Honor Codes).
	o **Discuss** definitions and basic concepts and issues related to plagiarism/electronic cheating and **describe** personal and societal consequences of plagiarism.	o **Discuss** definitions and basic concepts and issues related to plagiarism/ electronic cheating and **describe** personal and societal consequences of plagiarism.	o **Discuss** definitions and basic concepts and issues related to plagiarism/electronic cheating and **describe** personal and societal consequences of plagiarism.
	o **Demonstrate** appropriate strategies for avoiding plagiarism (quoting, citing, acknowledging source and/or paraphrasing).	o **Practice** citing sources of text and digital information.	o **Demonstrate** appropriate strategies for avoiding plagiarism (quoting, citing, acknowledging source and/or paraphrasing)
	o **Discuss** the importance of respecting the rights of others regarding their work.	o **Determine and practice the use of** appropriate strategies for avoiding plagiarism (quoting, citing, acknowledging source and/or paraphrasing).	o **Determine** the most appropriate method for avoiding. plagiarism and **create** original work and **practice** citing sources of text and digital information.
			o **Demonstrate and advocate** for ethical behaviors among peers, family, and community.
D. Make ethical and legal decisions while using technology, tech-	o **Discuss** definitions and basic concepts and issues related to	o **Discuss** definitions and basic concepts and issues related to	o **Discuss** definitions and basic concepts and issues related to

nology systems, digital media, and information technology when confronted with usage dilemmas.	intellectual property, media copyright laws, private/public domain, fair use, and file sharing.	intellectual property, media copyright laws, private/public domain, fair use, and file sharing.	intellectual property, media copyright laws, private/public domain, fair use, and file sharing.
	o **Describe** personal and societal consequences of respecting vs. ignoring rights, laws, and practices such as copyright, private/public domain, fair use, and file sharing.	o **Describe** personal and societal consequences of respecting vs. ignoring rights, laws, and practices such as copyright, private/public domain, fair use, and file sharing.	o **Describe** personal and societal consequences of respecting verses ignoring rights, laws and practices such as copyright, private/public domain, fair use and file sharing.
	o **Understand** and **follow** school, home, and community policies on access to information resources.	o **Understand** and **follow** school, home, and community policies on access to information resources and adhere to local, state, and federal laws.	o **Describe** personal and societal consequences involving intellectual property rights, media copyright laws, private/public domain, fair use and file sharing.
		o **Demonstrate** appropriate social and ethical behaviors when using technology and digital media including the recognition of intellectual property rights, fair use of copyrighted material, and legal file sharing or downloading of software, music, and videos.	o **Understand** and **follow** school, home, and community policies on access to information resources and adhere to local, state, and federal laws.
		o **Make ethical and legal** use of technology, technology systems, digital media, and information technology when confronted with usage dilemmas.	o **Distinguish** the legal implications between personal, educational and commercial uses of protected works.
			o **Demonstrate** social and ethical behaviors when using technology and digital media regarding intellectual property recognition, fair use of

			copyrighted material, including file sharing and pirating vs. legal downloading of software, music, and videos. o **Make ethical and legal** use of technology, technology systems, digital media, and information technology when confronted with usage dilemmas. o **Demonstrate and advocate** for legal and ethical behaviors in this domain among peers, family, and community.
E. Exhibit responsibility and Netiquette when communicating digitally. **F. Recognize the signs and emotional effects, the legal consequences and effective solutions for Cyberbullying.**	o **Recognize** personal differences and **practice** etiquette within diverse situations. o **Recognize** positive and negative social and ethical behaviors when using technology and digital media and information technology. o **Understand** and **discuss** the signs and solutions for **Cyberbullying**. o **Recognize** appropriate time & place to use digital tools, techniques, and resources (e.g., when appropriate to use lingo & emoticons, when to use cell	o **Recognize** personal differences and **practice** etiquette within diverse digital communities. o **Recognize** positive and negative social and ethical behaviors when using technology and digital media and information technology. o **Demonstrate** a thorough understanding about **the signs and emotional effects, the legal consequences and effective solutions for Cyberbullying.** o **Recognize** appropriate time & place to use digital	o **Recognize** personal differences and **practice** etiquette within diverse digital communities. o **Recognize** and **analyze** positive and negative social and ethical behaviors when using technology and digital media and information technology. o **Demonstrate** a thorough understanding about **the signs and emotional effects, the legal consequences and effective solutions for Cyberbullying.** o **Make informed choices when** con-

	phone and text message).	tools, techniques and resources (e.g., when appropriate to use lingo & emoticons, when to use cell phone and text message).	fronted with Cyberbullying dilemmas.
	o **Apply** proper netiquette- communication skills when communicating digitally.	o **Apply** proper netiquette- communication skills when communicating digitally.	o **Recognize** appropriate time & place to use digital tools, techniques and resources (e.g., when appropriate to use lingo & emoticons, when to use cell phone and text message).
			o **Apply** proper netiquette- communication skills when communicating digitally.
			o **Practice** digital etiquette to support collaboration
			o **Advocate** for proper netiquette behaviors among peers, family, and community.
G. Recognize appropriate time and place to use digital tools, techniques, and resources. H. Understand the importance of online identity management and monitoring. Advocate others to understand the importance of Online Reputation Management.	o **Understand** that content posted to the web or sent through other digital means (cell phone, cameras) are accessible to a wide audience and can be permanently archived.	o **Understand** that content posted to the web or sent through other digital means (cell phone, cameras) are accessible to a wide audience and can be permanently archived.	o **Understand** that content posted to the web or sent through other digital means (cell phone, cameras) are accessible to a wide audience and can be permanently archived.
	o **Understand** the importance of Online Reputation Management and Monitoring (ORM).	o **Understand** the importance of Online Reputation Management and Monitoring (ORM).	o **Understand** the importance of Online Reputation Management and Monitoring (ORM).
	o **Recognize** positive and negative uses of electronic postings as related to ORM	o **Recognize** positive and negative uses of electronic postings as related to ORM.	o **Recognize** positive and negative uses of electronic media/postings as related to ORM.
		o **Demonstrate**	o **Demonstrate**

		appropriate strategies for protecting, monitoring and/or positively promoting personal identity- Online Reputation Management and monitoring (ORM).	appropriate strategies for protecting, monitoring and/or positively promoting personal identity— Online Reputation Management and monitoring (ORM). o **Analyze** selected electronic media/postings and reflect, as an individual, on the appropriateness of each for effective ORM.

Cybersafety			
Physical and Psychological Well-being Students practice safe strategies to protect themselves and promote positive physical and psychological well-being when using technology, technology systems, digital media, and information technology including the Internet			
	Basic	**Intermediate**	**Proficient**
A. Recognize online risks, make informed decisions, and take appropriate actions to protect themselves while using technology, technology systems, digital media and information technology.	**Safe and Responsible Practices** **Recognize** safety issues related to technology, technology systems, digital media and information technology including the Internet (e.g., online predator tactics, posting controversial content). **Use** safe practices related to technology, technology systems, digital media and information technology including the Internet. **Recognize** and **understand** the	**Safe and Responsible Practices** **Recognize** and **discuss** safety issues related to technology, technology systems, digital media and information technology including the Internet (e.g., online predator tactics, posting controversial content). **Use** safe practices and procedures related to technology, technology systems, digital media and information technology including the Internet. **Explain** the	**Safe and Responsible Practices** **Recognize** and **discuss** safety issues related to technology, technology systems, digital media and information technology including the Internet (e.g., online predator tactics, posting controversial content). **Use** safe practices and procedures related to technology, technology systems, digital media and information technology including the Internet.

	purpose of protection measures (including filtering systems) for various types of technology, technology systems, digital media and information technology.	purpose of technology, technology systems, digital media and information technology protection measures.	**Explain** the purpose and **analyze** the use of different protection measures for technology, technology systems, digital media and information technology.
B. Make informed decisions about appropriate protection methods and secure practices within a variety of situations.	**Adhere** to privacy and safety guidelines, policies, and procedures. **Discuss the potential for** addictive behaviors and the excessive use of technology and the Internet. **Describe** procedures for exiting an inappropriate site. **Describe** procedures for reducing your chances of being a victim of cyberbullying. **Describe** procedures for reporting cyberbullying and other inappropriate behavior or content.	**Adhere** to privacy and safety guidelines, policies, and procedures. **Describe** technology and Internet addictive behaviors. **Describe** procedures for exiting an inappropriate site. **Describe** procedures for reducing your chances of being a victim of cyberbullying. **Describe** effective steps to manage and resolve a cyberbullying situation. **Monitor** understanding about current safety needs.	**Adhere** to privacy and safety guidelines, policies, and procedures. **Describe** and **practice** procedures for disciplined and productive Internet use. Balance between time on and off the Internet. **Describe** and **practice** procedures for exiting an inappropriate site. **Describe** and **practice** procedures for reducing your chances of being a victim of cyberbullying. **Describe** and **practice** effective steps to manage and resolve if a cyberbullying situation.
C. Demonstrate and advocate for safe behaviors among peers, family, and community.		**Model** personal safety within a variety of situations.	**Model** personal safety within a variety of situations. **Demonstrate** commitment to

			stay current on safety issues and effective protection practices. **Advocate** for safe practices and behaviors among peers, family, and community.

Cybersecurity			

Digital Security
Practice secure strategies that assure personal protection and help defend network security

	Basic	Intermediate	Proficient
A. Recognize online risks, make informed decisions, and take appropriate actions to protect themselves while using technology, technology systems, digital media, and information technology.	**Secure Practices** **Understand** security risks and the potential harm of intrusive applications related to technology, technology systems, digital media, and information technology including the Internet (e.g., email viruses, digital propaganda, spy ware, adware, identity theft, phishing/pharming/spoofing scams, spam, social engineering). **Understand** effective basic security practices related to technology, technology systems, digital media, and information technology including the Internet (e.g., strong passwords, protecting password and user ID, not disclos-	**Secure Practices** **Understand** and **discuss** security risks and the potential harm of intrusive applications related to technology, technology systems, digital media, and information technology including the Internet (e.g., email viruses, digital propaganda, spy ware, adware, identity theft, phishing/pharming/spoofing scams, spam, social engineering). **Describe** and **practice** effective security practices, beyond the basic level, related to technology, technology systems, digital media and information technology including the Internet. **Recognize** and	**Secure Practices** **Understand** and **discuss** security risks and the potential harm of intrusive applications related to technology, technology systems, digital media and information technology including the Internet (e.g. email viruses, digital propaganda, spy ware, adware, identity theft, phishing/pharming/spoofing scams, spam, social engineering). **Practice** effective security practices and **analyze new options**, beyond the basic level, related to technology, technology systems, digital media and information tech-

	ing important personal information, minimizing/ evaluating pop up ads). **Recognize** and **understand** the purpose of technology, technology systems, digital media and information technology security protection measures. **Discuss** strategies for managing everyday hardware and software problems.	**understand** the purpose of security protection measures for technology, technology systems, digital media and information technology. **Monitor** understanding about current security needs.	nology including the Internet and **critically evaluate** digital resources. **Recognize** and **understand** the purpose of security protection measures for technology, technology systems, digital media and information technology.
B. Make informed decisions about appropriate protection methods and secure practices within a variety of situations.		**Adhere** to security guidelines, policies, and procedures. **Use effective** strategies for managing everyday hardware and software problems. **Use effective** strategies for securing wireless connections (e.g., connecting to only legitimate wi-fi hot spots or turn off wi-fi, turn off file share mode, encrypting sensitive data/information, use and update anti-virus software, use a firewall, update operating system).	**Adhere** to security guidelines, policies, and procedures. **Describe** and **practice** strategies for managing everyday hardware and software problems. **Describe** and **practice** strategies for securing wireless connections (e.g., connecting to only legitimate wi-fi hot spots or turn off wi-fi, turn off file share mode, encrypting sensitive data/information, use and update anti-virus software, use a firewall, update operating system.
C. Demonstrate commitment to stay current on security issues, software and ef-		**Model** secure practices within a variety of digital communities.	**Demonstrate** commitment to stay current on security issues and effective security

fective security practices. **D. Advocate for secure practices and behaviors among peers, family, and community.**			practices. **Model** secure practices within a variety of digital communities. **Advocate** for secure practices and behaviors among peers, family, and com- munity.

Note

1 Inappropriate use could include, but is not limited to, viewing inappropriate content, using the school's network for non-educational purposes, or work networks for non-school/work related activities, posting incorrect/inaccurate information, bullying, hate groups, harassing or sending/posting mean com- ments, hacking, illegally downloading copyrighted materials/movies/music and/or making and sharing copies of copyrighted materials etc.

References

Anderson, L. W., & Krathwohl, D. R. (eds.). (2001). *A taxonomy for learning, teaching and assessing: A revision of Bloom's Taxonomy of educational objectives.* Complete edition, New York: Longman.

Pruitt-Mentle, D. (2000). The C3 framework: Cyberethics, cybersafety and cybersecurity implications for the educational setting. C3 is a trademark registered with ETPRO. Materials can be used for educational and non-profit use. For other uses, contact Davina Pruitt-Mentle, dpruitt@umd.edu.

APPENDIX D Digital Millenium Copyright Act

http://www.copyright.gov/legislation/pl105-304.pdf *(Effective July 2010)*

U.S. Copyright has made several huge changes that impact educators in the K-12 classroom, universities, and students. Media literacy educators especially have been working to make the idea of "fair use" much more accessible for the classroom. The beginning of those changes has just begun. In effect, the Copyright Office ruled that K-12 students and educators could use free online software to get screen grabs and short clips without copying DVDs. There were six classes of work changed and they are:

(1) Motion pictures on DVDs that are lawfully made and acquired and that are protected by the Content Scrambling System when circumvention is accomplished solely in order to accomplish the incorporation of short portions of motion pictures into new works for the purpose of criticism or comment, and where the person engaging in circumvention believes and has reasonable grounds for believing that circumvention is necessary to fulfill the purpose of the use in the following instances:

(i) Educational uses by college and university professors and by college and university film and media studies students

(ii) Documentary filmmaking

(iii) Noncommercial videos

(2) Computer programs that enable wireless telephone handsets to execute software applications, where circumvention is accomplished for the sole purpose of enabling interoperability of such applications, when they have been lawfully obtained, with computer programs on the telephone handset.

(3) Computer programs, in the form of firmware or software, that enable used wireless telephone handsets to connect to a wireless telecommunications network, when circumvention is initiated by the owner of the copy of the computer program solely in order to connect to a wireless telecommunications network and access to the network is authorized by the operator of the network.

(4) Video games accessible on personal computers and protected by technological protection measures that control access to lawfully obtained works, when circumvention is accomplished solely for the purpose of good faith testing for, investigating, or correcting security flaws or vulnerabilities, if

(i) The information derived from the security testing is used primarily to promote the security of the owner or operator of a computer, computer system, or computer network; and

(ii) the information derived from the security testing is used or maintained in a manner that does not facilitate copyright infringement or a violation of applicable law.

(5) Computer programs protected by dongles that prevent access due to malfunction or damage and which are obsolete. A dongle shall be considered obsolete if it is no longer manufactured or if a replacement or repair is no longer reasonably available in the commercial marketplace.

(6) Literary works distributed in ebook format when all existing ebook editions of the work (including digital text editions made available by authorized entities) contain access controls that prevent the enabling either of the book's read-aloud function or of screen readers that render the text into a specialized format.

In Summary. Copyright law is reviewed every three years in order to make revisions or exemptions. The six "classes" now exempt from prosecution under the Digital Millennium Copyright ACT (DMCA) are

1. Defeating a lawfully obtained DVD's encryption for the sole purpose of short, fair use in an educational setting or for criticism

2. Computer programs that allow you to run lawfully obtained software on your phone that you otherwise would not be able to run, aka Jailbreaking to use Google Voice on your iPhone

3. Computer programs that allow you to use your phone on a different network, aka Jailbreaking to use your iPhone on T-Mobile

4. Circumventing video game encryption (DRM) for the purposes of legitimate security testing or investigation

5. Cracking computer programs protected by dongles when the dongles become obsolete or are no longer being manufactured

6. Having an ebook be read aloud (i.e. for the blind) even if that book has controls built into it to prevent that sort of thing.

U.S. Copyright Office
101 Independence Avenue SE
Washington, DC 20559-6000
(202) 707-3000

Thinking about Tools in Schools Timeline

David M. Considine

"You can have the most creative, compellingly valid, educationally productive idea in the world, but whether it can be embedded and sustained in a socially complex setting, will be primarily a function of how you conceptualize the implementation-change process."
—*Seymour Sarason, in* Revisiting the Culture of the School and the Problem of Change, 1994

"Adding technology to the classroom is the easy part. The difficult work is reshaping the relationship between students and teachers. The real revolution in learning is not about adding technology on top of the current structure of schooling. Instead, the real revolution is about a transformational shift of control from the school system to the learner."
—*Alan November,* Empowering Students with Technology, 2001

A SHORT TIMELINE of TECHNOLOGY IN SCHOOL & SOCIETY

ESTIMATES suggest American K-12 schools will spend 21.9 billion on technology by the year 2013. Is it WORTH IT?

1910. Rochester schools in New York become first system to adopt films [silent] for regular use in classroom.

1911. Taylor writes *The Principles of Scientific Management.*

1912. *Titanic* sinks. A human error, not mechanical/technological failure.

July 1913. Thomas Edison says, "Books will soon be obsolete in the schools. Scholars will soon be instructed through the eye. It is possible to teach every branch of human knowledge with the motion picture. Our schools systems will be completely changed in 10 years."

1918. First teacher education course in visual instruction offered at the University of Minnesota. By 1921, Kansas and North Carolina both offered such courses.

1919. Johns Hopkins University begins first large-scale instructional film research using film for the "control, repression and elimination of venereal disease."

Researchers concluded that while film was effective for disseminating information, a single screening or exposure would "not be effective in bringing about any basic changes in attitudes or behavior."

1919. Society for Visual Education Inc. established.

1922. The organization fails because it did not develop educational films that systematically supplemented existing courses of study.

1923. Establishment of National Education Association Department of Visual Instruction.

Same year, Judd Committee concludes that visual education is receiving little financial support.

In the same year the McClusky Report concludes that "the movement for visual education will progress in direct ratio to the number of teachers trained in the technique of visual instruction."

The same report notes that too much training focuses on "handling equipment" not on "techniques of instruction."

[***PLEASE now SEE 1997 Presidential Report on Technology]

1927. Payne Fund Studies begin a series of important reports on the impact of movies on social attitudes, values, and behavior in children and youth. They are in fact the first systematic studies of mass media. The studies will ultimately document broad range of effects on children, concluding that, "the motion picture is a **POTENT MEDIUM OF EDUCATION.**"

Chronicles of American Photoplays developed by Yale University to teach 7th grade history.

Researchers concluded:

"The ability of the pupils to grasp and appreciate the relationships was determined in no small degree **BY THE TEACHER'S OWN INTEREST IN THEM AND THE EMPHASIS WHICH SHE ATTACHED TO THEM**... However inherently effective the photoplays may be....it will only attain its highest degree of effectiveness when **ACCOMPANIED BY GOOD TEACHING.**"

Lasswell's classic study *Propaganda Techniques in the World War* defines propaganda:

"The control of opinion by significant symbols...influencing human action by the manipulation of representations...that may be spoken, written, pictorial or musical in form."

1928. Development of talkies meant existing hardware and software was no longer useful.

1929. Creation of the National Advisory Council on Radio in Education.

1937. The Rockefeller Foundation investigates failure of film in the classroom. The report notes that commercial producers, educators and businessmen develop the notion that education, entertainment, and commercialism do not mix well.

Also notes that heads of educational institutions devoted little time, energy, thought to the organization and supervision of visual education.

Establishment of Institution for Propaganda Analysis.

1940s. Film used as major training tool on both the home front and in theater of war. U.S. Gov...used film to shape perceptions and attitudes [Capra's, *Why We Fight* series]; to encourage women to join the workforce and after the war to encourage them to go back home.

Research with Capra's series indicates film can provide information, but single showings have little impact on those with strongly held opinions.

1948. Development of Harold Lasswell's famous communication formula:
WHO
SAYS WHAT
TO WHOM
IN WHICH CHANNEL
WITH WHAT EFFECT?

1949. Development of Shannon & Weaver's *Mathematical Theory of Communication*.
SENDER...MESSAGE TRANSMITTER...NOISE...RECEIVER...[S & R]

Hovland's research of one-sided and two-sided messages demonstrates that audience characteristics are important variables when considering the influence and impact of any media message.

1952. Alabama begins statewide instructional television network.

Successful use of instructional TV in Pittsburgh **DELMARVA** during the period of research concluded that

> "The effectiveness of televised lessons depended to an important degree on the quality of the follow-up by classroom teachers."

1960s. ASPEN INSTITUTE *Learning by Television* concluded that, "television has not transformed education, nor has it significantly improved the learning of most students...it is far from fulfilling its obvious promise."

1966. NBC becomes first 100% color network.

1967. Marshall McLuhan writes *The Medium is the Message*. Coins phrases like "the global village" and "allatonceness." Says the first generation of children raised in TV era is "growing up absurd" and **"CANNOT DISCOVER HOW THE EDUCATIONAL SCHEME RELATES TO HIS MYTHICAL WORLD OF ELECTRONICALLY PROCESSED DATA."**

1970. Alvin Toffler publishes *Future Shock*.

1971. *Communication of Innovations* by Rogers and Shoemaker, documents stages of change and the social context in which change takes place in organizations/institutions. Change is seen as a social **PROCESS.**

IBM develops "floppy" disk.

First distributed E-mail system invented.

1977. *The Definition of Educational Technology*. The key concept, educational technology, was briefly defined by Association for Educational Communication & Technology as

> "A complex, integrated process, involving people, procedures, ideas, devices and organization, for analyzing problems and devising, implementing, evaluating and managing solutions to those problems, involved in all aspects of human learning."

The definition, accepted as official by the AECT Board of Directors, now centered on a problem-solving process, rather than on audiovisual materials.

1980. Alvin Toffler publishes *The Third Wave*.

Seymour Papert publishes *Mind-storms: Children, Computers and Powerful Ideas*.

Challenges the idea of computer-aided instruction in which the computer programs the student. Argues that children should program computers to acquire sense of mastery. His central focus is "not on the machine but on the mind."

1981. Pascale and Athos publish *The Art of Japanese Management*, noting: "man is limited not by his tools but by his vision."

1982. *MEGATRENDS: Ten New Directions Transforming Our Lives*, published by John Naisbitt.

The author describes the shift from industrial to information society, adding that "we are drowning in information and starved for knowledge." In a cautionary aside, he says, "we must learn to balance the material wonders of technology with the spiritual demands of our human nature."

Internet Protocol (IP), in use with TCP, becomes the ARPANET standard. The Internet becomes the name for a set of networks connected using TCP/IP.

1983. *A Nation at Risk* proclaims American education is "a rising tide of mediocrity."

Time magazine selects the computer as Man of the Year.

Oddly enough, in the same year, *Popular Computing* runs a cover story and says:

Rather than slowing down and examining their short & long term goals, school districts are scrambling for the latest technology...the influx of microcomputers in education is engulfing teachers and administrators in confused expectations and unfulfilled promises...**THERE'S NO MASTER PLAN, NO ONE AT THE HELM, JUST INNOVATION FOR IT'S OWN SAKE.**"

Gavriel Salomon describes the "mindful processing" of media texts in terms of A.I.M.E. [Amount of Invested Mental Effort/energy]. Children comprehend more and recall more when teacher provide them with cues and expectations for viewing. Otherwise they engage in "cognitive economy" or "shallow processing."

Apple develops Macintosh.

1985. Writing in *SLMQ*, Considine describes personality profiles and attitudes held about media and technology: advocates, adversaries accomplices. Author argues when it comes to understanding tools in the schools "it's not the hardware or the software but the underwear" that

matters most. This referred to the policies related to how schools first acquired the applied technology.

Microsoft Windows developed.

1986. *Challenger* explodes. Rogers Commission blames organizational culture of NASA and human error, not mechanical/technological failure.

1987. *What Do Our 17-Year-Olds Know?* Published by NEH. Says high school seniors are "ignorant of things that they should know, and that they and generations to follow are at risk of being gravely handicapped by that ignorance upon entry to adulthood, citizenship and parenthood."

Tellingly the report observes, "This generation as well as their younger siblings has been raised on television and movies. It takes more than a textbook and a lecture to awaken their interest."

1989. Ontario Ministry of Education and Canada's Association for Media Literacy cooperate to create Media Literacy Resource Guide.

Channel One introduced to American classrooms.

Exxon Valdese oil disaster in Alaska. Corporate culture implicated in cause.

1991. *Star Wars* creator George Lucas founds George Lucas Educational Foundation to empower educators. See http://www.edutopia.org/.

1992. Publication of *Visual Messages: Integrating Imagery into Instruction* [Considine and Haley]. Center for Media Literacy describes it as first comprehensive media literacy textbook.

Neil Postman writes *Technopoly: The Surrender of Culture to Technology*.
"The milieu in which Technopoly flourishes is one in which the tie between information and human purpose has been severed. That is, information appears indiscriminately, directed at no one in particular, in enormous volume and high speeds, disconnected from meaning, theory and purpose."

****1993.** Hodas writes *Technology Refusal and the Organizational Culture of Schools* arguing that innovative tools are subverted by organizational characteristics that emphasize: **"THE CONSERVATION &**

TRANSMISSION OF PRE-EXISTING, PRE-DEFINED CATEGORIES OF KNOWLEDGE."

...As a 1976 Phi Delta Kappa Report [*The New Secondary Education*] put it, "New Programs into Old Systems Won't Go."

1995. First National Media Literacy Conference held in United States at Appalachian State University and sponsored with the National Telemedia Council and V.I.E.W. (Visual Information Education Workshops). Subsequent conferences follow in L.A., Colorado Springs, St. Paul, Austin, Baltimore, San Francisco, St. Louis and Detroit.

1995. Carnegie Council on Adolescent Development publishes, *Great Transition* noting that the world of the adolescent cannot be understood without understanding media. The report endorses media literacy.

1996. Seymour Papert writes *The Connected Family: Bridging the Digital Generation Gap.*
"When I visit a school, 90 times out of 100 I cringe. What is actually being done there is a sheer travesty of what could be done with technology. The fact is that technology is going out into the world in a state of marginal readiness. It does wonders. It's marvelous. But it's a mess. You'll save yourself a lot of nervous strain **IF YOU RECOGNIZE THIS AT THE OUTSET AND LEARN ENOUGH TO UNDERSTAND WHY."**

1997. Report to the President on the Use of Technology to Strengthen K-12 Education in the United States
"As schools continue to acquire more and better hardware and software, the benefit to students will increasingly depend on the skill with which some 3 million teachers are able to use these new tools...Yet teachers currently receive **LITTLE TECHNICAL, PEDAGOGIC OR ADMINISTRATIVE SUPPORT** for these fundamental changes...most teachers **ARE LARGELY LEFT ON THEIR OWN as they STRUGGLE TO INTEGRATE** technology into their curricula."
Concludes that 30% of technology budgets should be spent on **STAFF DEVELOPMENT.**

1998. Kathleen Tyner writes *Literacy in a Digital World: Teaching & Learning in the Age of Information.*

1999. First master's degree in media literacy in the United States is authorized at Appalachian State University.

2000. Networks call presidential election result too early and get it wrong.

Howe & Strauss publish *Millennials Rising*, noting, "They believe in the future and see themselves as its cutting edge. They show a fascination for and a mastery of new technologies."

David Buckingham writes *After the Death of Childhood: Growing Up in the Age of Electronic Media.*

2001. Office of National Drug Control Policy at the White House publishes *Helping Youth Navigate the Media Age: A New Approach to Drug Prevention* which supports media literacy and describes "best practices."

Marc Prensky coins the term "digital natives and digital immigrants."

Larry Cuban publishes *Oversold and Underused: Computers in the Classroom.* The book notes that despite widespread access to computers and other technology, "There was no clear and substantial evidence of students increasing their academic achievement as a result of using information technologies."

In his book, *A Mind at a Time*, Mel Levine argues that contemporary media "can stunt the growth of key neurodevelopmental functions ...the stress is very much on visual imagery rather than complex language use or interpretation."

2002. *The Digital Disconnect* report from The Pew Internet Project called school Internet-based projects "poor" and "uninspiring".'.. stating that "many schools and teachers have not yet recognized—much less responded to the new ways students communicate and access information."

2003. The Big Difference: The Growing Technology Gap Between Students and Teachers.

This report from Bell South found significant differences between how teachers and students viewed use of technology in school. "The widening gap between the perceptions of what teachers and students believe is or is not happening in the classroom is **A STARTLING RED FLAG....MANY** students may look for learning content outside of the classroom and **MAY NO LONGER SEE SCHOOL AS THEIR ONLY, OR EVEN PRIMARY SOURCE FOR BUILDING KNOWLEDGE."**

James Gee writes *What Video Games Have to Teach Us about Learning & Literacy.*

2004. *The Flickering Mind: Saving Education from The False Promise of Technology*, Todd Oppenheimer challenges the idea that technology is capable of changing organizations as old as schools, noting an **"...inherent conflicts between the culture of school & the culture of technology."**

2005. Generation M in Lives of 8-t-18 Year-Olds report published by Kaiser Family Foundation. [www.kff.org]. They note that young people spend 6.5 hours per day with media, adding that "the potential of media to impact virtually every aspect of young people's lives cannot be ignored."

2006. The Media Family: Electronic Media in the Lives of Infants, Toddlers, Preschoolers and Their Families, report published by Kaiser Family Foundation [www.kff.org].

Space shuttle *Columbia* explodes. Once again poor communication and NASA culture seen as contributing to the tragedy.

Report from EPE [Educational Progress in Education annual survey] finds that only nine states require principals and administrators to have any formal instruction with technology.

Speaking to librarians in Boston, Lee Ranie, director of the Pew Internet & American Life Projects says of young people:
"They are not all tech-savvy. They are often unaware of and indifferent to their use of technology. They are often uncaring about their own privacy...it would be good to MODEL MEDIA LITERACY FOR THEM before someone gets into real trouble."

Renee Hobbs writes *Non-optimal Use of Video* which documents ineffective use of media in the classroom including using media as a reward, as a baby sitter and without preview or purpose.

The Archive of Pediatric & Adolescent Medicine reports the "first quantitative evidence" that media literacy can actively affect change and work as a tool to combat smoking among teenagers.

National Association of Secondary School Principals notes that the growth of Internet technologies have created both **OPPORTUNITIES & CHALLENGES** for schools. "It represents **A SAFETY MINEFIELD** for students and the adults who care for them." They call for a **"BALANCED** approach that recognizes the **BENEFICIAL** aspects of technology as well as its **POTENTIAL DANGERS**."

2007. National School Boards Association publishes **CREATING & CONNECTING** report on the need for social networking applications in education.

> "With words, music, photos and videos, students are expressing themselves by creating, manipulating and sharing content online. Yet the vast majority of school districts have stringent rules against nearly all forms of social networking during the school day...., School districts may want to consider re-examining their policies and practices and explore ways in which they could use social networking for educational purposes."

Former Vice President Al Gore publishes *The Assault on Reason*. The book argues that "our democracy is in danger of being hollowed-out" by a "new generation of media Machiavellis."

Andrew Keen publishes, *The Cult of the Amateur: How Today's Internet Is Killing Our Culture*. He argues that the line has blurred between author and audience, fact and fiction, with the result that we are seeing "a decline of the quality and reliability of the information we receive....corrupting our national civic conversation."

Educational Technology in Teacher Education Programs for Licensure, National Center for Educational Statistics. The study concludes that while colleges of education have increased technology courses and competencies in undergraduate teacher preparation, when young teachers are hired they often find competing priorities that discourage using these skills.

David Buckingham writes *Beyond Technology: Children's Learning in the Age of Digital Culture*. In his chapter, "Waiting for the Revolution" he states that teachers use technology to **ENHANCE** rather than to **TRANSFORM** teaching & learning activities. He also notes that the broadly **CONSTRUCTIVIST** approach advocated by many technology supporters is "**AT ODDS** with other aspects of educational policy ...characterized by a move **BACK TO BASICS**...and **OLDER** teaching methods."

Jennifer Stone's *Popular Websites in Adolescents' Out-of-School Lives: Critical Lessons on Literacy*, describes a disconnect between the reading performance of young people in school and online. She notes that many students categorized as low performers in school actively engage with more complex texts online.

2008. A U.K. report for the British Library concludes that "the information literacy of young people **HAS NOT IMPROVED** with widening access to technology."

Pew Internet & American Life Project publishes *Writing, Technology & Teens*, which explores the relationship between informal e-communication and writing and the formal writing required in school. "Most teenagers spend a considerable amount of their life **COMPOSING TEXTS**, but they do **NOT THINK** that a lot of the material they create electronically is REAL writing."

The Atlantic features an article that asks, *"IS GOOGLE MAKING US STUPID?"*

Publication of Bauerlein's, *The Dumbest Generation: How the Digital Age Stupefies Young Americans and Jeopardizes Our Future*.

2009. S. Craig Watkins writes *The Young & The Digital*. "Have we created a culture in which the ability to pay attention to a single thing for a sustained period of time is simply no longer possible in an age of constant stimulation, communication and gratification? Anyone managing a classroom today can **NO LONGER IGNORE THE REALITY OF CONTINUOUS PARTIAL ATTENTION** and personal media."

Trilling and Fadel publish *21st Century Skills: Learning for Life in Our Times*. In their chapter, "Retooling Schooling" they identify the elements that must work together [vision, coordination, official policy, leadership, learning technology and teacher learning]. They warn that "changes in one support system…uncoordinated changes…may generate enthusiasm for a while, but without the support necessary from the other systems, to sustain the change, they almost always become short-lived experiments."

Clearly just adding more equipment to schools and classrooms is not going to transform the culture and climate of schools or lead to 21st century teaching & learning.

2010. BP creates worst oil spill in U.S. history.

Minnesota's Gibbon-Fairfax-Winthrop School Board decides to replace textbooks with the Apple iPad.

Kaiser Family Foundation publishes *Generation M: Media in Lives of 8-to18-Year-Olds*. This report updates the earlier studies and notes a dramatic increase in daily exposure to media. Because of multitasking the total amount of daily media content consumed is reported to be 10.45 hours. While the study did not establish a cause and effect relationship, it did note that the heaviest media users report getting lower grades.

Author's Note:
This timeline has been created for your use by David Considine consideinedm@appstate.edu. It was created for use in his media/technology class and is by no means comprehensive. It reflects broad concerns about media/technology and the institutional context in which those tools are acquired & applied. Readers are welcome to modify the timeline to reflect their own focus and priorities.

APPENDIX F The ISTE National Educational Technology Standards

Standards and Performance Indicators for Teachers (NETS•T)

Effective teachers model and apply the National Educational Technology Standards for Students (NETS•S) as they design, implement, and assess learning experiences to engage students and improve learning; enrich professional practice; and provide positive models for students, colleagues, and the community. All teachers should meet the following standards and performance indicators. Teachers should

1. Facilitate and Inspire Student Learning and Creativity

Teachers use their knowledge of subject matter, teaching and learning, and technology to facilitate experiences that advance student learning, creativity, and innovation in both face-to-face and virtual environments. Teachers:

a. promote, support, and model creative and innovative thinking and inventiveness;

b. engage students in exploring real-world issues and solving authentic problems using digital tools and resources;

c. promote student reflection using collaborative tools to reveal and clarify students' conceptual understanding and thinking, planning, and creative processes; and

d. model collaborative knowledge construction by engaging in learning with students, colleagues, and others in face-to-face and virtual environments.

2. Design and Develop Digital-Age Learning Experiences and Assessments

Teachers design, develop, and evaluate authentic learning experiences and assessments incorporating contemporary tools and resources to maximize content learning in context and to develop the knowledge, skills, and attitudes identified in the NETS•S. Teachers:

a. design or adapt relevant learning experiences that incorporate digital tools and resources to promote student learning and creativity;

b. develop technology-enriched learning environments that enable all students to pursue their individual curiosities and become ac-

tive participants in setting their own educational goals, managing their own learning, and assessing their own progress;

c. customize and personalize learning activities to address students' diverse learning styles, working strategies, and abilities using digital tools and resources; and

d. provide students with multiple and varied formative and summative assessments aligned with content and technology standards and use resulting data to inform learning and teaching.

3. Model Digital-Age Work and Learning

Teachers exhibit knowledge, skills, and work processes representative of an innovative professional in a global and digital society. Teachers:

a. demonstrate fluency in technology systems and the transfer of current knowledge to new technologies and situations;

b. collaborate with students, peers, parents, and community members using digital tools and resources to support student success and innovation;

c. communicate relevant information and ideas effectively to students, parents, and peers using a variety of digital-age media and formats; and

d. model and facilitate effective use of current and emerging digital tools to locate, analyze, evaluate, and use information resources to support research and learning.

4. Promote and Model Digital Citizenship and Responsibility

Teachers understand local and global societal issues and responsibilities in an evolving digital culture and exhibit legal and ethical behavior in their professional practices. Teachers:

a. advocate, model, and teach safe, legal, and ethical use of digital information and technology, including respect for copyright, intellectual property, and the appropriate documentation of sources;

b. address the diverse needs of all learners by using learner-centered strategies and providing equitable access to appropriate digital tools and resources;

c. promote and model digital etiquette and responsible social interactions related to the use of technology and information; and

d. develop and model cultural understanding and global awareness by engaging with colleagues and students of other cultures using digital-age communication and collaboration tools.

5. Engage in Professional Growth and Leadership

Teachers continuously improve their professional practice, model life-long learning, and exhibit leadership in their school and professional community by promoting and demonstrating the effective use of digital tools and resources. Teachers:

a. participate in local and global learning communities to explore creative applications of technology to improve student learning;

b. exhibit leadership by demonstrating a vision of technology infusion, participating in shared decision making and community building, and developing the leadership and technology skills of others;

c. evaluate and reflect on current research and professional practice on a regular basis to make effective use of existing and emerging digital tools and resources in support of student learning; and

d. contribute to the effectiveness, vitality, and self-renewal of the teaching profession and of their school and community.

Standards and Performance Indicators for Students (NETS•S)

1. Creativity and Innovation

Students demonstrate creative thinking, construct knowledge, and develop innovative products and processes using technology. Students:

a. apply existing knowledge to generate new ideas, products, or processes;

b. create original works as a means of personal or group expression;

c. use models and simulations to explore complex systems and issues; and

d. identify trends and forecast possibilities.

2. Communication and Collaboration

Students use digital media and environments to communicate and work collaboratively, including at a distance, to support individual learning and contribute to the learning of others. Students:

a. interact, collaborate, and publish with peers, experts, or others employing a variety of digital environments and media;

b. communicate information and ideas effectively to multiple audiences using a variety of media and formats;

 c. develop cultural understanding and global awareness by engaging with learners of other cultures; and

 d. contribute to project teams to produce original works or solve problems.

3. Research and Information Fluency

Students apply digital tools to gather, evaluate, and use information. Students:

 a. plan strategies to guide inquiry;

 b. locate, organize, analyze, evaluate, synthesize, and ethically use information from a variety of sources and media;

 c. evaluate and select information sources and digital tools based on the appropriateness to specific tasks; and

 d. process data and report results.

4. Critical Thinking, Problem Solving, and Decision Making

Students use critical thinking skills to plan and conduct research, manage projects, solve problems, and make informed decisions using appropriate digital tools and resources. Students:

 a. identify and define authentic problems and significant questions for investigation;

 b. plan and manage activities to develop a solution or complete a project;

 c. collect and analyze data to identify solutions and/or make informed decisions; and

 d. use multiple processes and diverse perspectives to explore alternative solutions.

5. Digital Citizenship

Students understand human, cultural, and societal issues related to technology and practice legal and ethical behavior. Students:

 a. advocate and practice safe, legal, and responsible use of information and technology;

 b. exhibit a positive attitude toward using technology that supports collaboration, learning, and productivity;

 c. demonstrate personal responsibility for lifelong learning; and

 d. exhibit leadership for digital citizenship.

6. Technology Operations and Concepts

Students demonstrate a sound understanding of technology concepts, systems, and operations. Students:

a. understand and use technology systems;
b. select and use applications effectively and productively;
c. troubleshoot systems and applications; and
d. transfer current knowledge to learning of new technologies.

APPENDIX G National Education Technology Plan 2010

Transforming American Education: Learning Powered by Technology

U.S. Department of Education, Office of Educational Technology

Goals and Recommendations

To transform education in America, we must turn ideas into action. The NETP presents five goals that address the key components of this plan—learning, assessment, teaching, infrastructure, and productivity—along with recommendations for states, districts, the federal government, and other stakeholders in our education system for achieving these goals.

1.0 Learning: Engage and Empower

All learners will have engaging and empowering learning experiences both in and out of school that prepare them to be active, creative, knowledgeable, and ethical participants in our globally networked society.

To meet this goal, we recommend the following:

1.1 States should continue to revise, create, and implement standards and learning objectives using technology for all content areas that reflect 21st-century expertise and the power of technology to improve learning.

Our education system relies on core sets of standards-based concepts and competencies that form the basis of what all students should know and should be able to do. Whether the domain is English language arts, mathematics, sciences, social studies, history, art, or music, states should continue to consider the integration of 21st-century competencies and expertise, such as critical thinking, complex problem solving, collaboration, multimedia communication, and technological competencies demonstrated by professionals in various disciplines.

1.2 States, districts, and others should develop and implement learning resources that use technology to embody design principles from the learning sciences.

Advances in learning sciences, including cognitive science, neuroscience, education, and social sciences, give us greater understanding of three connected types of human learning—factual knowledge, procedural knowledge, and motivational engagement.

Technology has increased our ability to both study and enhance all three types. Today's learning environments should reflect what we have learned about how people learn and take advantage of technology to optimize learning.

1.3 States, districts, and others should develop and implement learning resources that exploit the flexibility and power of technology to reach all learners anytime and anywhere.

The always-on nature of the Internet and mobile access devices provides our education system with the opportunity to create learning experiences that are available anytime and anywhere. When combined with design principles for personalized learning and Universal Design for Learning, these experiences also can be accessed by learners who have been marginalized in many educational settings: students from low-income communities and minorities, English language learners, students with disabilities, students who are gifted and talented, students from diverse cultures and linguistic backgrounds, and students in rural areas.

1.4 Use advances in learning sciences and technology to enhance STEM (science, technology, engineering, and mathematics) learning and develop, adopt, and evaluate new methodologies with the potential to inspire and enable all learners to excel in STEM.

New technologies for representing, manipulating, and communicating data, information, and ideas have changed professional practices in STEM fields and what students need to learn to be prepared for STEM professions. Technology should be used to support student interaction with STEM content in ways that promote deeper understanding of complex ideas, engage students in solving complex problems, and create new opportunities for STEM learning throughout our education system.

2.0 Assessment: Measure What Matters

Our education system at all levels will leverage the power of technology to measure what matters and use assessment data for continuous improvement.

To meet this goal, we recommend the following actions:

2.1 States, districts, and others should design, develop, and implement assessments that
- give students, educators, and other stakeholders timely and actionable feedback about
- student learning to improve achievement and instructional practices.

Learning science and technology combined with assessment theory can provide a foundation for new and better ways to assess students in the course of learning, which is the ideal time to improve performance. This will require involving experts from all three disciplines in the process of designing, developing, and using new technology-based assessments that can increase the quality and quantity of feedback to learners.

2.2 Build the capacity of educators, education institutions, and developers to use technology to improve assessment materials and processes for both formative and summative uses.

Technology can support measuring performances that cannot be assessed with conventional testing formats, providing our education system with opportunities to design, develop, and validate new and more effective assessment materials. Building this capacity can be accelerated through knowledge exchange, collaboration, and better alignment between educators (practitioners) and experts.

2.3 Conduct research and development that explores how embedded assessment technologies, such as simulations, collaboration environments, virtual worlds, games, and cognitive tutors, can be used to engage and motivate learners while assessing complex skills.

Interactive technologies, especially games, provide immediate performance feedback so that players always know how they are doing. As a result, they are highly engaging to students and have the potential to motivate students to learn. They also enable educators to assess important competencies and aspects of thinking in contexts and through activities that students care about in everyday life. Because interactive technologies hold this promise, assessment and interactive technology experts should collaborate on research to determine ways to use them effectively for assessment.

2.4 Conduct research and development that explores how Universal Design for Learning can enable the best accommodations for all students to ensure we are assessing what we intend to measure

rather than extraneous abilities a student needs to respond to the assessment task.

To be valid, an assessment must measure those qualities it is intended to measure and scores should not be influenced by extraneous factors. An assessment of science, for example, should measure understanding of science concepts and their application, not the ability to see print, to respond to items using a mouse, or to use word processing skills.

Assessment and technology experts should collaborate to create assessment design tools and processes that make it possible to develop assessment systems with appropriate features (not just accommodations) so that assessments capture examinees' strengths in terms of the qualities that the assessment is intended to measure.

2.5 Revise practices, policies, and regulations to ensure privacy and information protection while enabling a model of assessment that includes ongoing gathering and sharing of data on student learning for continuous improvement.

Every parent of a student under 18 and every student 18 or over should have the right to access the student's own assessment data in the form of an electronic learning record that the student can take with them throughout his or her educational career. At the same time, appropriate safeguards, including stripping records of identifiable information and aggregating data across students, classrooms, and schools, should be used to make it possible to supply education data derived from student records to other legitimate users without compromising student privacy.

3.0 Teaching: Prepare and Connect

Professional educators will be supported individually and in teams by technology that connects them to data, content, resources, expertise, and learning experiences that enable and inspire more effective teaching for all learners.

To meet this goal, we recommend the following actions:

3.1 Expand opportunities for educators to have access to technology-based content, resources, and tools where and when they need them.

Today's technology enables educators to tap into resources and orchestrate expertise across a school district or university, a state, the

nation, and even around the world. Educators can discuss solutions to problems and exchange information about best practices in minutes, not weeks or months. Today's educators should have access to technology-based resources that inspire them to provide more engaging and effective learning opportunities for each and every student.

3.2 Leverage social networking technologies and platforms to create communities of practice that provide career-long personal learning opportunities for educators within and across schools, preservice preparation and in-service education institutions, and professional organizations.

Social networks can be used to provide educators with career-long personal learning tools and resources that make professional learning timely and relevant as well as an ongoing activity that continually improves practice and evolves their skills over time. Online communities should enable educators to take online courses, tap into experts and best practices for just-in-time problem solving, and provide platforms and tools for educators to design and develop resources with and for their colleagues.

3.3 Use technology to provide all learners with online access to effective teaching and better learning opportunities and options especially in places where they are not otherwise available.

Many education institutions, particularly those serving the most vulnerable students and those in rural areas, lack educators with competencies in reaching students with special needs and educators with content knowledge and expertise in specialized areas, including STEM. Even in areas where effective teaching is available, students often lack options for high-quality courses in particular disciplines or opportunities for learning that prepare them for the modern world. Online learning options should be provided to enable leveraging the best teaching and make high-quality course options available to all learners.

3.4 Provide preservice and in-service educators with professional learning experiences powered by technology to increase their digital literacy and enable them to create compelling assignments for students that improve learning, assessment, and instructional practices.

Just as technology helps us engage and motivate students to learn, technology should be used in the preparation and ongoing learning of educators to engage and motivate them in what and how they teach.

This will require synthesizing core principles and adopting best practices for the use of technology in preparing educators. Technology also should be an integral component of teaching methods courses and field experiences rather than treated as a discrete skill distinct from pedagogical application.

3.5 Develop a teaching force skilled in online instruction.

As online learning becomes an increasingly important part of our education system, we need to provide online and blended learning experiences that are more participatory and personalized and that embody best practices for engaging all students. This creates both the need and opportunity for educators who are skilled in instructional design and knowledgeable about emerging technologies. Crucial to filling this need while ensuring effective teaching are appropriate standards for online courses and teaching and a new way of approaching online teacher certification.

4.0 Infrastructure: Access and Enable

All students and educators will have access to a comprehensive infrastructure for learning when and where they need it.

To meet this goal, we recommend the following actions:

4.1 Ensure students and educators have broadband access to the Internet and adequate wireless connectivity both in and out of school.

Students and educators need adequate broadband bandwidth for accessing the Internet and technology-based learning resources. "Adequate" should be defined as the ability to use the Internet in school, on the surrounding campus, throughout the community, and at home. It should also include simultaneous use of high-bandwidth resources, such as multimedia, communication and collaboration environments, and communities. Crucial to providing such access are the broadband initiatives being individually and jointly managed by various federal agencies.

4.2 Ensure that every student and educator has at least one Internet access device and appropriate software and resources for research, communication, multimedia content creation, and collaboration for use in and out of school.

Only with 24/7 access to the Internet via devices and technology-based software and resources can we achieve the kind of engagement,

student-centered learning, and assessments that can improve learning in the ways this plan proposes. The form of these devices, software, and resources may or may not be standardized and will evolve over time. In addition, these devices may be owned by the student or family, owned by the school, or some combination of the two. The use of devices owned by students will require advances in network filtering and improved support systems.

4.3 Support the development and use of open educational resources to promote innovative and creative opportunities for all learners and accelerate the development and adoption of new open technology-based learning tools and courses.

The value of open educational resources is now recognized around the world, leading to the availability of a vast array of learning, teaching, and research resources that learners of any age can use across all content areas. Realizing this value will require new policies concerning the evaluation and selection of instructional materials so that digital resources are considered and processes are established for keeping educational resource content up to date, appropriate, and tagged according to identified content interoperability standards.

4.4 Build state and local education agency capacity for evolving an infrastructure for learning.

Building an infrastructure for learning is a far-reaching project that will demand concerted and coordinated effort. The effort should start with implementing the next generation of computing system architectures and include transitioning computer systems, software, and services from in-house datacenters to professionally managed data centers in the cloud for greater efficiency and flexibility. This will require leveraging and scaling up the human talent to build such an infrastructure, which should ultimately save money and enable education IT professionals to focus more on maintaining the local infrastructure and supporting teachers, students, and administrators.

4.5 Develop and use interoperability standards for content and student-learning data to enable collecting and sharing resources and collecting, sharing, and analyzing data to improve decision making at all levels of our education system.

Fragmented content and resources and student-learning data siloed in different proprietary platforms and systems, along with a lack of common standards for collecting and sharing data, are formidable barriers to leveraging resources for teaching and learning. These bar-

riers exist because we lack common content interoperability standards and tools to enable use of such standards. The lack of common standards affects the quality of tools because developers limit their R&D investments into narrow markets and are not able to leverage overall market advancements in research and development. Interoperability standards are essential to resolving these issues.

4.6 Develop and use interoperability standards for financial data to enable data-driven decision making, productivity advances, and continuous improvement at all levels of our education system.

Just as content, resources, and student learning data are fragmented in disconnected technology systems and throughout our education system, the same is true for financial data. Therefore, we also need financial data interoperability standards and tools that enable the use of these standards.

5.0 Productivity: Redesign and Transform

Our education system at all levels will redesign processes and structures to take advantage of the power of technology to improve learning outcomes while making more efficient use of time, money, and staff.

To meet this goal, we recommend the following actions:

5.1 Develop and adopt a common definition of productivity in education and more relevant and meaningful measures of outcomes, along with improved policies and technologies for managing costs, including those for procurement.

Education has not incorporated many of the practices other sectors regularly use to measure outcomes, manage costs, and improve productivity, a number of which are enabled or enhanced by technology. As other sectors have learned, we are unlikely to improve outcomes and productivity until we define and start measuring them. This starts with identifying what we seek to measure. It also requires identifying costs associated with components of our education system and with individual resources and activities so that the ratio of outcomes to costs can be tracked over time.

5.2 Rethink basic assumptions in our education system that inhibit leveraging technology to improve learning, starting with our current practice of organizing student and educator learning around seat time instead of the demonstration of competencies.

To realize the full potential of technology for improving performance and increasing productivity, we must remove the process and structural barriers to broad adoption. The education system must work to identify and rethink basic assumptions of the education system. Some of these include measurement of educational attainment through seat time, organization of students into age-determined groups, the structure of separate academic disciplines, the organization of learning into classes of roughly equal size, and the use of time blocks.

5.3 Develop useful metrics for the educational use of technology in states and districts.

Current data on the use of educational and information technology in our system consist of records of purchases and numbers of computers and Internet connections. Very little information on how technology is actually used to support teaching, learning, and assessment is collected and communicated systematically. Only by shifting our focus to collecting data on how and when technology is used will we be able to determine the difference it makes and use that knowledge to improve outcomes and the productivity of our education system.

5.4 Design, implement, and evaluate technology-powered programs and interventions to ensure that students progress seamlessly through our P–16 education system and emerge prepared for college and careers.

The United States has a long way to go if we are to see every student complete at least a year of higher education or postsecondary career training. Achieving this target will require dramatically reducing the number of students who leave high school without getting a diploma and/or who are unprepared for postsecondary education. A complex set of personal and academic factors underlie students' decisions to leave school or to disengage from learning, and no one strategy will prevent every separation from the education system. Collaboration between P–12 and higher education institutions and practices supported with technology are crucial to addressing the problem.

U.S. Department of Education, Office of Educational Technology, Transforming American Education: Learning Powered by Technology, Washington, D.C., 2010.

Bibliography

Alexander, B. (2010). "The horizon report." *New Media Consortium* and *Educause Learning Initiative*.

Alvermann, D. (October 25, 2001). "Effective literacy instruction for adolescents." Paper presented at the *National Reading Conference*.

Alvermann, D. E. (Ed.). (2002). *Adolescents and literacies in a digital world*. New York: Peter Lang.

Alvermann, D. E., & Hagood, M. C. (2000a). "Fandom and critical media literacy." *Journal of Adolescent & Adult Literacy*, 43(5), 436–446.

Alvermann, D. E., & Hagood, M. C. (2000b). Critical media literacy: Research, theory, and practice in 'new times.'" *Journal of Educational Research*, 93(3), 193–205.

Alvermann, D. E., Moon, J. S., & Hagood, M. C. (1999). *Popular culture in the classroom: Teaching and researching critical media literacy*. Newark: DE: International Reading Association.

Anderson, S. W. (October 9, 2009). "Why Wordle?" *Tech & Learning*. Retrieved: http://www.techlearning.com/article/24518.

Anderson, L. W., & Krathwohl, D. (2001*). A taxonomy for learning, teaching and assessing: A revision of Bloom's Taxonomy of educational objectives*. Longman, New York.

Anderson, L. W., & Sosniak, L. A. (Eds.). (1994). "Bloom's taxonomy: a forty-year retrospective." *Ninety-third yearbook of the National Society for the Study of Education*, Pt.2. Chicago, Illinois: University of Chicago Press.

Animoto. (2010). "Animoto for education." Retrieved: http://animoto. com/education.

Associated Press. (June 11, 2010). "PTA teams up with facebook to promote online safety for kids, parents." *Yahoo News*. Retrieved: http://news.yahoo.com/s/ap/20100610/ap_on_hi_te/us_tec_facebook_pta.

Baird, S. (September 18, 1998). "If schools want to teach values, they have to talk media." *National Catholic Reporter,* 10–15.

Baumbach, D. (March/April 2009). "Web 2.0 and you." *Knowledge Quest,* 37(4), 12–19.

Bazalgette, C. (1997). "Beyond the province of enthusiast: Re-establishing media education." *Metro Education*, 35(10), 17-21.

Bertolucci, J. (April 28, 2010). "Oregon schools using Google Apps., Microsoft should worry." *PC World*. Retrieved: http://www. networkworld.com/news/2010/042810-oregon-schools-using-google-apps.html?source=nww_rss

Bloom, B., Englehart, M., Furst, E., Hill, W., & Krathwohl, D. (1956). *Taxonomy of educational objectives: The classification of educational goals. Handbook 1: Cognitive Domain*. New York, Toronto: Longmans, Green.

Bosco, J. (May 2009). "Leadership for Web 2.0 in education: Promise and reality." *Consortium for School Networking.* Retrieved: http://www.cosn.org/Portals/7/docs/Web%202.0/ExecSummaryCoSN%20Report042809Final.pdf.

Boss, Suzie. (September 2009). "Ten top tips for teaching with new media." *Edutopia.* Retrieved: http://www.edutopia.org/ten-top-tips.

boyd. d. (2008) "Why youth love social network sites: The role of networked publics in teenage social life." In *Youth, Identity, and Digital Media.* The John D. and Catherine T. MacArthur Foundation Series on Digital Media and Learning. Cambridge, MA: The MIT Press, 119–142.

boyd, d. ((May 24, 2010). "Facebook and 'radical transparency.'" *danah boyd. Apophenia.* Retrieved: http://www.zephoria.org/thoughts/archives/2010/05/14/facebook-and-radical-transparency-a-rant.html

Brown, J. S., & Adler, R. P. (January/February 2008). "Minds on Fire." *Educause Review.* Retrieved: http://net.educause.edu/ir/library/pdf/ERM0811.pdf.

Buckingham, D. (1998). English and media studies: Making the difference. *English Quarterly*, 25(2–3), 8–13.

Buckingham, D. (2003). *Media education literacy, learning and contemporary culture.* Malden, MA: Blackwell.

Buckingham, D. (2007). *Beyond technology: Children's learning in the age of digital culture.* Cambridge: Polity.

Byron, T. (March 27, 2008). "Safer children in a digital world." *The Report of the Byron Review.* Nottingham, England. Retrieved: http://www.dcsf.gov.uk/byronreview.

Byron, T. (January 2010). "Do we have safer children in a digital world? A review of progress since the 2008 Byron Review." *The Byron Review.*

Cervetti, G., Pardales, M. J., & Damico, J. S. (April 2001). "A tale of differences: Comparing the traditions, perspectives, and educational goals of critical reading and critical literacy." *Reading Online*, 4(9). Retrieved: http://www.readingonline.org/articles/art_index.asp?HREF=/articles/cervetti/index.html.

Churches, A. (April 1, 2008). "Bloom's taxonomy blooms digitally." *TechLearning.* Retrieved: http://www.techlearning.com/article/ 8670.

Collier, A. (February 27, 2009). "*Social* media literacy: The new Internet safety." *NetFamilyNews.org.* Retrieved: http://netfamilynews.blogspot.com/2009_02_22_archive.html.

Comber, B. (April 2001). "Negotiating critical literacies." *School Talk*, 6(3), 1–2.

Considine, D. (1997). "Media literacy a compelling component of school reform." *Media Literacy in an Information Age.* New Brunswick, NJ: Transaction, 150–157.

Considine, D. (Spring 2002a). National developments and international origins—Media Literacy. *Journal of Popular Film and Television,* 7–15.

Considine, D. (October 2002b). "Putting the ME in media literacy." *Middle Ground: The Magazine of Middle Level Education,* 6, 15–21.

Considine, D., Horton, J., & Moorman, G. (March 2009). "Teaching and reading the millennial generation through media literacy." *Journal of Adolescent & Adult Literacy.* 52(6), 471–481.

Cook, G. (September 2007). "Study: Social networking can work for K-12 educators." *American School Board Journal,* 6–7.

Crary, D. (May 25, 2010). "Cartoon network plans major anti-bullying campaign." *Associated Press.* Retrieved: http://www.google.com/ hostednews/ap/article/ALeqM5iiJ_Y1JcborFhfKLO8KBDh0RKGNgD9F U1TOG0

Daly, J. (September 2004). "Life on the screen: Visual literacy in education." *Edutopia.* Retrieved: http://www.edutopia.org/life-screen.

Darling-Hammond, L. (2010*). The flat world and education.* New York: Teachers College Press.

De Abreu, B. (November, 2007). "21st century literacy." *Cable in the Classroom,* 10–11.

De Abreu, B. (2009). "Web 2.0 and the socialization of learning working together." *The Journal of Media Literacy,* 56(1&2), 30–32.

Del Vecchio, G. (2002). *Creating ever-cool: A marketer's guide to a kid's heart.* Gretna, LA: Pelican Publishing Company.

Department of Education Australian Curriculum. (November 2009). "Critical literacy." Retrieved: http://www.education.tas.gov.au/ curriculum/standards/english/english/teachers/critlit.

DeVoogd, G. L. & McLaughlin, M. (2005). *Critical literacy: Enhancing students' comprehension of text.* New York: Scholastic Publisher.

Diigo. (2010). "Annotate, archive, organize." Retrieved: http://www. diigo.com/learn_more.

Dretzin, R. & Rushkoff, D. (2010). "*Frontline*: Digital Nation transcript." *PBS.* Retrieved: http://www.pbs.org/wgbh/pages/frontline/ digitalnation/etc/script.html.

Duncan, B. (1997). *Mass media and popular culture.* Toronto, Canada: Harcourt.

Dyck, Brenda. (February 27, 2009). "Hooked on Glogster: Poster 2.0." *Education World.* Retrieved: http://www.educationworld.com/a_ tech/columnists/dyck/dyck037.shtml.

Dyson, A. H. (November 2003). "Popular literacies and the 'All' Children: Rethinking literacy development for contemporary childhoods."

Language Arts, 81(2), 100-109.

Eberhardt, D. M. (September–October 2007). "Facing up to Facebook." *About Campus*, 12(4), 18–26.

Educause. (March 2008). "7 Things you should know about Google Apps." *Educause Learning Initiative*. Retrieved: http://net.educause.edu/ir/library/pdf/ELI7035.pdf.

Ellsworth, E. (1997). *Teaching positions: Difference, pedagogy, and the power of address*. New York: Teachers College Press.

Engdahl, S. (2007). *Online social networking (Current controversies)*. New York: Greenhaven.

Facione, P. (1998). "Critical thinking: What it is and why it counts" *California Academic Press*. (n.p.). Retrieved: http://step.ufl.edu/explanation.pdf

Ferenstein, G. (March 1, 2010). "How Twitter in the classroom is boosting student engagement." *Mashable: The Social Media Guide*. Retrieved: http://mashable.com/2010/03/01/twitter-classroom/.

Ferguson, H. (June/July 2010). "Join the flock!" *Learning & Leading with Technology*, 37(8), 12–17.

Fletcher, D. (May 31, 2010). "Facebook: Friends without borders." *Time*, 175(21), 32–38.

Flip Video. (2010). "Flip for education." Retrieved: http://www.theflip.com/en–us/buy/Educators.aspx.

Flores-Koulish, S. (2005). *Teacher education for critical consumption of mass media and popular culture*. New York: Routledge Falmer.

Fodeman, D. & Monroe, M. (June 2009). "The impact of Facebook on our students." *Teacher Librarian*, 36(5), 36–40.

Foehr, U. G. (December 2006). "Media Multitasking Among American Youth: Prevalence, Predictors and Pairings." *Kaiser Family Foundation*. Available: http://www.kff.org/entmedia/upload/7592.pdf.

Freire, P.(1970). *Pedagogy of the oppressed*. (pp. 35–43). New York: Continuum.

Freire, P. & D. Macedo. (1987) *Literacy: Reading the word and the world*. South Hadley, MA: Bergin and Garvey.

Gainer, J. (February 2010). "Critical media literacy in middle school: Exploring the politics of representation." *Journal of Adolescent and Adult Literacy*, 53(5), 364–373.

Gerbner, G., Gross, L., Morgan, M., & Signorielli, N. (1994). "Growing up with television: The cultivation perspective." In J. Bryant & D. Zillmann (Eds.) *Media effects: Advances in theory and research*. Hillsdale, NJ: Lawrence Erlbaum, 17- 42.

Goodstein, A. (2007). *Totally wired: What teens and tweens are really doing online*. New York: St. Martin's Griffin.

Grace, D. J. & Tobin, J. (1998). "Butt jokes and mean-teacher parodies: Video production in the elementary classroom." *Teaching popular culture beyond radical pedagogy.* New York: Holt Publishers, 42-62.

Gray, L. (2010). "The official social network of the global education conference." *The Global Education Collaborative.* Retrieved: http://global education.ning.com/.

Greaves, T. (February 2007). The ubiquitous-technology dream: Fully personalizing the education experience. *Edutopia.* [Online]. Retrieved: http://www.edutopia.org/print/3199.

Greenhow, C. (March/April 2010). "A new concept of citizenship for the digital age." *Learning and Leading with Technology,* 37(6), 24–25.

Halpern, D. F. (1996). *Thought and knowledge: An introduction to critical thinking.* Mahwah, NJ: Lawrence Erlbaum.

Hamm, M., & Adams, D. (1992). *The Collaborative Dimensions of Learning.* Norwood, NJ: Ablex.

Hancock, M., Randall, R., & Simpson, A. (Summer 2009). "From safety to literacy: Digital citizenship in the 21st century." *Threshold,* 4–7.

Hargadon, S. (October 2007). "A little help from my friends: Classroom 2.0 educators share their experiences." *School Library Journal,* 53(10), 44–48.

Hargadon, S. (March 4, 2008). "Web 2.0 is the future of education." *TechLearning.* Retrieved: http://www.stevehargadon.com/2008/03/web-20-is-future-of-education.html.

Helft, M., & Wortham, J. (May 26, 2010). "Facebook bows to pressure over privacy." *New York Times.* Retrieved: http://www.nytimes.com/2010/05/27/technology/27facebook.html?pagewanted=1.

Hobbs, R. (1996). "Expanding the concept of literacy." In R. Kubey (Ed.), *Media literacy in the Information Age.* (pp. 163–186). New York: Transaction Press.

Hobbs, R. (1998). "The seven great debates in the media literacy movement." *Journal of Communication,* 48(1), 16–32.

Hobbs, R. (2003). "Understanding teachers' experiences with media literacy in the classroom." *Visions/Revisions: Moving Forward with Media Education.* Madison, WI: National Telemedia Council.

Hoffman, J. (December 31, 2009). "Justin Bieber is living the dream." *New York Times.* Retrieved: http://www.nytimes.com/2010/01/03/fashion/03bieber.html.

Holson, L. M. (March 9, 2008). "Text generation gap: U R 2 Old (JK). *New York Times.* Retrieved: http://www.nytimes.com/2008/03/09/business/09cell.html.

International Reading Association & National Council of Teachers for English (1996). "Standards for the English language arts." Retrieved: http://www.ncte.org/library/NCTEFiles/Resources/Books/Sample/StandardsDoc.pdf.

Irwin, J. (2006). *Teaching reading comprehension processes*, 3rd Edition. New York: Allyn & Bacon/Merrill Education.

Ito, M., Horst, H., Bitttani, M., boyd, d., Herr-Stephensons, B., Lange, P., Pascoe, C.J., & Robinson, L. (November 2008). *Living and learning with new media: Summary of findings from the digital youth project.* The John D. and Catherine T. MacArthur Foundation. Retrieved: http://www.macfound.org/atf/cf/%7BB0386CE3-8B29-4162-8098-E466FB85 6794%7D/DML_ETHNOG_2PGR.PDF.

James, S. D. (January 26, 2010). "Immigrant teen taunted by cyberbullies hangs herself." *ABC News Health.* Retrieved: http://abcnews. go.com/Health/cyber-bullying-factor-suicide-massachusetts-teen-irish-immigrant/story?id=9660938

Jenkins, H. (July 2006). "Should Congress require schools and public libraries to block social-networking websites?" *MIT News Office.* Retrieved: http://www.cqresearcher.com.

Jenkins, H. (Winter 2007). "What Wikipedia can teach us about the new media literacies." *The Journal of Media Literacy*, 54(2&3), 11–28.

Jenkins, H. (October 2009). *Confronting the challenges of participatory culture: Media education for the 21st century.* Cambridge, MA: The MIT Press.

Johnson, L., Smith, R., Levine, A., & Haywood, K., (2010). The 2010 Horizon Report: K-12 Edition. Austin, Texas: The New Media Consortium. Retrieved: http://www.nmc.org/pdf/2010-Horizon-Report-K12.pdf.

Jolls, T. & Thoman, E., (2005). *Literacy for the 21st century: An overview & orientation guide to media literacy education.* Los Angeles, CA: *Center for Media Literacy.*

Kane, S. (2003*). Literacy learning in the content areas.* Scottsdale, AZ: Holcomb Hathaway.

Kelsey, C. M. (2007). *Generation MySpace: Helping your teen survive online adolescence.* New York: Da Capo.

Kist, W. (2002). "Beginning to create the new literacy classroom: What does the new literacy look like?" *Journal of Adolescent & Adult Literacy*, 45, 368-377.

Kist, W. (2005). New literacies in action: Teaching and learning in multiple media. New York: Teachers College.

Klein, A. (2003). *Stealing time: Steve Case, Jerry Levin, and the collapse of AOL Time Warner.* New York: Simon & Schuster.

Kleinman, Z. (December 12, 2009). "Children who use technology are 'better writers.'" *BBC News.* Retrieved from http://news.bbc.co.uk/go/pr/fr/-/2/hi/technology/8392653.stm.

Knowledge@Wharton. (May, 3, 2006). "MySpace, Facebook, and other social networking sites: Hot today, gone tomorrow?" Retrieved: http://www. knowledge.wharton.upenn.edu/article.cfm?articleid=1463.

Kubey, R.(2003). "Why U.S. media education lags behind the rest of the

English-speaking world." *Television & New Media*, 4 (4), 351-370.

Kubey, R. (2002a). "The case for media education." *Media Literacy Review*. Retrieved: http://interact. uoregon.edu/medialit/mlr/readings/articles/kubey.htm.

Kubey, R. (2002b). "Think. Interpret. Create. How media education promotes critical thinking, democracy, health, and aesthetic appreciation." *Cable in the Classroom*. Washington, D.C. Retrieved: http://www.ciconline.com.

Lang, A. (June 30, 2010). "Kentucky becomes the 15th state to join P21." *Partnership for 21st Century Skills*. Retrieved: http://www.p21.org/index.php?option=com_content&task=view&id=948&Itemid=64.

Lenhart, A. (December 15, 2009). "Teens and sexting" *Pew Internet & American Life Project*. Retrieved: http://pewinternet.org/Reports/2009/Teens–and–Sexting.aspx.

Lenhart, A., Madden, M., Smith, A., & Macgill, A. (December 2007). "Teens and social media." *Pew Internet & American Life Project*. Retrieved: http://www.pewinternet.org/PPF/r/230/report_display.asp.

Lenhart, A., Purcell, K., Smith, A., & Zickuhr, K. (February 3, 2010). "Social media & mobile Internet use among teens and young adults." *Pew Internet & American Life Project*. Retrieved: http://pewinternet.org/Reports/2009/Teens-and-Sexting.aspx

Lewis, J., & Jhally, S. (Winter 1998). "The struggle over media literacy." *Journal of Communication*, 48(1), 2–8.

Liptak, A., & Johnston, D. (June 28, 2005). "Court declines to rule on case of reporter's refusal to testify." *New York Times*. [Online]. Retrieved: http://query.nytimes.com/gst/fullpage.html?res=9805E5DC153AF93BA15755C0A9639C8B63.

Livemocha. (2010). "The world's largest online language learning community." *Livemocha*. Retrieved: http://www.livemocha.com/pages/about.

Luke, C. (February 2000). "New literacies in teacher education." *Journal of Adolescent and Adult Literacy*, 43(2), 424–435.

Madden, M., & Smith, A. (May 26, 2010). "Reputation management and social media." *Pew Internet & American Life Project*. Retrieved: http://www.pewinternet.org/Reports/2010/Reputation-Management.aspx

Martin, S. (July/August 2003). "Close the book. It's time to read." *Clearing House*, 76(6), 289–291.

McCannon, B. (2002). "Media literacy: What? why? how?" In *Children Adolescents & The Media*. (pp. 322–367). London: Sage Publications.

McLuhan, M. (1964). *Understanding media: The extensions of man*. (1st Ed.) NY: McGraw Hill.

Meech, S. (June/July 2010). "Kidblog offers safe and simple interface." *Learning & Leading with Technology*, 37(8), 38.

Meigs, D. & Torrent, J. (2009). "Why incorporate media education?" *Mapping media education policies in the worlds: Visions, programmes and challenges.* New York: UN-Alliance of Civilizations, 182.

Melago, C. (December 10, 2007). "Educators get TeacherTube." *NY Daily News.* Retrieved: http://www.nydailynews.com/ny_local/education/2007/12/09/2007-12-09_educators_get_teachertube.html.

Merchant, G. (2010). "View my profile(s)." *Adolescents' Online Literacies.* New York: NY: Peter Lang, 59.

McHugh, J. (September 26, 2005). "Synching up with the iKid: Connecting to the twenty-first-century student educators must work to understand and motivate a new kind of digital learner." *Edutopia.* Reyrieved: http://www.edutopia.org/print/1355.

Mills, E. (June 4, 2010). "Scare tactics, blocking sites can be bad for kids." *CNET News:* Retrieved: http://news.cnet.com/8301-27080_3-20006868-245.html.

Mraz, M., Heron, A., & Wood, K. (January 2003). "Media literacy, popular culture, and the transfer of higher order thinking abilities." *Middle School Journal,* 51-56.

National Council for Social Studies. (2010). "National curriculum standards for social studies: A framework for teaching, learning, and assessment." Retrieved: http://www.socialstudies.org/standards/strands.

National Council of Teachers of Mathematics. (2009). "Standards and focal points." Retrieved: http://www.nctm.org/standards/default.aspx?id=58.

National Education Technology Plan. (November 2010). "Transforming American education: Learning powered by technology. Office of Educational Technology, *US. Department of Education.* Retrieved: http://www.ed.gov/sites/default/files/netp2010.pdf.

National School Board Association. (July 2007). "Creating & connecting: Research and guidelines on online social—and educational—networking, 1–9. Retrieved: http://www.nsba.org/SecondaryMenu/TLN/CreatingandConnecting.aspx.

National Science Teachers Association. (1998). *National Science Education Standards,* Washington, DC: National Academy Press, Retrieved: http://www.nap.edu/openbook.php?record_id=4962&page=209.

Nielsen, L. (July 21, 2009). "Eight ways to use school wikis." *Tech & Learning.* Retrieved: http://www.techlearning.com/article/22064.

Nielsen, L. (April 25, 2010). "Teaching kids to manage their digital footprint." *The Innovative Educator.* Retrieved: http:// theinnovativeeducator.blogspot.com/2010/02/teaching-kids-to-manager-their-digital.html

Norris, S. P. (May 8, 1985). "Synthesis of research on critical thinking." *Educational Leadership,* 42(8), 40–45.

Obama, B. (June 2008). "Remarks of Senator Barack Obama: Renewing American competitiveness." *Organizing for America.* Retrieved:

http://www.barackobama.com/2008/06/16/remarks_of_senator_barack
_obam_79.php

O'Hanlon, C. (August 2007). "If you can't best 'em, join 'em." *The Journal.* Retrieved: http://www.thejournal.com.the printarticle/?id=21081.

Oliver, K. (March/April 2010). "Integrating Web 2.0 across the curriculum." *TechTrends*, 54(2), 50–60.

Palfrey, J., Grasser, U., & boyd, d. (February 24, 2010). "Response to FCC Notice of Inquiry 09-94- Empowering Parents and Protecting children in an evolving media landscape." *The Berkman Center for Internet & Society* at Harvard University. Retrieved: http://cyber.law.harvard.edu/sites/cyber.law.harvard.edu/files/Palfrey _Gasser_boyd_response_to_FCC_NOI_09-94_Feb2010.pdf.

Partnership for 21st Century Skills. (December 2006). "Results that matter: 21st century skills and high school reform." Retrieved: http://www.21stcenturyskills.org/index.php?Itemid=114&id=204&opt ion=com_content&task=view.

Paul, I. (May 31, 2010). "It's quit Facebook day, are you leaving?" *PCWorld.* Retrieved: http://www.pcworld.com/article/197621/its_ quit_facebook_day_are_you_leaving.html.

Paul, R. (1995). *Critical thinking: How to prepare students for a rapidly changing world.* CA: Dillon Beach: Foundation For Critical Thinking, Appendix B, 521-552.

Petress, K. (March 1, 2004). "Critical thinking: An extended definition." *Education*, 124(3), 461–467.

Phillips, J. (1999). *Foreign Language Standards: Linking research, theories, and practice.* Lincolnwood, IL: ACTFL Foreign Language Education Series.

Pogue, D. (March 31, 2010). "Looking at the iPad from two angles." *The New York Times.* Retrieved from: http://www.nytimes.com/2010/04/ 01/technology/personaltech/01pogue.html.

Potter, W. J. (2005). *Media literacy.* (3d ed.). Thousand Oaks, CA: Sage Publications.

Prensky, M. (October 2001). "Digital native, digital immigrants." *On the Horizon.* (9)5.

Prensky, M. (December 2005/January 2006). "Listen to the natives." *Educational Leadership,* 63(4), 1–2.

Quesada, A. (October 2000). "The media literacy imperative." *Technology & Learning.*

Ramaswami, R. (May 2008). "Fill 'Er Up," *T.H.E. Journal.* Retrieved: http://www.thejournal.com/articles/22571.

Ricci, C. (2004). The case against standardized testing and the class for a revitalization of democracy. *The Review of Education, Pedagogy, and Cultural Studies.* 26, 339-361.

Richardson, W. (Jan/Feb 2004). "Blogging and RSS—The 'what's it?' and 'how to' of powerful new web tools for educators." *MultiMedia & Internet@Schools*, 11(1). Retrieved: http://www.infotoday.com/MMSchools/jan04/richardson.shtml.

Rideout, V. J., Foehr, U. G., & Roberts, D. F. (January 2010). "Generation M2: Media in the lives of 8–to 18-year olds." *Kaiser Family Foundation*.

Rideout, V. J., Foehr, U. G., & Roberts, D. F. (March 2005). "Generation M: Media in the lives of 8–18 year-olds." *Kaiser Family Foundation*. Available: http://www.kff.org/entmedia/entmeida030905pkg.cfm.

Rideout, V. J., Foehr, U. G., Roberts, D. F, & Brodie, M. (November 1999). "Kids & media at the new millennium." *Kaiser Family Foundation*. Available: http://www.kff.org/entmedia/1535–index.cfm.

Robinson, J. P., DiMaggio, P., & Hargittai, E. (Summer 2003). "New social survey perspectives on the digital divide." *IT & Society*, 1(5), 1–22.

Rothberg, I. (2006). "Assessment around." *Educational Leadership*. 64(3), 58-63.

Ryan, J. (July 7, 2009). "Some surprising usage facts about Twitter." *Web 2.0 Journal*. Retrieved: http://web2.sys–con.com/node/ 1026329.

Rutledge, P. (May 22, 2010). "Social media: The media we love to hate." *Psychology Today* Retrieved: http://www.psychology today.com/node/43006.

Salpeter, J. (October 15, 2003). "21st century skills: Will our students be prepared?" *TechLearning*. Retrieved: http:// www.techlearning.com/showArticle.php?articleID=15202090.

Scheibe, C. (September 2004). "A deeper sense of literacy." *American Behavioral Scientist*, 48(1), 60–68.

Scholastic Administrator. (September/October 2009). "Will the Kindle change education? E-book reader advances are pushing printed textbooks closer to extinction." Retrieved: http://www2.scholastic.com/browse/article.jsp?id=3752572.

Schwartz, G. (Spring 2001). "Literacy expanded: The role of media literacy in teacher education." *Teacher Education Quarterly*. 111–119.

Serafini, F. (September/October 2002). "Possibilities and challenges: The national board for professional teaching standards." *Journal of Teacher Education*, 53(4), 316–327.

Scharrer, E. (January 2003). "Making a case for media literacy in the curriculum outcomes and assessment." *Journal of Adolescent and Adult Literacy*, 46(4), 354-358.

Shapiro, J. J., & Hughes, S. K. (1996). "Information technology as a liberal art: Enlightenment proposals for a new curriculum." *Educom Review* 31(2), 31-35.

Shor, I. (1999). *What is critical literacy? Critical literacy in action.* New

York: Heinemann Press. Retrieved: http://www. lesley.edu/journals/jppp/4/shor.html.

Singer, D. G., and Singer, J. L. (1976). "Family television viewing habits and the spontaneous play of preschool children." *American Journal of Orthopsychiatry*, 46, 496-502.

Silverblatt, A. (2000). "Media literacy in the digital age." *Reading Online*, 4(3). Retrieved: http://www.readingonline.org/newliteracies/ lit_index.asp?HREF=/newliteracies/silverblatt/ index. html.

Silverblatt, A. (2001). *Media literacy: Keys to interpreting media messages*. Westport, CT: Praeger.

Silvernail, D., & Lane, D. (2004). "The impact of Maine's one-to-one laptop program on middle school teachers and students." University of Southern Maine: *Maine Education Policy Research Institute*.

Thoman, E. (1997). "Skills and strategies for media education." *Center for Media Literacy*. Los Angles, CA. Retrieved: http://www.medialit.org/ reading-room/skills-strategies-media-education

Thompson, A. (August 2010). "Point/counterpoint—is technology killing critical thinking skills?" *Learning and Leading with Technology*. 38(1), 6–7.

Tufte, T., & Enghel, F. (November 1, 2009). "Youth engaging with the world: Media, communication and social change." *The International Clearinghouse on Children, Youth and Media's Yearbook 2009*.

Tyner, K. (1998). *Literacy in a digital world: Teaching and learning in the age of information*. Mahwah, NJ: Lawrence Erlbaum.

Tyner, K. (2003). "Beyond boxes and wires." *Television & New Media*, 4(4), 371–388.

United Nations Educational, Scientific and Cultural Organization. (2010). "Communication and Information." *UNESCO*. Retrieved: http://portal.unesco.org/ci/en/ev.php- URL_ID=1657&URL_DO=DO_TOPIC&URL_SECTION=201.html.

Wallis, C. & Steptoe, S. (December 18, 2006). "How to bring our schools out of the 20th century." *Time,* 168(25), 51–56.

Walsh, P. (June 20, 2008). "U study praises educational value of MySpace, Facebook." *Minneapolis Star Tribune.* Retrieved: http://www.startribune.com/20598114.html.

Warlick, D. (October 15,2006). "A day in the life of Web 2.0." *Technology & Learning Magazine*. Retrieved: http://www.techlearning.com/article/13980.

Warlick, D. (October, 2008). "Literacy and learning in the 21st century." *Technology and Learning,* TechForum Conference, New York City.

Waters, J. (January 2009). "A secondary life for educators." *THE Journal*, 36(1), 29–34.

Willard, N. (2006). "Schools and online social networking." *Education World*. Retrieved: http://www.educatoin–world.com/a_issues/ issues/issues423.shtml.

Wilson, L. (May 15, 2008). "Txt msg lingo defended." *The Australian News*. Retrieved: http://www.theaustralian.news.com.au.story. 0.25197.23700796–2702.00.html.

Wordle. (2010). "Wordle blog." Retrieved: http://blog.wordle.net/.

Yan, J. (Winter 2008). "Social networking as a new medium in the classroom." *New England Journal of Higher Education*, 22(4), 27–30.

Yoder, M. B. (September/October 2009). "Walk, fly, or teleport to learning." *Learning and Leading with Technology*. Retrieved: http://www.eric.ed.gov/ERICDocs/data/ericdocs2sql/content_storage_0 1/0000019b/80/45/91/ac.pdf.

Young, L. (April 29, 2010). "NJ Principal asks parents to ban social networking." *WCBS-TV*. Retrieved: http://wcbstv.com/technology/facebook.social.networking.2.1662565.ht ml.

Zaretsky, M. (March 25, 2010). "Branford budget advances after some moderate trimming." *New Haven Register*. Retrieved: http://www.nhregister.com/articles/2010/03/25/news/shoreline/b6– rfinance.txt.

Index

CRITICAL ISSUES
FOR LEARNING AND TEACHING

Shirley R. Steinberg & Pepi Leistyna
General Editors

Minding the Media is a book series specifically designed to address the needs of students and teachers in watching, comprehending, and using media. Books in the series use a wide range of educational settings to raise consciousness about media relations and realities and promote critical, creative alternatives to contemporary mainstream practices. *Minding the Media* seeks theoretical, technical, and practitioner perspectives as they relate to critical pedagogy and public education. Authors are invited to contribute volumes of up to 85,000 words to this series. Possible areas of interest as they connect to learning and teaching include:

- critical media literacy
- popular culture
- video games
- animation
- music
- media activism
- democratizing information systems
- using alternative media
- using the Web/internet
- interactive technologies
- blogs
- multi-media in the classroom
- media representations of race, class, gender, sexuality, disability, etc.

- media/communications studies methodologies
- semiotics
- watchdog journalism/investigative journalism
- visual culture: theater, art, photography
- radio, TV, newspapers, zines, film, documentary film, comic books
- public relations
- globalization and the media
- consumption/consumer culture
- advertising
- censorship
- audience reception

For additional information about this series or for the submission of manuscripts, please contact:

Shirley R. Steinberg and Pepi Leistyna,
msgramsci@aol.com | Pepi.Leistyna@umb.edu

To order other books in this series, please contact our Customer Service Department:

(800) 770-LANG (within the U.S.)
(212) 647-7706 (outside the U.S.)
(212) 647-7707 FAX

Or browse online by series:
www.peterlang.com